Presented to

Spring Branch Memorial Library

By

Annette Farid

**In Honor of
Anneka Farid**

Harris County
Public Library
your pathway to knowledge

Published in the UK in 1997 by
Tauris Parke Books
an imprint of I.B.Tauris and Co. Ltd
Victoria House
Bloomsbury Square
London WC1B 4DZ

Copyright © 1994 C.J. Bucher Verlag, Munich
Translation © 1997 I.B.Tauris and Co. Ltd
Translated into English by Isabel Varea

A full CIP record is available from the British Library

ISBN 1 86064 164 4

Printed and bound in Italy

CHÂTEAUX OF THE LOIRE

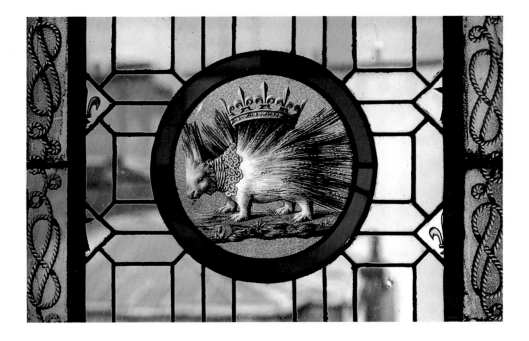

Photographs by Axel M. Mosler
Text by Thorsten Droste

TAURIS PARKE BOOKS

LONDON • NEW YORK

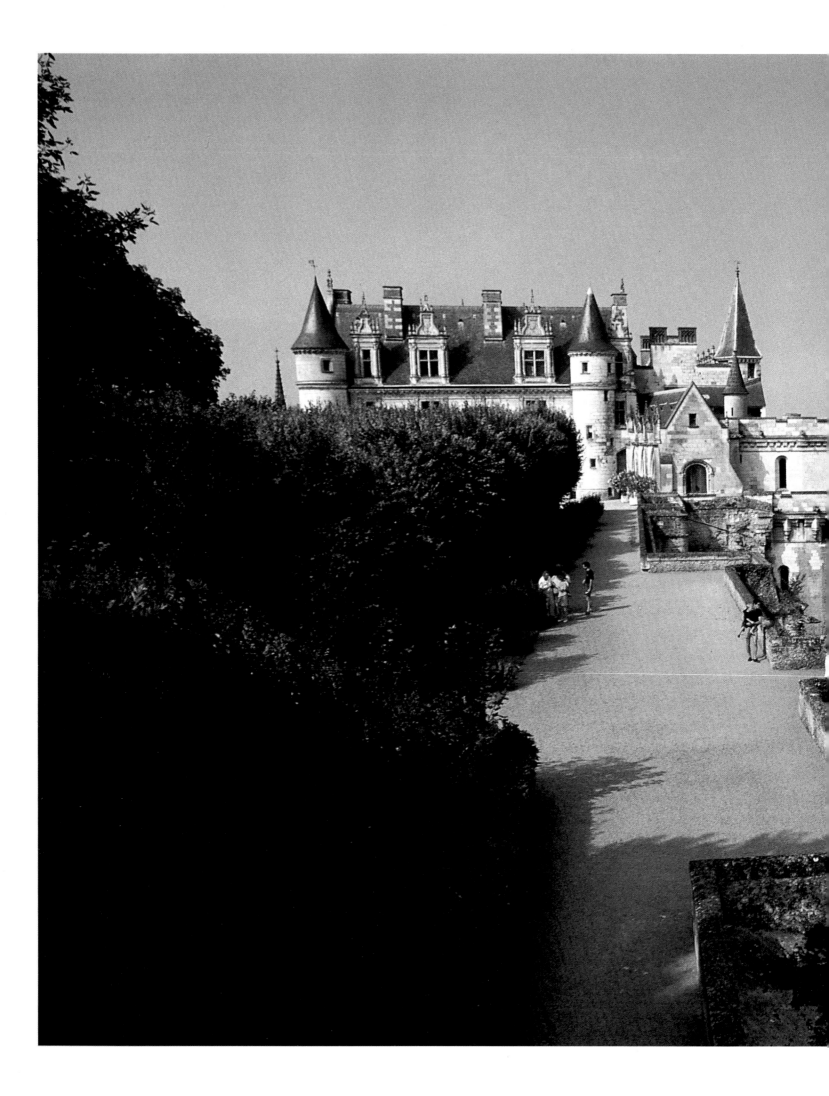

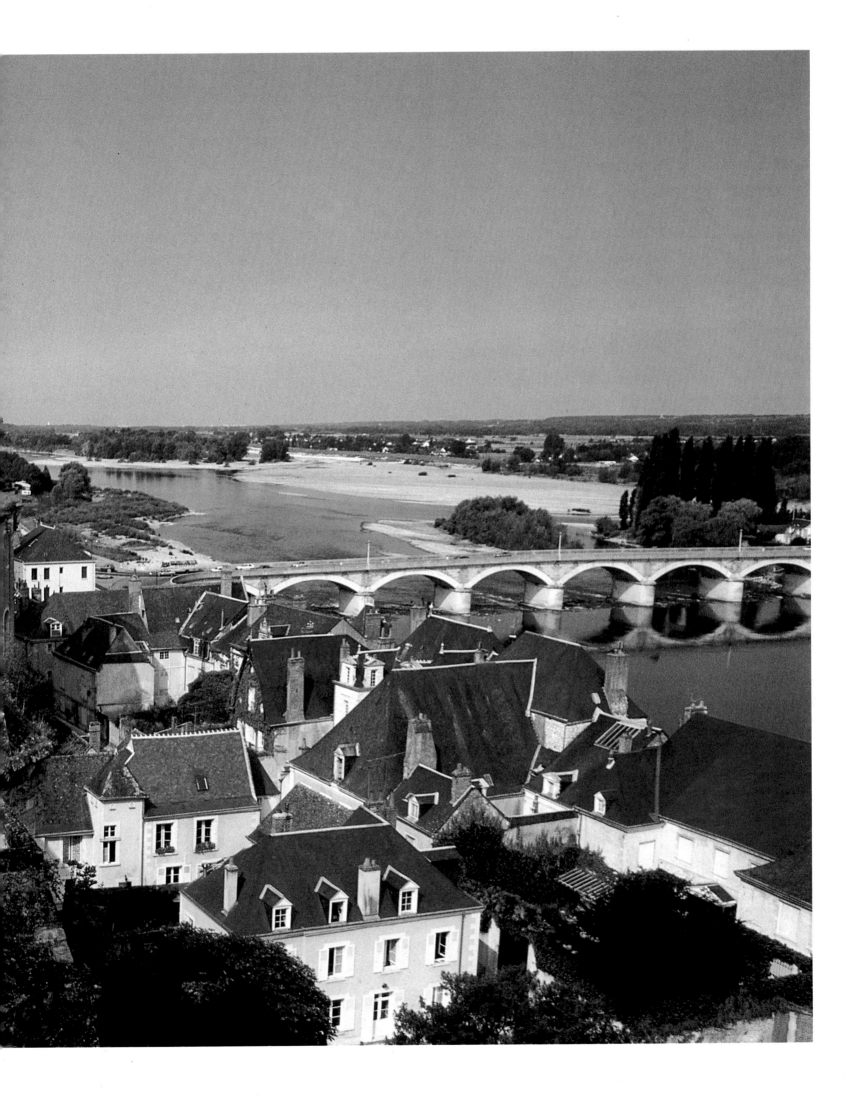

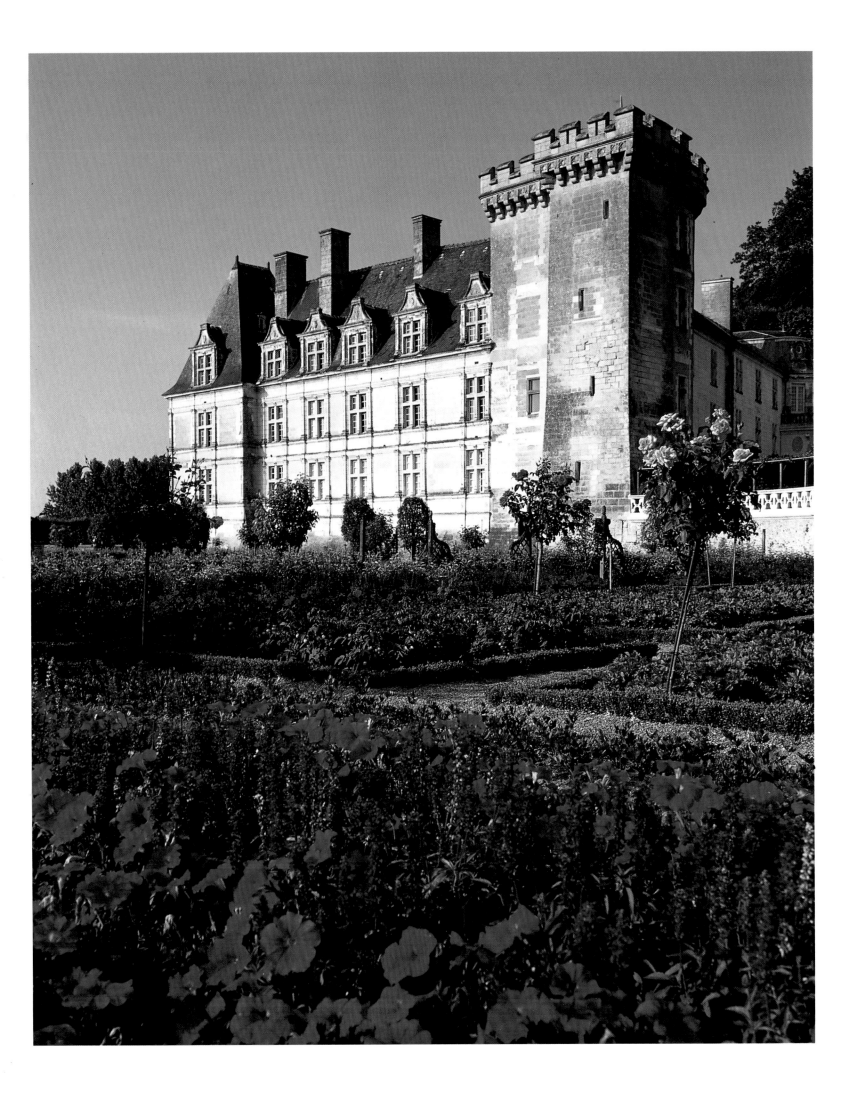

CONTENTS

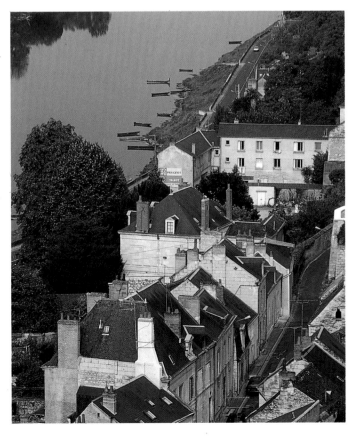

Page 1: A stained glass window at the Château of Blois. The porcupine is the heraldic beast of Louis XII.

Page 2/3: The Château of Amboise is picturesquely set high above the banks of the Loire.

Page 4: The Château of Villandry's greatest fame is its beautiful park.

Page 5, left: The little town of Chinon lies in the shadow of its château complex on the Vienne.

Page 5, right: The Château of Ussé, with its many towers, is like a fairy-tale castle.

THE LOIRE VALLEY

LANDSCAPE, HISTORY AND ART

The River Loire, at 1012 kilometres long, is France's mightiest river. Rising in the Massif Central under the conical volcano Gerbier-de-Jonc, it separates Burgundy from the Bourbonnais as it makes its resolute way northwards. Since primeval times, the river followed this course doggedly, and in the Stone Age its waters flowed into the Seine. Millions of years ago, however, the 'capricious lady' changed direction at the old porcelain-manufacturing town of Gien. Here, it curves in a broad arc towards the north-west, with the city of Orléans standing at its most northerly point. From Blois, the river continues westwards in a virtually straight line, finally meeting the Atlantic at Saint-Nazaire. Travelling from the source of the Loire to its mouth, exploring the country on either side, the visitor passes through more than a quarter of present-day France. The river's immense scale also explains the catchment area of its drainage system, which covers about twenty per cent of the total surface area of France. The Loire's most important tributaries are, to the south, the Allier, Cher, Indre, Vienne and Thouet. From the north, it is fed by the Loir, Sarthe and Mayenne.

The Loire Valley's fame as a tourist destination rests on its numerous châteaux, nearly three hundred of which are concentrated along the stretch from Orléans to Angers. The classic journey along the Loire, during which visitors can watch centuries of French history unfold, begins just before Orléans. The châteaux along the lower third of the Loire were witnesses to momentous events and even now have much to teach us about France's past. The river's historical significance is so deeply rooted in the consciousness of every French man and woman, that many refer to the valley of the Loire simply as *Le Val*.

On its way from Gien to Saint-Nazaire, the Loire crosses four regions: the Orléanais, the Blésois, Touraine and finally Anjou. It so happens that all of these regions extend along both banks, so that the river itself never actually separates them. It only becomes a boundary marker in the upper reaches, fairly close to where the Orléanais begins. There the river begins by pushing its way through mountains and rolling hills, separating the various regions from each other. After Gien, the river valley widens and the border between the plains of the Ile de France in the north and the edge of the Aquitaine basin in the south becomes more fluid.

Even in the Orléanais, it is clear that the Loire Valley's nickname, 'the garden of France', is well deserved. Tree nurseries, orchards and fields of flowers are everywhere.

The sandy soil of the western Orléanais, washed up by the river over millions of years, is fertile ground for spring vegetables, especially asparagus. Extensive woodlands, alternating with cultivated land, enliven the gently sweeping landscape, creating a multifaceted mosaic.

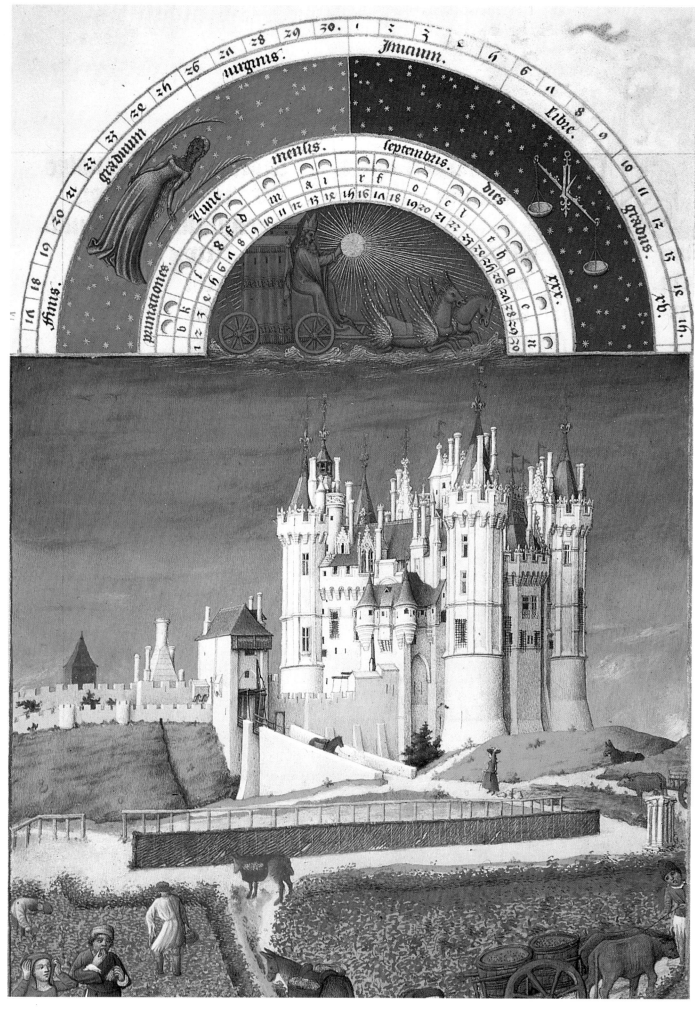

Illumination representing the month of September (the grape harvest) from the 'Très Riches Heures du Duc de Berry' – the Book of Hours, painted for the Duke of Berry in the early fifteenth century by the Limbourg brothers (the original is now in the Château of Chantilly). In the background is the Château of Saumur, with numerous turrets and gables that no longer exist. Observe the similarity between the roof of the old kitchen to the left of the main gate and that of Fontevraud Abbey (see page 196).

7

The relatively small Blésois forms a bridge between the Orléanais and Touraine. Here and there, among forests rich with game, endless fields of grain and vegetable gardens, the first grapevines can be seen. Blois is also a modest industrial centre, but who in this part of the world ever talks about agriculture or business? People are much more concerned with the region's proudest possessions, the magnificent châteaux of Blois and Chambord, unchallenged in their position at the top of the list of feudal buildings. Equally famous are Cheverny, Chaumont, Villesavin and Beauregard, not to mention the host of aristocratic country seats, manor houses and summer residences from every period.

A perfect example of the beautiful landscape of the Loire Valley is Touraine, lying between Chaumont and Amboise. Thanks not only to its impressive array of citadels and châteaux – Amboise, Chenonceaux, Azay-le-Rideau, Villandry, Langeais, to name but the most important – but also to the world-famous novels of Honoré de Balzac, Touraine has come to symbolize the Loire Valley. Balzac was an eloquent champion of his homeland and never missed an opportunity to extol the virtues of the region, much of which is devoted to viticulture. White grapes, in particular, thrive here on the chalk and loess soil. The driest among them (Vouvray, for example) produce sparkling wine similar to champagne. Artificial caves, hewn over the centuries in the tufa, or soft volcanic rock, of the banks of the Loire and its tributaries, provide ideal conditions in which to age the wine. People actually live in some of these caves. Tufa provides excellent insulation all the year round, so that in the summer the interiors of the caves stay cool, while the soft rock retains the heat in winter.

In the Middle Ages, Chinon, on the lower reaches of the Vienne, was the most important fortress on the Touraine-Anjou border. Visitors today will notice very little difference between the landscape of the two regions, both characterized by extensive fields, vineyards and orchards, broken occasionally by woodland. The generally flat valley is edged with gently rising chains of hills. The chalky soil of the district around Chinon drains more rapidly than that of Touraine and the Saumur area (home of an excellent sparkling wine). Conditions are good for the production of red wine and this is France's most northerly vineyard for growing red grapes. Anjou is also known for its fruity rosé. The local caves, many of them manmade, are used for growing mushrooms, and ninety per cent of all French mushrooms come from Anjou.

After Nantes, the width of the river increases to several hundred metres. If the river has so far had the effect of uniting the regions, here it serves to separate them and the two are clearly distinct from one another: the beginnings of Brittany lie to the north, with Vendée to the south. But even here the Loire is not an insuperable boundary. Vendée and Brittany have not only similar scenery (green-clad granite), but also many cultural aspects in common, dating back to the times of megalithic culture. It seems only right and proper that, when regional boundaries were redrawn in 1972, the two *départements* north and south of the mouth of the Loire should have been united as *Pays de la Loire*.

It is interesting to observe a certain correlation between the sobriety of the landscape, the smooth flow of the river, and the character of the local inhabitants. Here in *Le Val* people do not speak as quickly as they do in, say, Paris or the south of France. They set great store by good, clear pronunciation and it is no idle boast when it is claimed that the finest French is spoken in the Loire Valley. The locals have a remarkably laid-back attitude, combined with a lively understanding of practicalities and an eye to the main chance. This philosophy is humorously

Continued on page 17

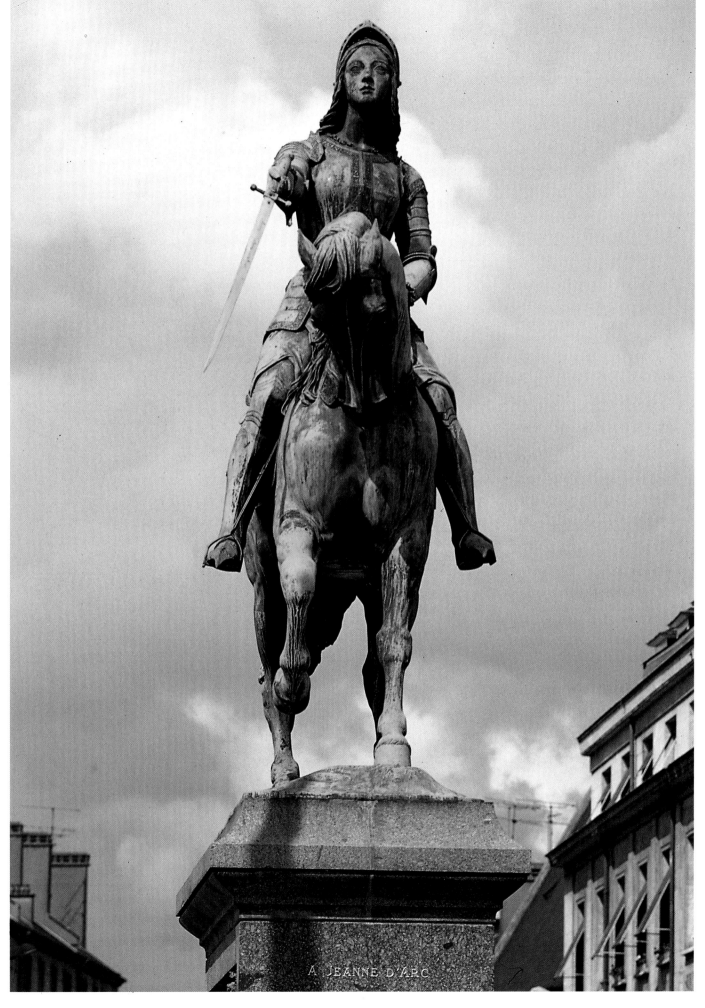

A warlike equestrian statue from 1855 of Joan of Arc, who fought to raise the English siege of Orléans during the Hundred Years War. In 1429 she succeeded in bringing King Charles VII to Reims for his coronation, a turning point in the war. Today she is France's national heroine, commemorated as she is here in Place du Martroi, Orléans.

Overleaf: View from the Cathedral of Saint-Louis, Blois, capital of the département Loir-et-Cher, to the River Loire, with a fascinating interplay between bluish slate roofs and red brick chimneys.

A JEANNE D'ARC

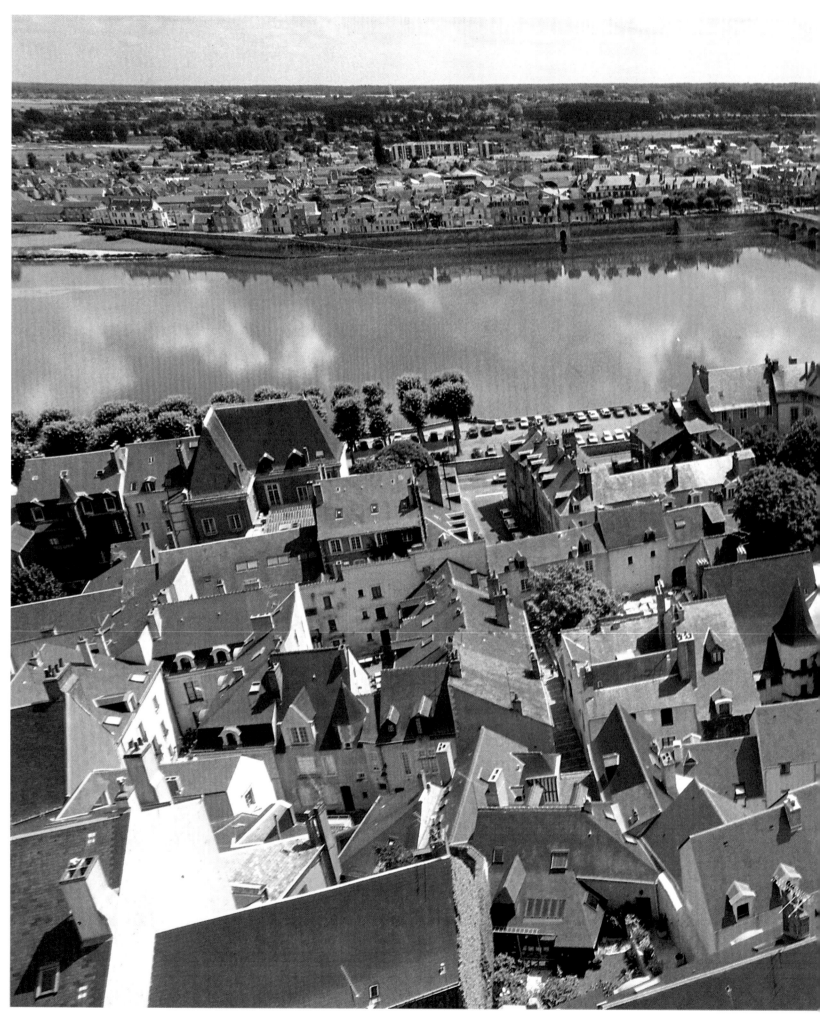

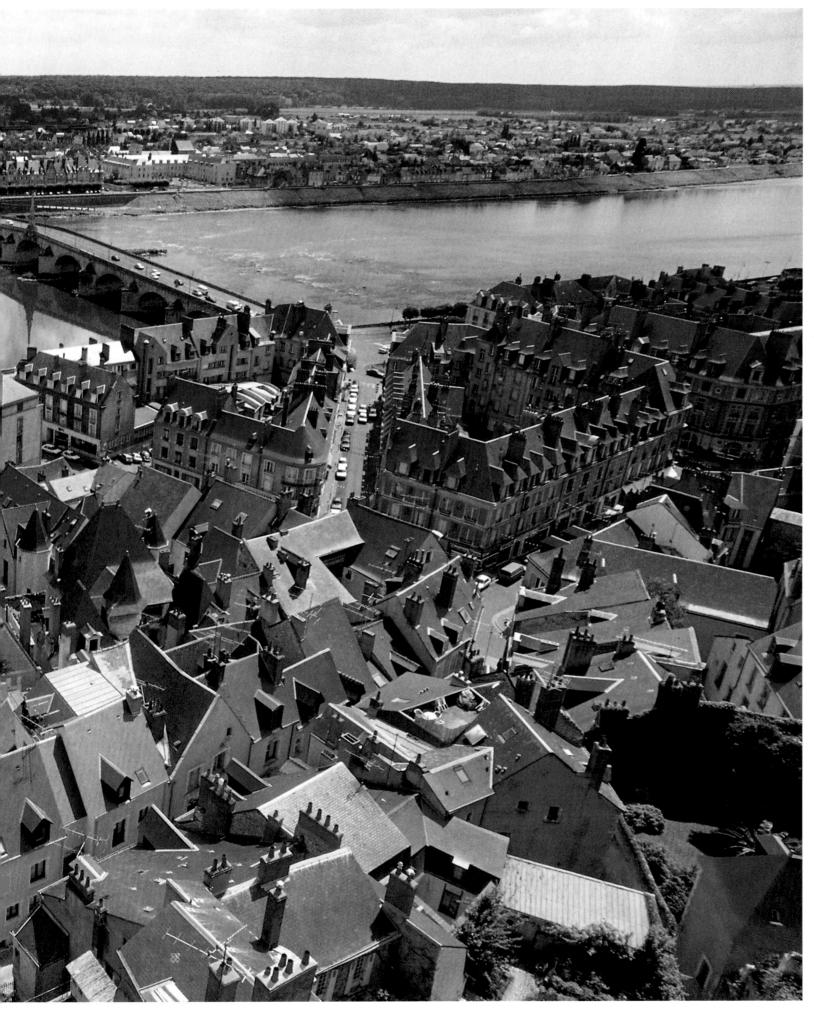

Near Saumur, the Loire flows around an island town, Ile d'Offard, making its dimensions look somewhat modest.

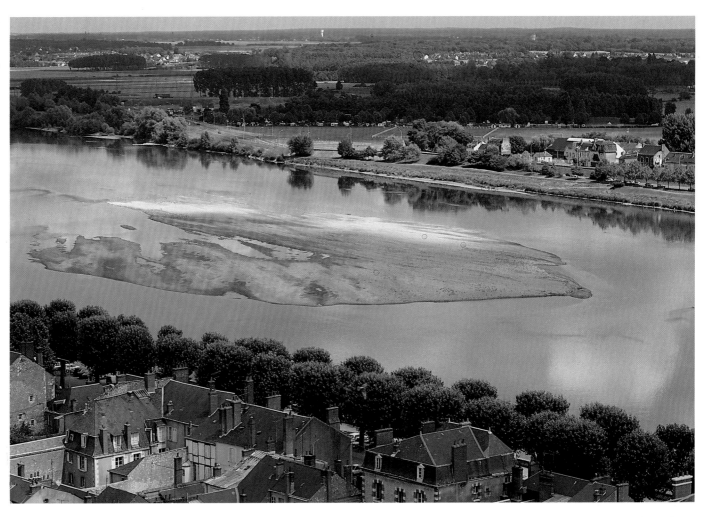

From Blois, the Loire flows westwards in an almost straight line, finally reaching the sea at Saint-Nazaire.

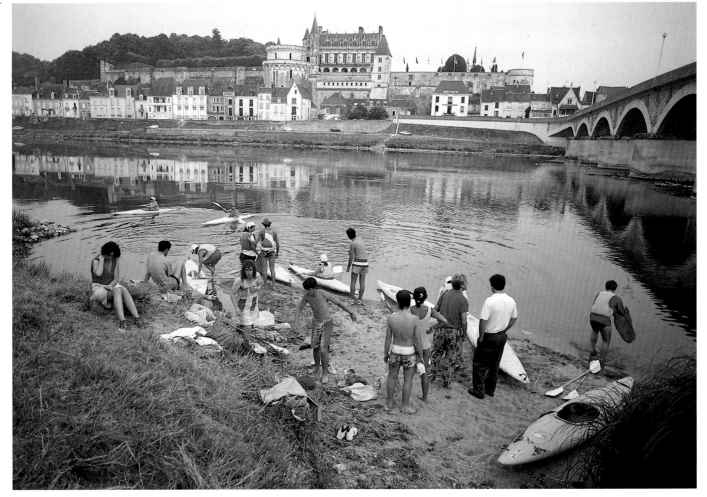

The Château of Amboise rises directly from the banks of the Loire, unlike all the other châteaux, which are set back from the river.

Overleaf: The massive riverside walls at Blois – seen here in summer when the water level is low – protect the city from floods. No other river in France suffers such extreme variations in water levels as the Loire.

13

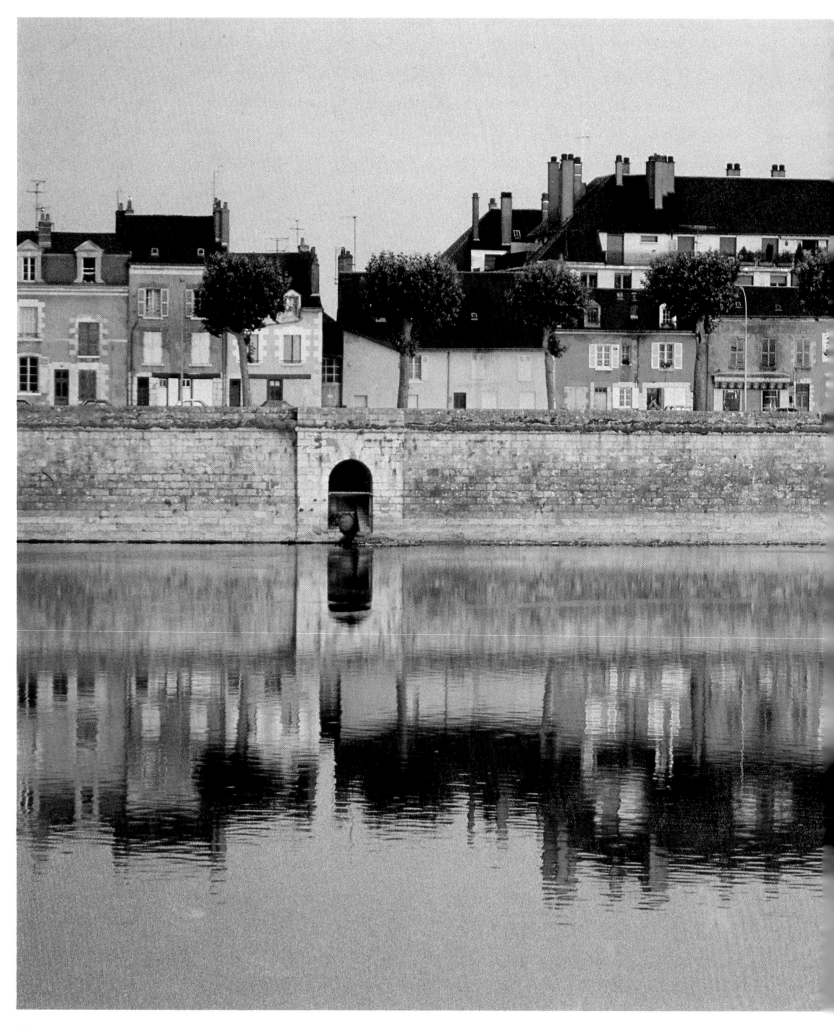

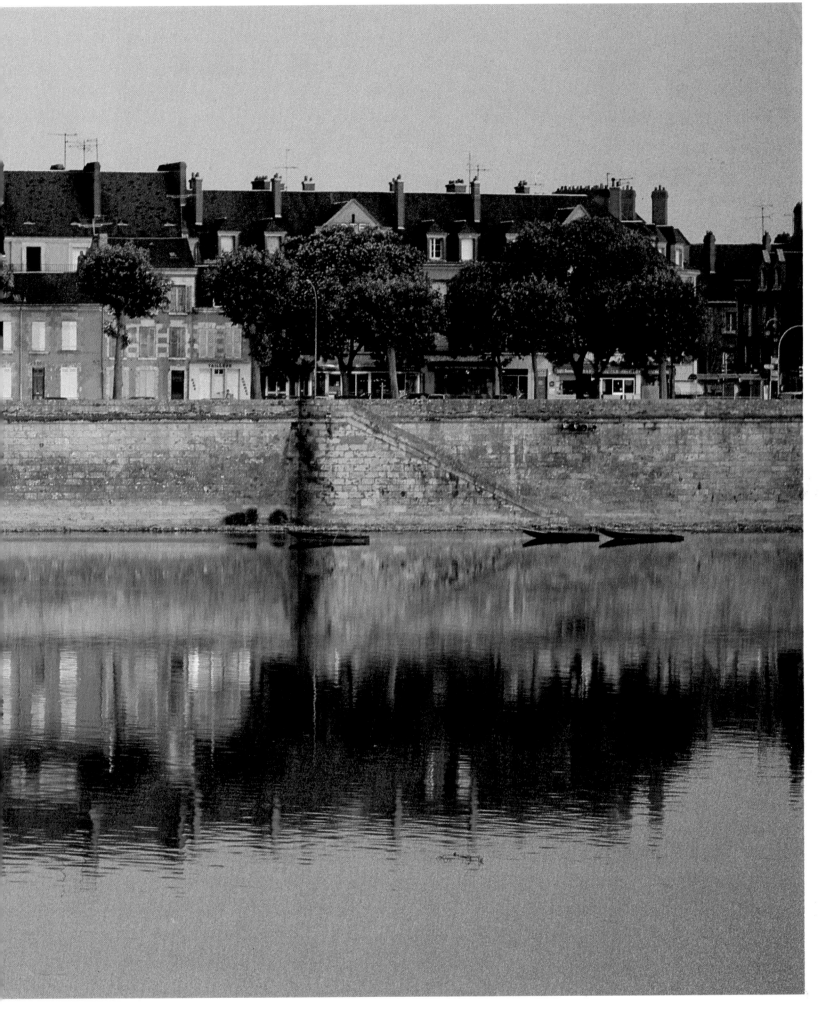

Traditional, flat-bottomed punts, seen here on the Vienne, are today used for ferrying goods and, of course, for fishing.

encapsulated in a medieval legend. There were once two cripples, who lived purely on what they could beg. One day, the relics of Saint Martin were being carried from Burgundy to Tours, and wherever the procession passed, the sick were healed. Our two heroes decided to make themselves scarce, as they did not want to be relieved of their infirmities, and thereby lose a secure source of income. But the procession moved faster than they could hobble. Reluctantly, they were cured, but found they could make just as steady a living by zealously singing the praises of the saint.

THE LOIRE IN PERIL

Anyone who sees the sights of the Loire Valley, either by visiting in person or by leafing through a book, cannot remain unmoved by the discreet charm of the Loire. But why this fascination? The châteaux and other monuments are certainly not the only explanation. Much of the magic that captivates so many lies in the unspoilt nature of the region. In fact, the Loire is the only major river in Central or Western Europe whose course man has not yet attempted to control. The river has never been a major shipping lane. Until well into the nineteenth century, punts loaded with goods were towed up river. With the coming of the railways, shipping was brought to a standstill, apart from vessels plying the coast between Saint-Nazaire and Nantes, and the Loire was left to its own devices and has since gone very much its own way. Recurring floods have led to constant shifts in the river bed, much to the dismay of those cartographic institutes forced to revise every new edition of their maps of the Loire. At the same time, something has been created that has a rarity value in modern Europe: an ecological area with a huge range of species of animal and plant life, which elsewhere have long since died out. Even the atomic power stations built here in the early Sixties have brought about little change.

Recently, though, this idyllic state of affairs has been called into question. The Loire itself has been the pretext for the planning of massive regulatory measures. Its water level varies critically according to the time of year: in the summer months it is reduced to a rivulet (as was the case in the extremely dry summer of 1989), while in spring it sometimes swells unpredictably. The unfortunate result has been the regular flooding of villages, towns and fields. In order to protect the population, it was proposed to build dykes along the lower reaches, and a whole series of dams on the upper reaches of the Allier, Cher and Loire to keep the river in check. The safety argument, however, was soon revealed as being merely an excuse, with the real motivation being simple economics. On the one hand, the regulated water level would ensure the supply of cooling water to the four large nuclear power stations on the banks of the Loire between Sancerre and Saumur. On the other, it was a question of increasing shipping, which planners wanted to see extended to the mouth of the Vienne. Alongside these measures, there were plans to reclaim the previously fallow flooded areas for agricultural use.

Since the French had hitherto shown little, or no more than half-hearted, interest in environmental protection, it seemed that there would be no serious resistance to these endeavours. But in spring 1989 the big surprise came. Virtually overnight the question of the regulation of the Loire was the subject of discussion among the wider public. The controversial issue caused environmentalists, who had so far led a shadowy existence, to capture ten per cent of the votes for seats in the European Parliament. Suddenly, efforts to conserve the environment, often derided as typically Teutonic hysteria, became a cause for serious concern, affecting every citizen. There were three issues that brought the millennium project into question.

Firstly, doubt was cast on the need to provide the power stations with cooling water, since there had long been over-production of electric current, so much so that France was supplying energy to neighbouring countries. It was even necessary to close down one of the nuclear power stations. Secondly, in view of the over-capacity of the EU market, reclamation of land for agricultural use did not make sense. Apart from the not very convincing economics of building dams and regulating the flow of the river, the environmental consequences became a crucial argument against the project. It was claimed that fish (such as eel, salmon and other types), amphibians, and a whole range of bird life, as well as insects and a broad spectrum of plant life would be affected by the measures. Western Europe's largest unspoilt ecological system was doomed to total destruction. Instead of a still fascinating variety of species and a living countryside, there would be a barren, monotonous, agricultural landscape, planned by bureaucrats.

The concerted action of environmentalists from all over Europe and various initiatives by numerous action groups, united, albeit belatedly, under the slogan *Loire vivante*, achieved their first success. The Ministry for the Environment called a temporary halt to the ambitious plans. Now it was left to the courts to decide on the appropriateness, use and consequences of the proposals. The sword of Damocles still hangs over the Loire.

One might ask why this particular project brought people to the barricades. Why did the construction of the giant nuclear reactor, whose few opponents once fought a lost cause, not produce the same response?

It is also remarkable that traditionally conservative groups, including hunting and fishing clubs, farmers and members of the aristocracy, usually passionate advocates of technological progress, joined the nationwide protest. Clearly, the proposed attack on the Loire touched a sensitive spot in the consciousness of the

French. The reason is obvious: as the scene of fateful events which were to affect the course of French history and France's idea of her own nationhood, the Loire Valley was part of the national identity, and no one would be allowed to play fast and loose with it.

THE GLORY DAYS OF THE FOUR PROVINCES

In the fifth century AD, even before the collapse of the Western Roman Empire, the Loire Valley was already recognized as a major centre in the Christianization of Gaul. Saint Martin, who came from Poitiers as a disciple of Saint Hilary, was appointed Bishop of Tours in 371. When Martin died in 397, the year in which Christianity became the official state religion, his tomb immediately became a place of pilgrimage, and in the Middle Ages he became the patron saint of the Franks. At this time, the Germanic tribes were already on the move and the Roman Empire was to crumble under their onslaught, paving the way for centuries of reform in Europe.

Orléanais and Anjou – Cradle of Royal Dynasties

In the thousand years between 500 and 1500, each of the Loire provinces in turn had its great moments in history, becoming the focal point of power politics.

The dance was led by the Orléanais. Having begun, in the middle of the fifth century, to expand southwards from their ancestral lands in what is now Belgium, the Franks under Clovis' leadership consolidated their position throughout Gaul. In the course of the repeated divisions and episodic reunifications of the territories under the control of the Merovingians, the Orléanais came to occupy the key position which it held for centuries. Because of its central location, both the Carolingians and their Capetian successors usually preferred Orléans to Paris. Only when the power of the sovereign became stronger and more centralized in the twelfth century did Orléans and the Orléanais lose this status.

In a kind of relay race run through the Loire provinces over the centuries, Anjou came to prominence in the eleventh century. At this time, having conducted innumerable local feuds with his neighbours from his capital Angers, the valiant Count Fulk Nerra had forged a stable principality. In combination with some astutely arranged marriages, his efforts elevated Anjou to a major European power. Geoffrey, one of Fulk's successors, married Matilda, widow of the German Emperor Henry V, who, as a grand-daughter of William the Conqueror, brought with her English ancestral estates. Geoffrey was honoured as the founder of the dynasty of Anjou. His habit of sporting in his hat a sprig of broom (*planta genestae*) gave the dynasty its name of Plantagenet. From the middle of the twelfth century, the Plantagenets were to wear the crown of England for three hundred years.

Geoffrey's son, Henry, pursued his father's policies. When he succeeded his father he also bore the titles of Count of Maine, Touraine and Anjou, and Duke of Normandy and Brittany. After a national council called at Beaugency in 1152 came one of the most spectacular marriage annulments of the entire medieval period. The marriage between King Louis VII of France and his wife Eleanor of Aquitaine was annulled, with the blessing of the Church, on the grounds of consanguinity. After observing the proprieties for a few months, Eleanor returned to the altar that same year, this time on the arm of Henry of Anjou. Eleanor brought to their union her estates in south-western France – the duchies of Gascony and Aquitaine, and

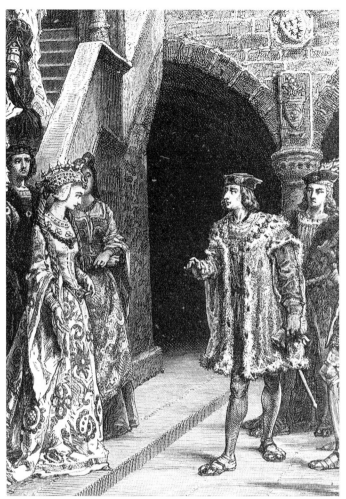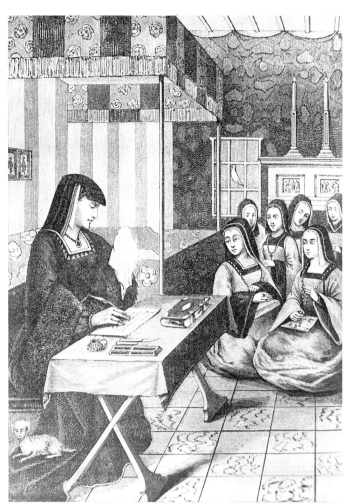

the countships of Toulouse and Auvergne – then the richest provinces in the land. At a stroke, the House of Anjou ruled about half of present-day France. Only two years later, in 1154, the English King Stephen died without issue, so that the Plantagenets also ruled England, and their domain now extended from Scotland to the Pyrenees. Nevertheless, what historians now refer to as the Angevin Empire was to be short-lived. Disagreements between members of the family undermined their authority. Henry II left Eleanor incarcerated for ten years, and his sons Geoffrey and Henry conspired against him. Then in 1198 came the untimely death of Richard the Lionheart, the most able of Henry and Eleanor's four sons. Following the battle of Bouvines in 1214, their youngest son, John Lackland, was forced to return most of his mainland possessions to the French King Philip II Augustus. Nonetheless, considerable territories, especially in south-west France, remained under English rule.

France during the Hundred Years War

In the fourteenth century, English claims to the French throne led to the Hundred Years War. Once again, the Loire Valley provided the setting for major historical events. The last member of the Capetian dynasty had died in 1328 without a male heir, creating a situation that gave lawyers an almost insoluble problem. There were two pretenders to the throne: Philip de Valois and Edward II of England, whose blood relationship with the last Capetian ruler gave them equally well-founded claims to the French crown. After all diplomatic efforts to settle the succession had failed, war broke out in 1338. At first, technical superiority and greater military discipline led the English from one victory to the next. Although France was

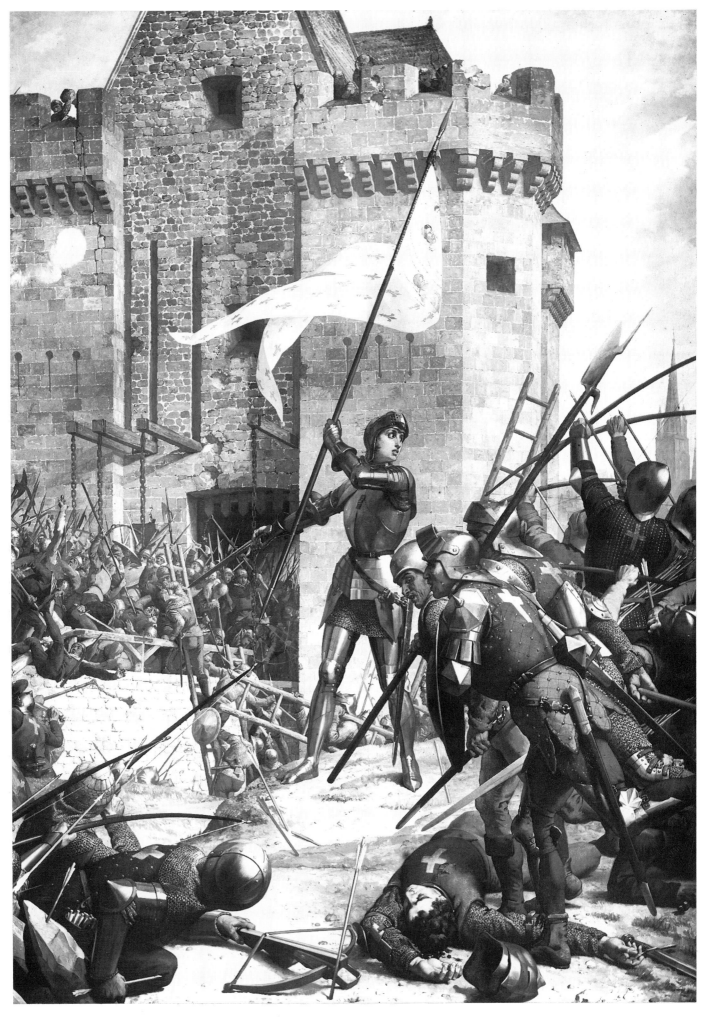

Joan of Arc, Saint Joan, raising the English siege of Orléans. Mural by J.E. Lenepveu at the Pantheon, Paris (c.1870).

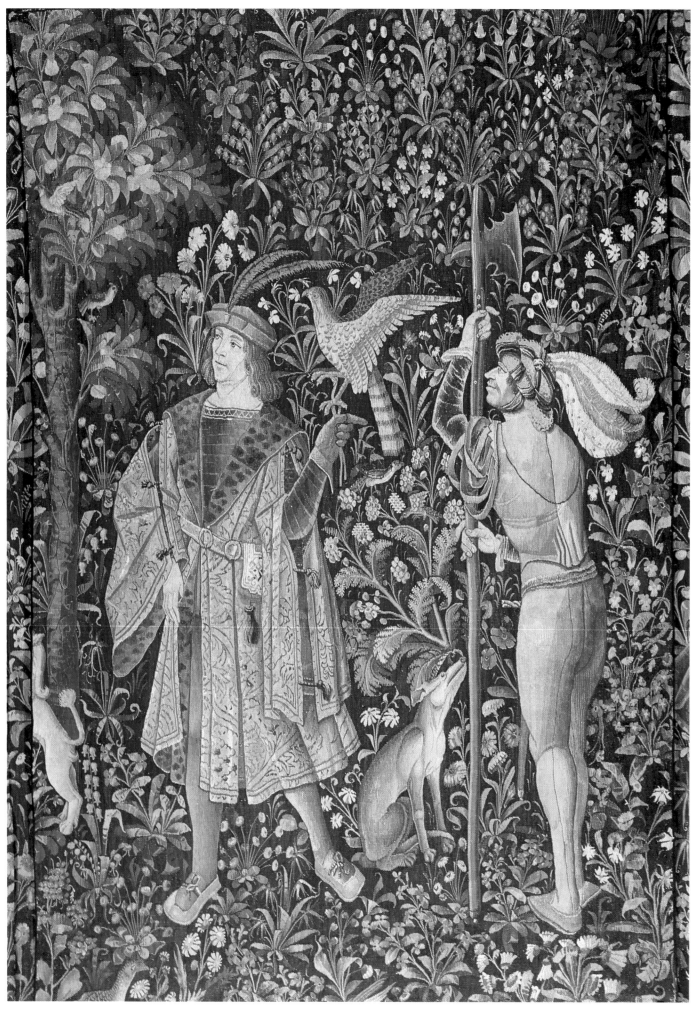

Tapestries such as this one hung in many Loire châteaux. They served both as decoration and as a protection against draughts and cold. The milles-fleurs *tapestry: "The Hunt Sets Out" dates from the early sixteenth century and can now be seen at the Musée de Cluny in Paris.*

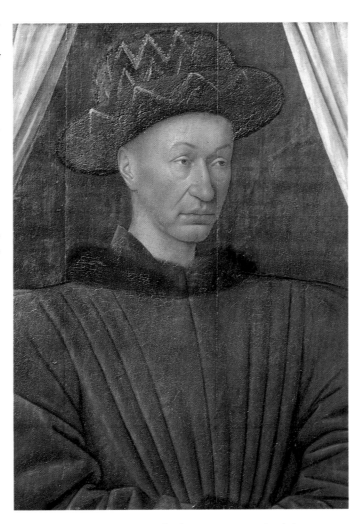
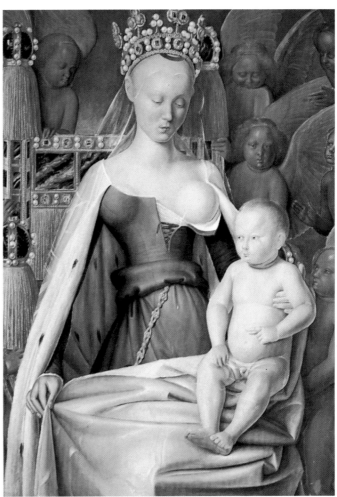

gradually losing ground, there was no decisive outcome in sight. But when England formed an alliance with Burgundy, it seemed that France's fate was finally sealed. Even Paris fell into enemy hands.

In the fifteenth century French territory was reduced to the dukedom of Berry, the countship of Poitiers and part of the Loire Valley. The English sought a final solution at Orléans. This last and crucial bastion of French sovereignty would give them the key to the entire Loire Valley, and France would inevitably become an English fiefdom. The turning point came at this critical moment. It came in the form of a girl named Joan from the town of Domrémy in Lorraine. At Chinon this young woman with a sacred mission managed to persuade the reluctant heir to the throne to place a small army under her command. Joan marched swiftly on Orléans, where the city lay under siege by the English. On 8 May 1429, catching the enemy unprepared, she forced the English to release the city from their clutches. In July the same year, Joan accompanied the Dauphin to Reims, where French monarchs were traditionally crowned. Here he was anointed as Charles VII, King of France. Joan was betrayed and fell into English hands in the spring of 1430 and was burned at the stake at Rouen for alleged witchcraft, but there was no stopping the triumphal march she had begun. Recognizing the change in the situation, the Burgundians were immediately reconciled with France. Deprived of their most important allies, the English retreated step by step, until finally, after the last battle at Castillon in the Dordogne in 1453, the war petered out. Perhaps the most decisive result of this last year of the war was that France, whose local princes had previously lived at odds with each other, saw itself as a nation for the first time. The melting pot in which this new identity was forged was the Loire Valley.

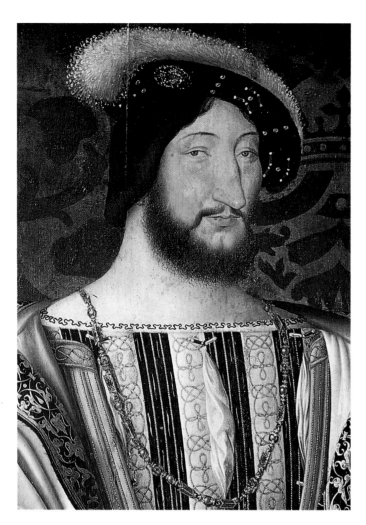

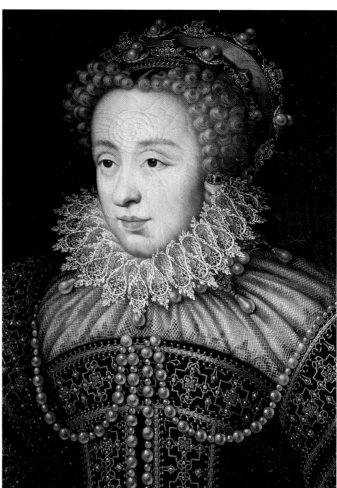

Blésois and Touraine – Favourite Provinces of the Valois

A further consequence of the long years of war was that, after the heyday of the Orléanais and Anjou, the Blésois and Touraine became the favourite provinces of the French kings. The Valois monarchs never managed to acquire a taste for Paris, so remained faithful to their royal seats on the Loire. Already Louis XI, son and heir of Charles VII, had committed himself wholeheartedly to rebuilding a land laid waste by war, famine, social unrest and epidemics. By staying put on the Loire he set an example to his successors. When Charles VIII commissioned the building of the château at Amboise, he was clearly stating his intention to remain on the Loire for years to come. At the same time, Charles managed to bolster the supremacy of the crown by marrying Anne, duchess of the previously independent Brittany. The king attached such importance to this territorial gain that the marriage contract stipulated that, should Charles predecease her without issue, she was to marry his successor. This is exactly what did happen: in 1498 on his way to watch a ball game at Amboise, he cracked his head so hard on a low lintel that he fractured his skull. He died of his injuries that same night, without a son to succeed him. When the last of the Valois, Charles VIII, died, he was succeeded by Louis XII, an heir to the collateral house of Valois-Orléans. Fulfilling to the letter the contract made with Charles VIII, Anne of Brittany married Louis XII. If contemporary sources are to be believed, although their union was a purely political arrangement, it was an extremely harmonious marriage and they were a devoted couple. Nevertheless, they were denied the longed-for male heir, but in 1499, their daughter, Claude – known as Claude de France – was born. Her name lives on in the French word for greengages (*reines-claudes*), which were specially cultivated for her. When her father died in 1515, the Valois-Orléans succession became a major

24

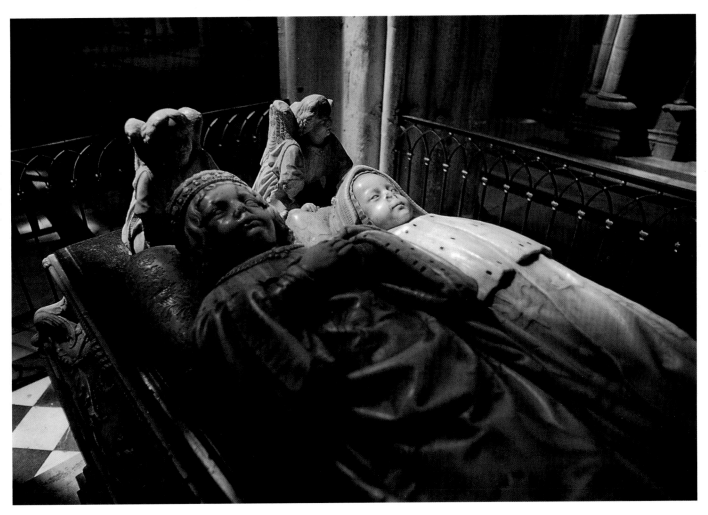

concern, as it had been on the death of Charles VIII. Thanks to their dynastic ramifications, the Valois had at their disposal a further source of possible heirs: the house of Valois-Angoulème, which went back to one of the sons of John the Good. So, quite unexpectedly, the young Francis I from the house of Cognac-Angoulème came to the throne. What better solution than to arrange a marriage between Claude and the new king? Their union would have the added advantage of underlining the legitimacy of Francis' claim to the throne. But the marriage was not destined to last. At the age of twenty-five, Claude de France died, exhausted by her many pregnancies, for in only eight years of marriage, she had given birth to seven children. The house of Valois achieved the height of its fame under Francis I, and the châteaux of Blois and Chambord bear tangible testimony to this prosperous age. During his reign, the court shook off the vestiges of the Middle Ages. For example, women, who had previously lived on the margins of a purely male society, played a far greater role in the life of the court. Their status was enhanced to that of ladies, while that of the men was raised from courtier to knight. Under the influence of Francis I, in addition to the traditional sports of kings, especially hunting, the court also enjoyed sumptuous balls and all manner of cultural events. Increasing respect was accorded to the fine arts and science.

In order fully to appreciate the implications of the developments of the period, we must set them against the background of the dawn of the Renaissance and the political intrigues that were to trigger even further developments. The marriage between Louis I of Orléans and Valentina Visconti had already forged dynastic links between the house of Valois and Milan. When Francis I, great-grandson of their union, claimed parts of northern Italy as his inheritance, it soon led to conflict with the German Emperor, in whose opinion the north of Italy had belonged to

the Holy Roman Empire of the German Nation since the time of Charlemagne. The dispute was settled on the battlefield at Pavia in 1525. Francis I was defeated at the most catastrophic military engagement of the entire sixteenth century and was taken prisoner by Charles V. It required the intervention of his highly influential sister Margaret of Angoulême to secure his release from captivity in Madrid. The king was forced to pay the Habsburgs a heavy price for his freedom, surrendering Naples, Milan and Burgundy. Henceforward, the question of who controlled Burgundy was to become a central theme in European politics and a coveted legacy to be fought over by the Habsburgs and the Bourbons. Francis I waged two further wars against Charles V, in an attempt to realize his dream of a mighty European empire under the domination of France. Ultimately, though, none of his efforts were to succeed. Even his Habsburg adversary, despite his triumph over France, was obliged to accept the failure of his own power politics. What defined this period in history was the triumph of the notion of national statehood over that of world domination. Although Francis' Italian escapades brought him no political gain, the close encounter with Italy brought in its wake fruitful developments in the field of culture. This explains why Francis I has gone down in history rather as a builder of châteaux and patron of the arts, than as a great ruler. The king succeeded in attracting to the Loire some of the leading figures of the Italian Renaissance. They included Primaticcio, Benvenuto Cellini and, most importantly of all, Leonardo da Vinci, who spent his declining years happily at Amboise.

Splendour and terror – the two facets of the sixteenth century – reigned on the banks of the Loire under the successors of Francis I. In 1547 Henry II succeeded his father. He was already married to Catherine de Medici, a purely political marriage, as was standard practice in feudal times. In this case, however, the aim was not the usual territorial gain, but to swell the state coffers, which Francis I had drained regularly in order to finance his bold endeavours. In return, the match brought great prestige to the family of Florentine merchants. Henry II, however, cared little for the podgy Catherine. He lavished all his affection on the legendary Diane de Poitiers, with whom he had fallen in love at the age of nineteen, when Diane was in her mid-thirties. The hatred between the two rivals is as much part of the annals of the Loire as to power politics. As long as Henry stood between them, Catherine's hands were tied. She stood helplessly by as the king raised taxes – including a levy on every bell rung in the kingdom – in order to satisfy his mistress' extravagant needs with the proceeds (an episode on which Rabelais based some of his most caustic satire). But when Henry died after a tragic accident at the age of only forty-one – during a tournament the splinter of a lance penetrated his eye and quickly led to a fatal infection – Catherine was able to give free reign to the resentment she had suppressed for years. She confiscated her rival's beloved château at Chenonceaux and banished her behind the murky walls of the fortress at Chaumont.

Although during the decades between 1550 and 1590, Catherine de Medici's three sons followed one another as official ruler, it was she who pulled the political strings, becoming increasingly involved in the Wars of Religion. Leading the Catholic side were the dukes of Guise, a branch of the House of Lorraine, who made no secret of their aspirations to the crown. Among the Protestant Huguenots, the most prominent were Admiral Coligny, the Prince of Condé and Jeanne d'Albret, Queen of Navarre. Catherine's supposed hatred of the Protestants does not stand up to historical investigation. Initially, the queen clearly sought a

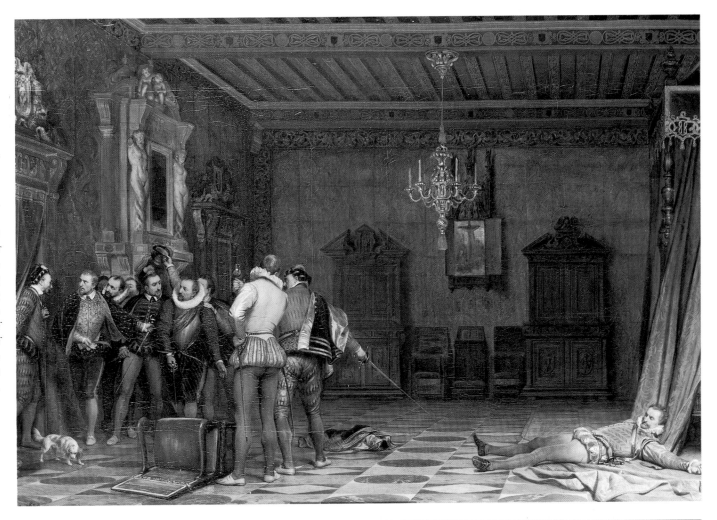

Top: The assassination of the Duke of Guise at the Château of Blois; painting by Paul Delaroche, 1834/35. Henry, Duke of Guise was murdered on the orders of King Henry III, because he had become too powerful.

Bottom: Another famous death scene: Leonardo da Vinci expires in the arms of Francis I in May 1519. The mortal remains of the great genius were laid to rest in the chapel of the Château of Amboise. Painting by Jean Auguste Dominique Ingres.

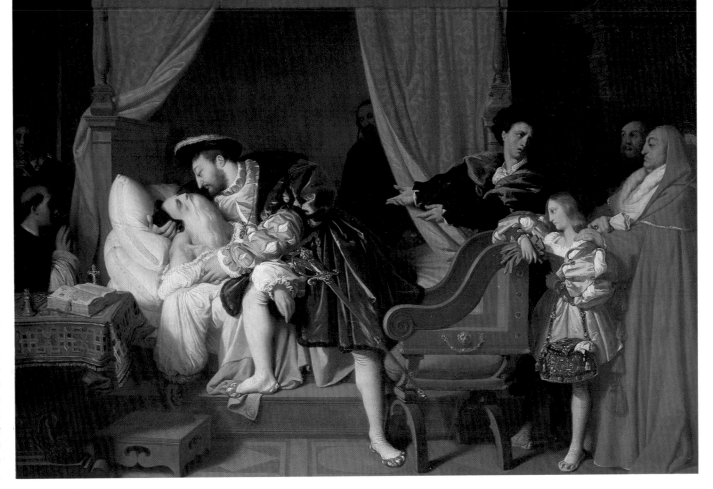

Overleaf: An uproarious ball at the Valois court. Festivities during the reign of the last of the Valois monarchs were riotous and almost unimaginably extravagant. Painting by an anonymous sixteenth-century French artist.

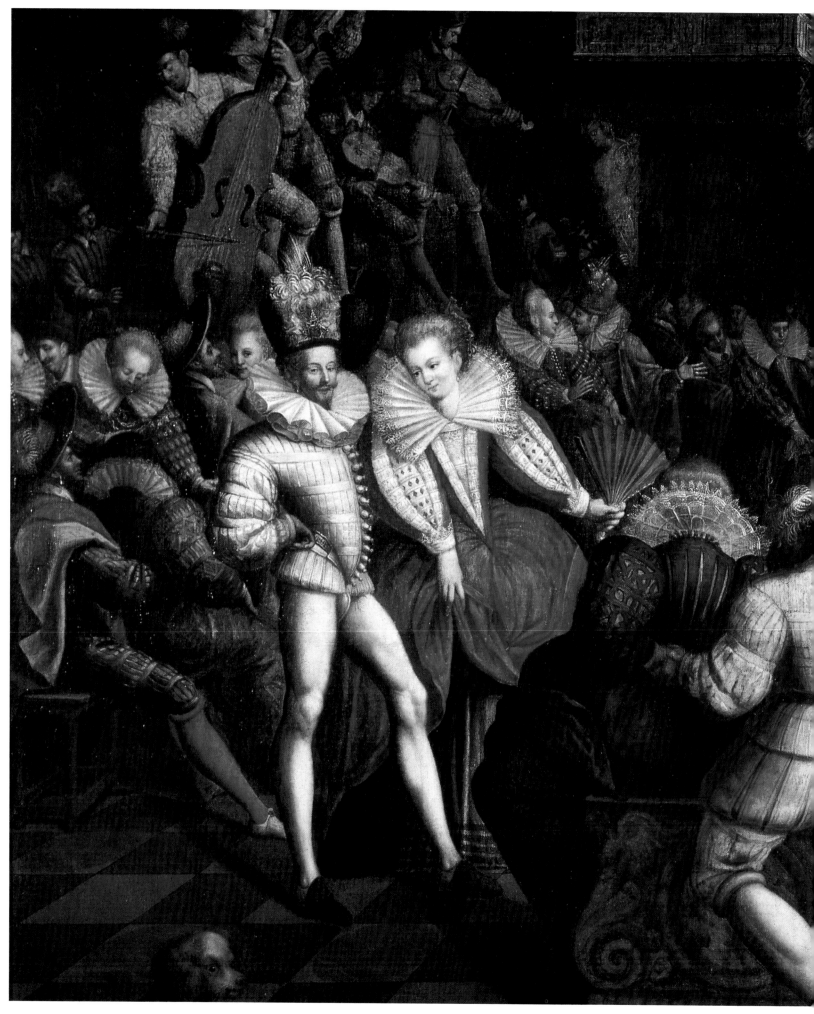

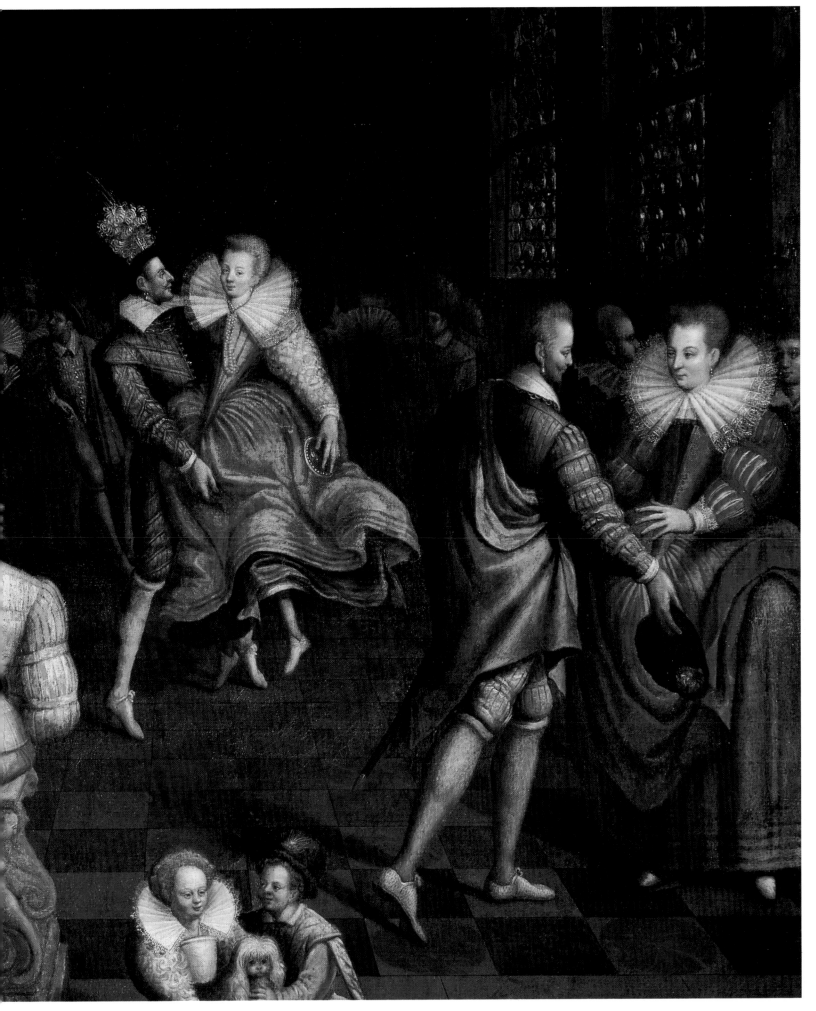

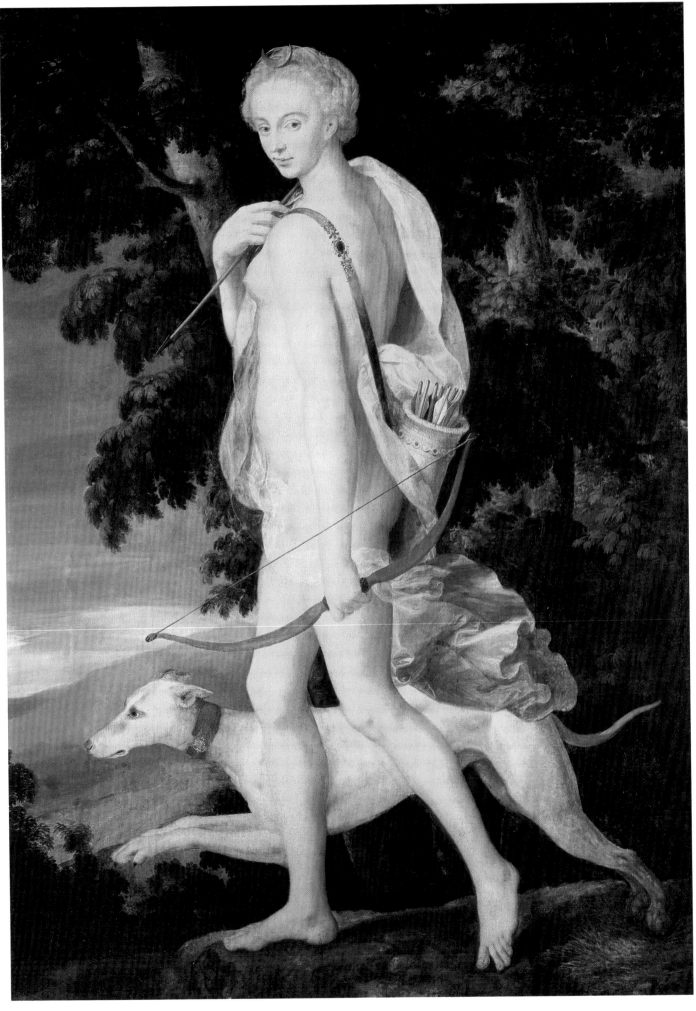

Diane de Poitiers was the mistress, first of Francis I and then of his son, Henry II. After his tragic death she was banished from the court. "Diana the Huntress", assumed to be a portrait of Diane de Poitiers. Painted in around 1550, it is attributed to Lucca Penni, who died in 1556.

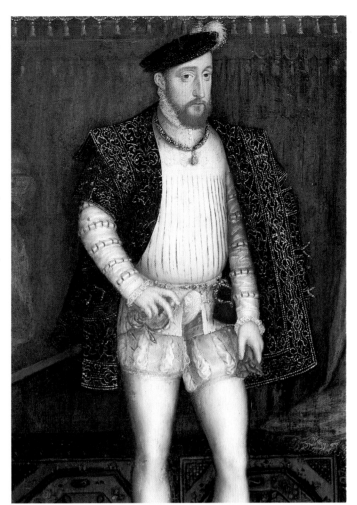

Left: Henry II
d'Albret, King of
Navarre, father of
Jeanne d'Albret and
grandfather of Henry
IV of France. Portrait
by François Clouet.

Right: Catherine de
Medici. Born in
Florence 1519, the
daughter of a wealthy
Tuscan family of
merchants, she
married Henry II in
1533. After his death,
she directed affairs of
state on behalf of her
three sons. She died at
Blois in 1589.

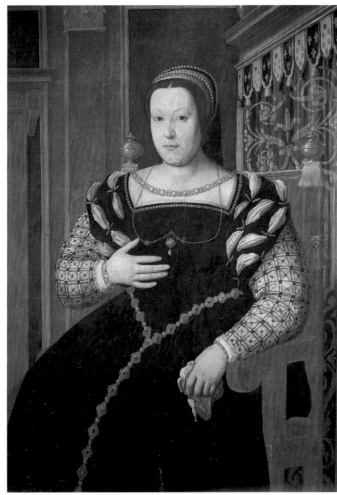

consensus, not least to guarantee the help of the Huguenots against the arrogant Guises. This did not mean, however, that she was not motivated by extreme self-interest.

It was Catherine's personal tragedy that, despite producing three sons, she was forced to witness the definitive decline of the Valois dynasty. Francis II died before he came of age after only one year of official rule. Charles IX remained on the throne for fourteen years, but, even so, was unable to escape from the overpowering shadow of his mother. It was during his reign that more than 15,000 Huguenots fell victim to the Saint Bartholomew's Eve Massacre, on 24 August 1572. History has laid the blame for this heinous deed at Catherine de Medici's door. Through skilful manoeuvring she had already secured the loyalty of Henry of Navarre, Jeanne d'Albret's son, by arranging his marriage to her daughter Margaret. Her youngest son, Henry III, was crowned King of Poland in 1573, but, following the death of Charles IX, he hurried back to the Loire to take over the vacant French throne. He immediately became a pawn in the game of the dukes of Guise, whose own designs on the throne were becoming increasingly apparent. In December 1588, as a last resort, Henry III ordered the murder of the Duke of Guise and his brother, the Cardinal of Lorraine, at Blois. Only a few days later also at Blois, at the beginning of January 1589, Catherine de Medici, the Queen Mother, died virtually unnoticed. The king now sought an alliance with Henry of Navarre.

After the spectacular assassination of the leaders of the Catholic League, he had to quell a civil uprising in Paris. Side by side with the young king of Navarre, his brother-in-law, Henry III rode to the unruly city, whose citizens were whole-heartedly opposed to the Valois. But even before reaching Paris, the king met his fate. Encamped at Saint-Cloud, he was stabbed by a fanatical Dominican monk.

The luckless monarch died in the arms of his brother-in-law, to whom he entrusted the succession.

Only a few years previously, when the house of Valois could look to three sons and heirs, no one would have expected Henry of Navarre to accede to the throne. But the murder of Henry III marked the end of the final chapter of the Valois dynasty. Under the Salic Law established in the feudal era, the way was clear for the Bourbons. Margaret of Angoulême, sister of Francis I, was the wife of the erstwhile King of Navarre. Their union produced Jeanne d'Albret, who in turn was married to the happy-go-lucky Antoine, Duke of Bourbon. They were the parents of Henry of Navarre who, in 1589, came to the French throne as Henry IV, the first of the Bourbon kings. The most important event of the reign of Henry IV, who was to go down in history as France's most popular king, was the issuing of the Edict of Nantes in 1598, allowing Protestants freedom of worship and so ending the Wars of Religion, an inglorious episode which had kept France on tenterhooks throughout the second half of the sixteenth century.

It was also under *bon Henri* that the curtain finally came down on the Loire Valley. For the Bourbons, who hailed from the Pyrenees, there was no sensible reason to maintain the Loire châteaux, particularly as they held such grim associations. They were drawn towards Paris. It was only at the beginning of the seventeenth century that the city began to assert its right as the undisputed capital of France, a role that might have fallen to Blois, had the Valois dynasty survived.

The Loire provinces were soon to share the fate of all provincial France. As government became more and more centralized under the successors of Henry IV, the provinces were condemned to insignificance. As a result of these developments, by the nineteenth century the regions of the Loire Valley were plunged into dire poverty. Many factories closed in Orléans, Tours and Angers. Nevertheless, the Loire Valley continued to be the setting for decisions affecting the fate of the nation. When, in 1793, there was a counter-revolutionary uprising in the Vendée, the decisive battles between Republicans and Royalists were fought in Anjou. Only the defeat of the Vendéans assured the continued existence of the new Republic. In both the First and Second World Wars the Loire Valley was the line along which the Allies advanced into the French interior in order to liberate the country from the forces of occupation. If, in our times, the champions of a better environment were to achieve victory over profit-obsessed technocrats, then once again it would fall to the Loire Valley to write a new chapter in the history of France.

A BRIEF HISTORY OF CHÂTEAU ARCHITECTURE

In the early Middle Ages, important innovations in both religious and secular architecture emerged from Normandy. Once the Normans settled permanently in western France at the beginning of the tenth century, they soon recognized the technical advantages of the Mediterranean and Latin practice of building in stone over their own traditional use of wood. Stone meant stability and durability. While sticking to the same basic design, they replaced wood with stone as a sturdier building material.

This period also saw the birth of a feature of feudal architecture that was soon to spread to every province of France during the Middle Ages. This was the donjon, or keep. This was a block-like closed tower, usually on a rectangular base. From the outside, the donjon gave few clues as to its structure, so that the number of storeys could only be deduced by the number of long, narrow lancet windows arranged

Continued on page 49

Although rebuilt during the Renaissance, the Château of Sully-sur-Loire still looks like a typical medieval fortress – an impression enhanced by its position surrounded by water. Beneath the great, steeply, sloping roof is a highly sophisticated roof truss made from chestnut wood in 1363, regarded as the finest example of medieval French timberwork.

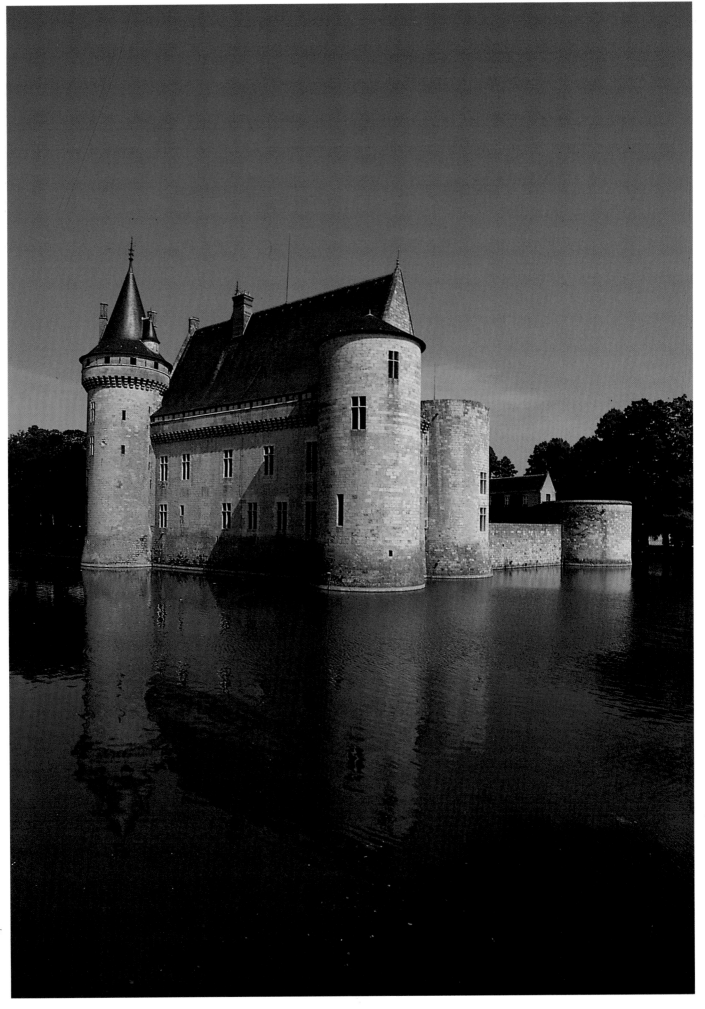

Overleaf: View from Sainte-Croix Cathedral over Orléans and Rue Jeanne d'Arc, constructed in 1840. The street, built to commemorate the liberation of France by the Maid of Orléans during the Hundred Years War, has become the city's main thoroughfare.

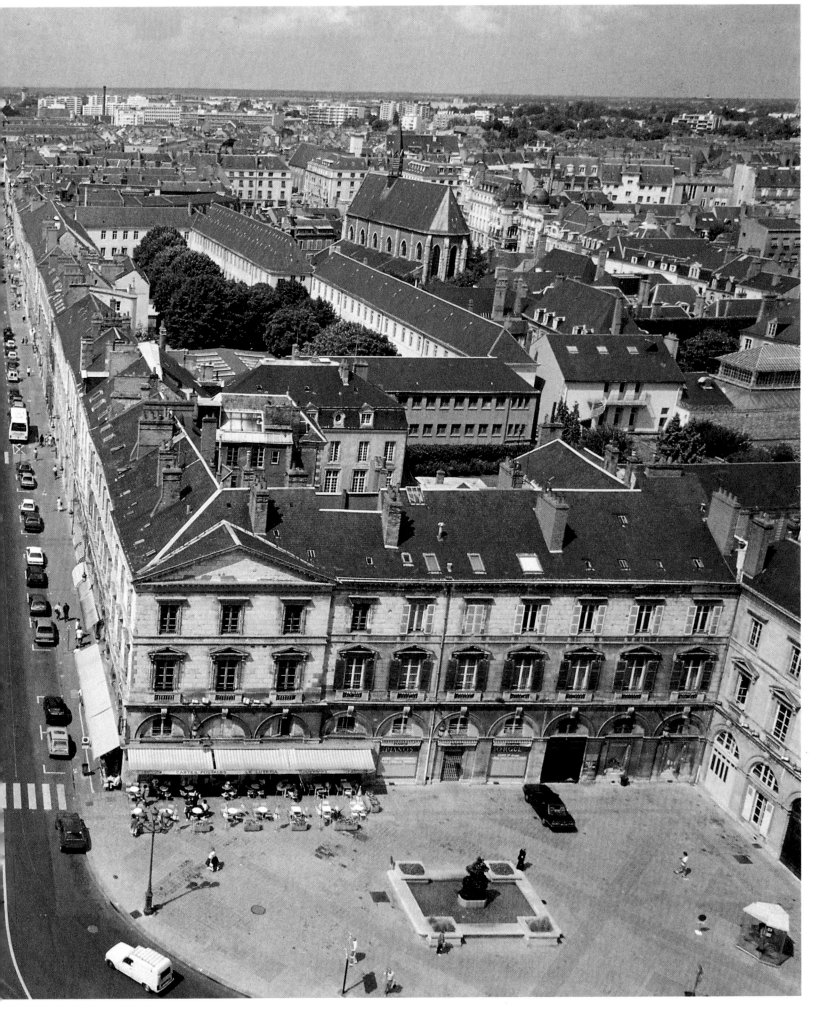

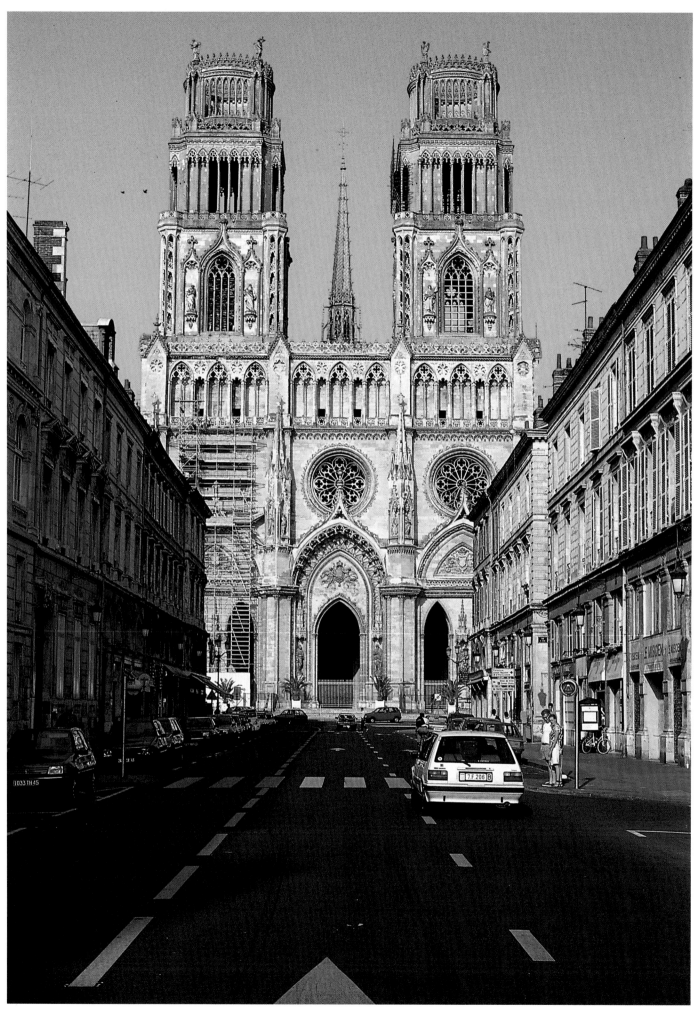

The western façade of Sainte-Croix Cathedral in Orléans was only built between 1767 and 1829. The building's status as a national monument is emphasized by the fidelity of the later façade to the Gothic style.

The Place du Martroi in Orléans was severely damaged during the Second World War. The buildings surrounding the equestrian statue of Saint Joan have been restored to create architectural unity.

Peace reigns in the early morning streets of Orléans.

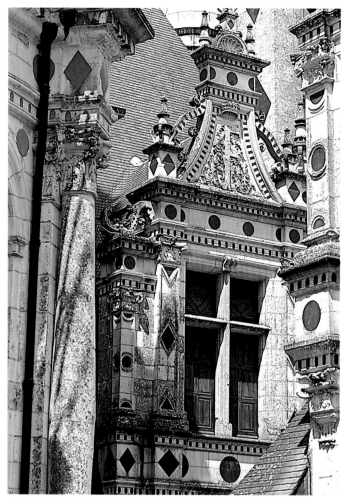

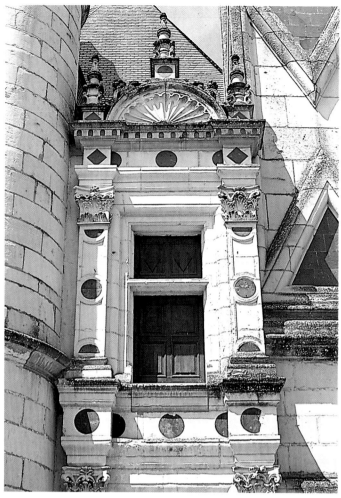

Oriel windows and lavish window frames are among the decorative additions to Chambord's roof. The royal emblem, the letter F (for Francis I) and the regal crown – seen here above the window in the picture on the left, is found in a variety of sizes all over the château.

View southwards from one of the balconies at Chambord. An incomplete square of buildings encircles the donjon, *or keep.*

Chambord's great park, covering an area of nearly 6,000 hectares, was for centuries the hunting ground of the French kings. The awe-inspiring complex of buildings was built in the first half of the sixteenth century to symbolize absolute monarchy.

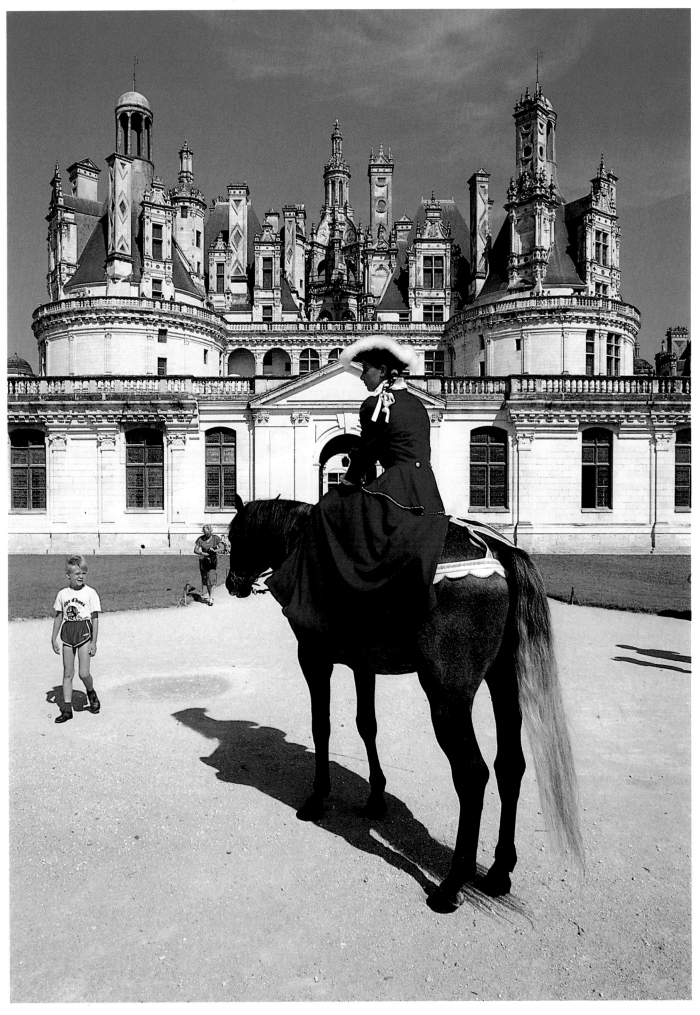

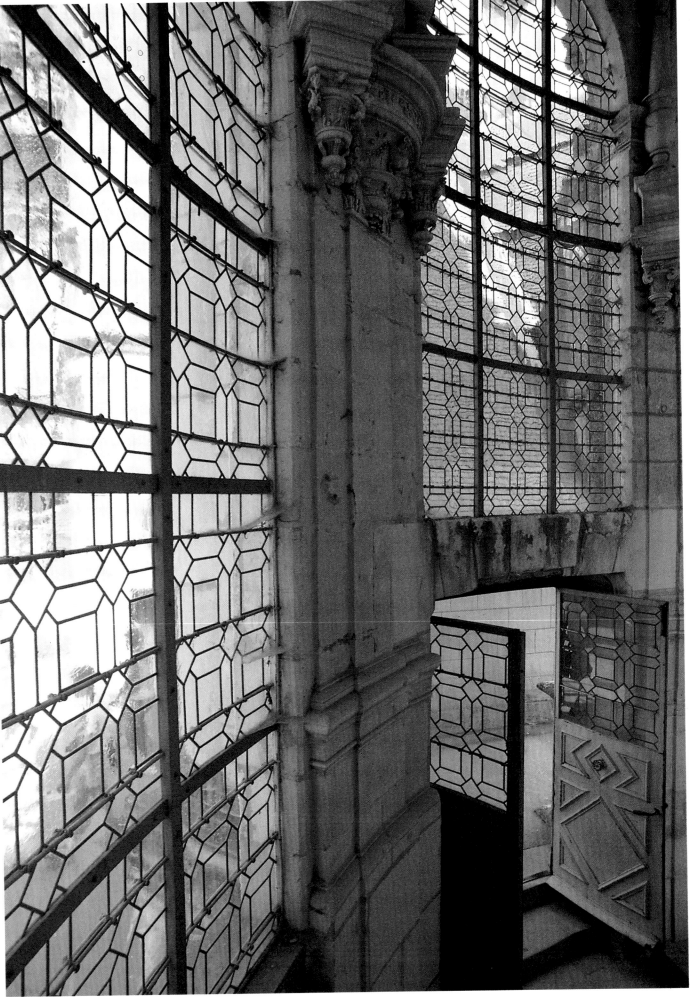

The staircase leading to the observation terrace in the centre of the Château of Chambord is delicately ornamented and full of natural light. There is no apparent separation between the interior and the world outside.

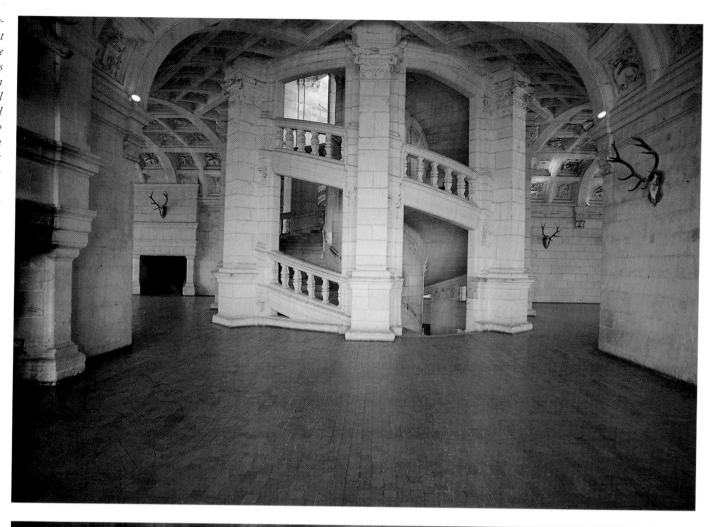

The core of the three-storey donjon at Chambord, and hence the château's centrepiece, is an intertwining spiral staircase, so designed that anyone going up never meets anyone coming down. It is said to have been designed by Leonardo da Vinci, who spent his final years at Amboise.

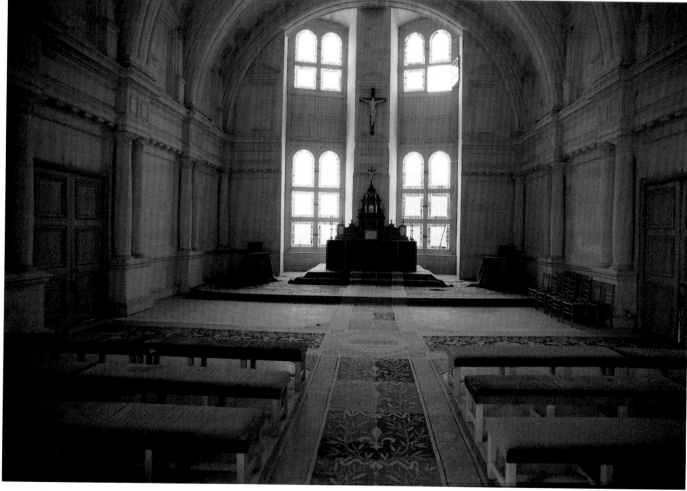

The chapel in Chambord's north-west tower only took on its present appearance during the reign of Louis XV. The château was plundered during the Revolution and the austere furnishings date from more recent times.

Overleaf: Chambord was conceived as a reflection of the ideals of kingship. The château's 440 rooms form a never-ending labyrinth. The building is crowned by more than 1,000 turrets, chimneys and oriels.

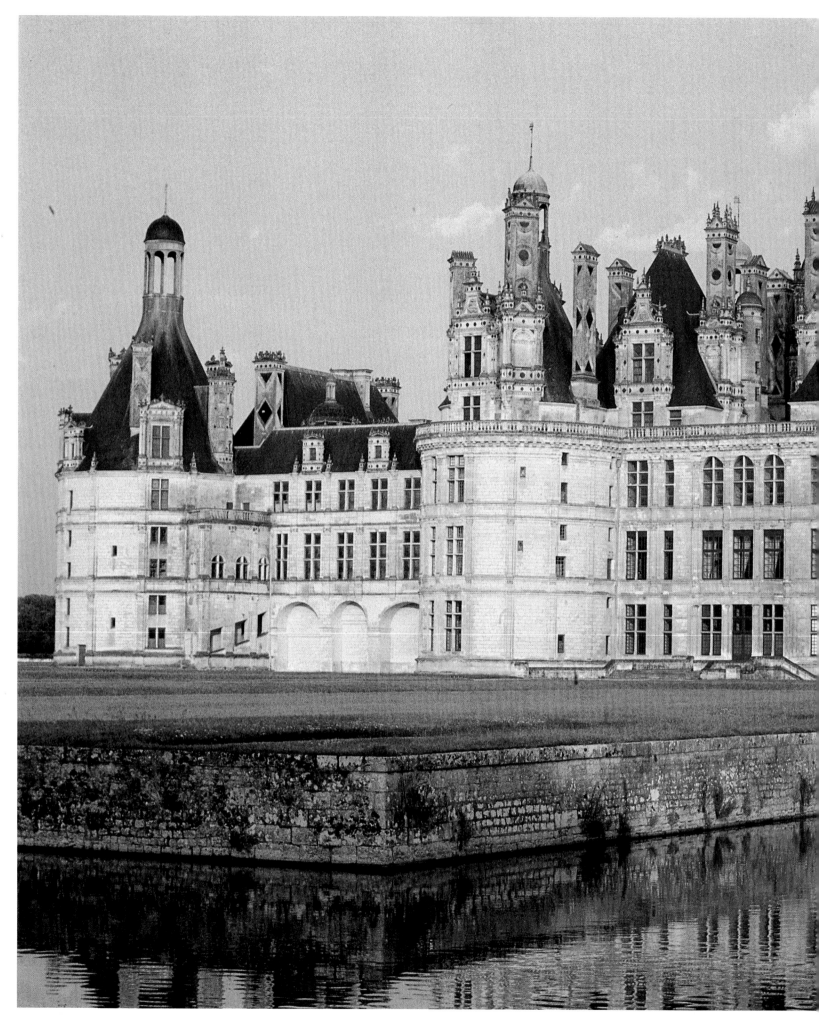

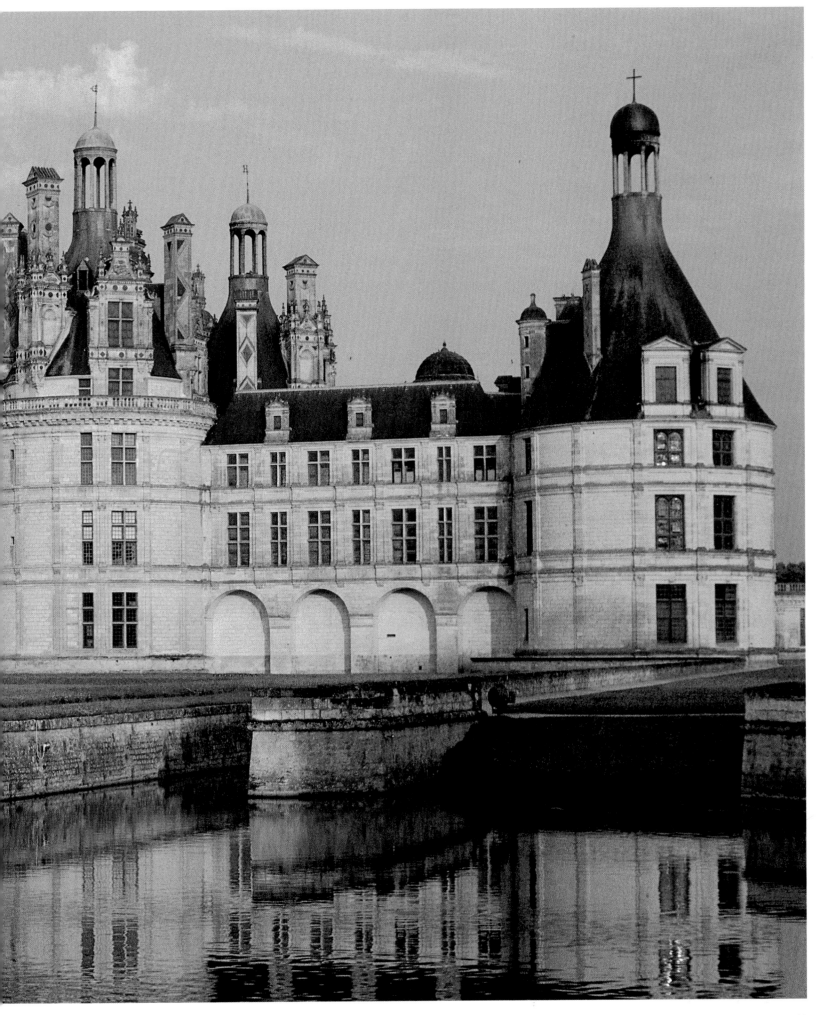

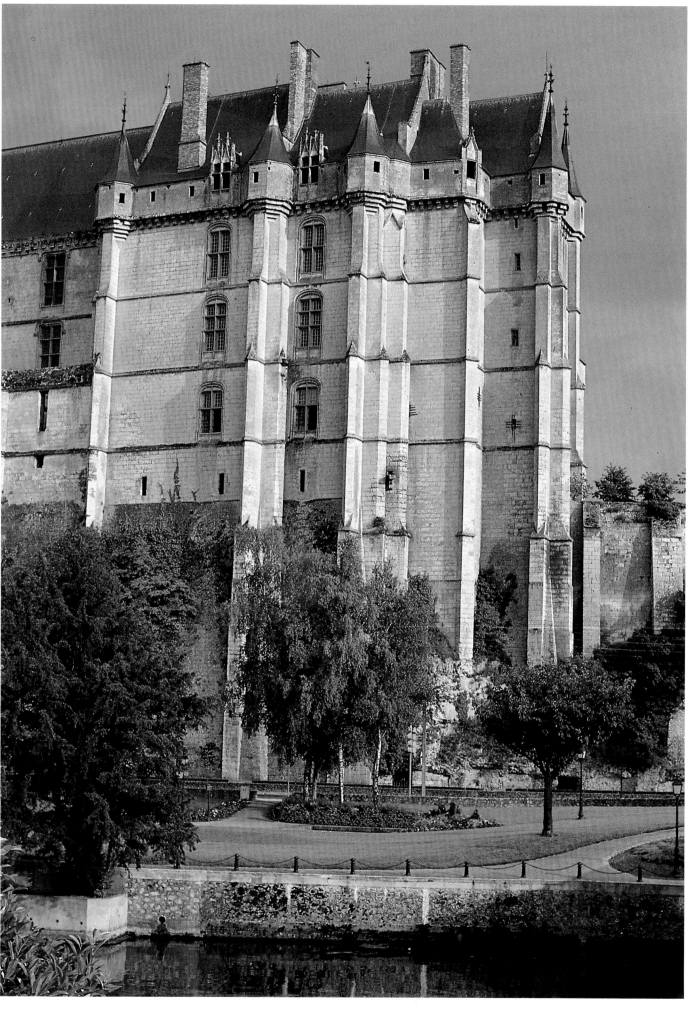

Châteaudun stands on the Loir, a tributary of the Sarthe. From outside, the building looks like a medieval fortress, while the interior dates from the Renaissance.

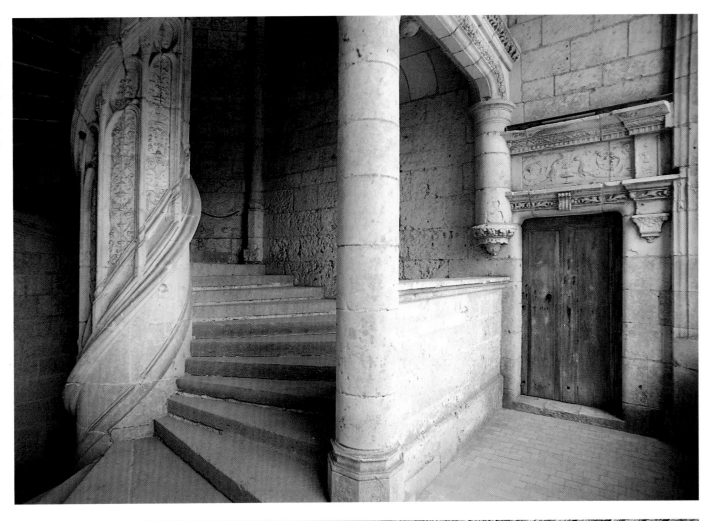

Châteaudun. The staircase of the so-called Longueville Wing is decorated in the Renaissance style. Similar ornamentation can be seen on the wing's external walls and in the inner courtyard.

Châteaudun's round keep (on the right of the photograph) is one of the first donjons of its kind and is one of the best-preserved twelfth-century examples. Lying in its shadow is the late Gothic chapel with its opulent interior.

Overleaf: The rooms of Cheverny, which are still in use, are characterized by the family colours of the former lords of the château: blue, gold and red. The present owner is the Marquis de Vibraye.

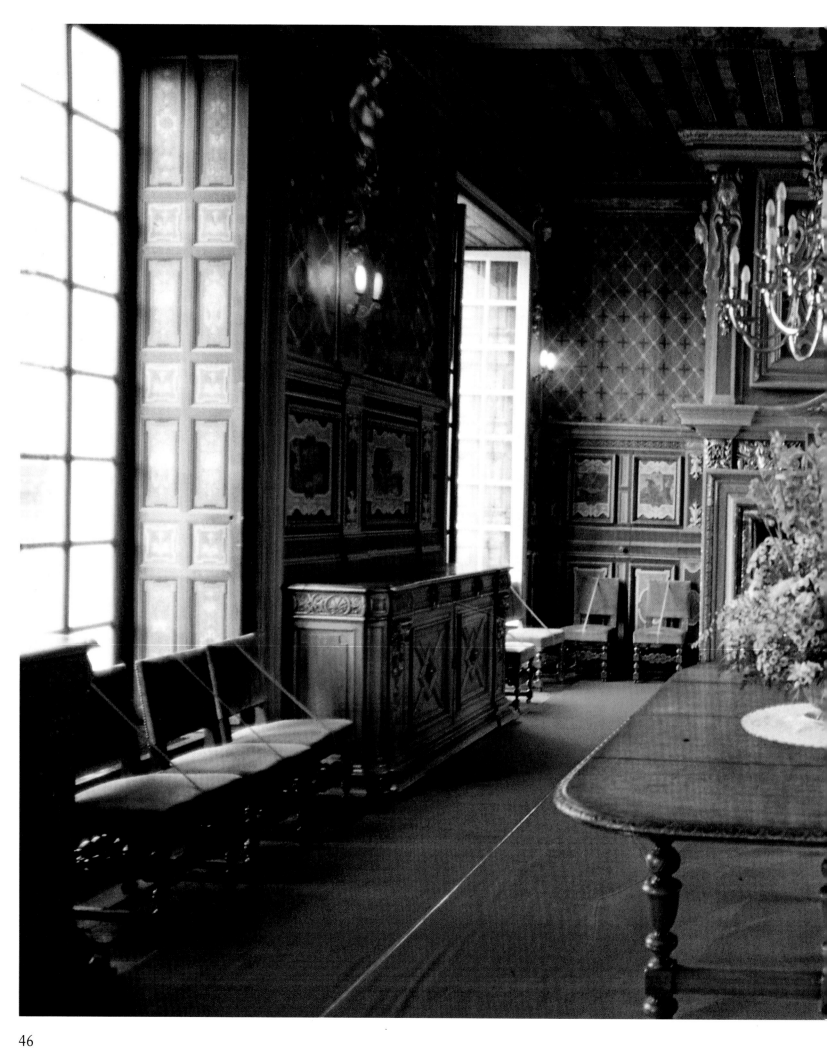

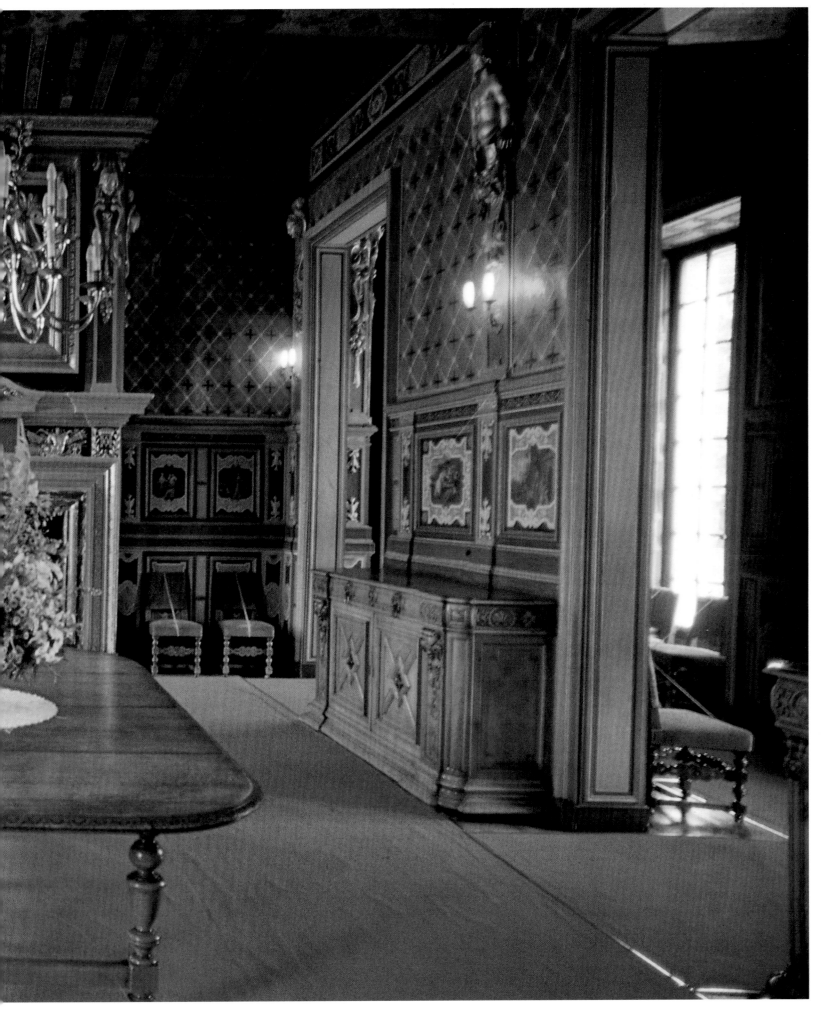

The Château of Cheverny is a splendid illustration of how secular buildings of the Baroque era were designed to provide a prestigious architectural setting for everyday activities. The main façade is clearly divided into five sections, while the extremely narrow side view reveals that the building is only as deep as a single room.

one above the other. The floors, of which there were normally three, occasionally four, were linked by wooden ladders. The reason for this was not a lack of knowledge of staircase construction techniques, but because of the way in which early medieval society thought about security. If an enemy managed to penetrate such a tower, its defenders would, as a last resort, be able to retreat to the upper levels. So the donjon, both inside and out, was designed purely as a means of defence. This was a necessity at a time when wars were not waged against an enemy in a far-off land. Local feuds were common and armed skirmishes with belligerent neighbours took place outside the front door.

Life in the donjons was extremely spartan. The uninhabited basement was used to store tools, weapons and provisions, and to provide a home for domestic animals. The main living accommodation was on the first floor. Here the household cooked, ate and slept. The women's apartments were usually on the top floor, so that the paternal head of the family could safeguard their chastity. Once the ladder had been removed, unauthorized contact was impossible.

Furnishings were unpretentious. The floor was covered with straw. Tables, beds and chests were made of roughly cut wood. The limited heating arrangements also meant that the residents of the donjon suffered real hardship. The visit of a minstrel, storyteller or even a troupe of strolling players must have been a very welcome diversion. Against such a melancholy background, we can perhaps understand why the knights of the early Middle Ages spent so much time fighting.

The oldest surviving donjons date from the end of the tenth century. The one at Langeais (now integrated into the château complex) was built around 990. During the eleventh century, the building of defences was taken a step further. Since the local population was in the habit of taking refuge close to the keep, extensive curtain walls were built around it, creating *cités*, or citadels, such as those preserved at Chinon, Angers and Loches. Later, as châteaux were enlarged, in many cases the donjon was integrated into the rest of the complex, which is why it is not always easy to determine their architectural structure. Only a very small number, including Beaugency, Loches and Montrichard, remain unaltered.

The twelfth century brought considerable advances in fortress construction, a development prompted by the Crusades and the consequent encounters with other cultures. The most dramatic architectural change was the introduction, in about 1200, of much larger fortresses. These no longer consisted only of the keep, which now became the focal point of a substantial complex. Another important innovation of the period was the round tower. While rectangular walls had been an easy target for projectiles, the circular structure reduced the strike power of enemy catapults. At the same time, battlemented parapets and machicolations provided effective protection from an attacker. For even greater security, many fortresses were now surrounded by a moat. The châteaux of Le Plessis-Bourré, Fougères-sur-Bièvre, Sully-sur-Loire and Chaumont, are outstanding examples of state-of-the-art bastions of the high Middle Ages.

A new spirit also penetrated to the inside of the fortress. In the Orient the knights had seen a refined style of interior design, which they promptly began to emulate. Apart from changing the arrangement of the furniture, the most important new acquisitions were carpets and tapestries. Woven fabrics were now used to cover the chilly stone floors and hung on the often cold, damp walls, to retain more heat and create a more homely atmosphere. Likewise, the martial exterior of the fortress gradually evolved to create a more benevolent impression. In the late Middle Ages

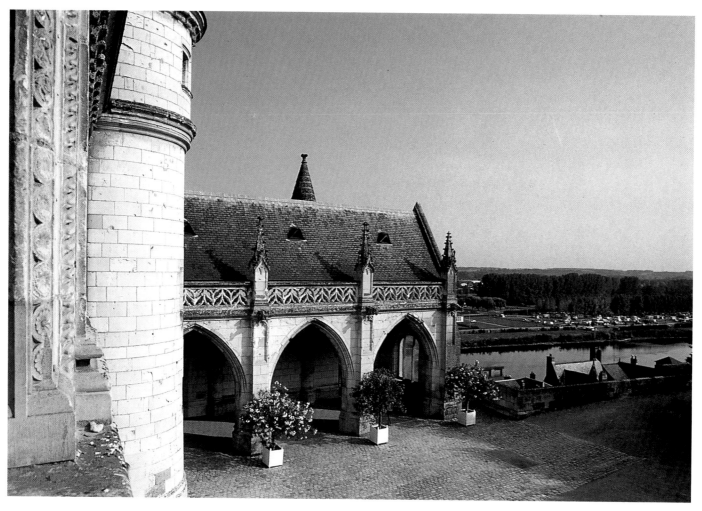

ornamental towers, turrets and oriels began to appear on fortresses. Ussé and Saumur are particularly fine examples of this period.

The end of the Hundred Years War heralded a whole new era. Local skirmishes between rival overlords became a thing of the past, and even the threat from foreign enemies had diminished. Now, the issue of defence, which had dictated the appearance of every fortress, was no longer of any real importance; so began a new stage of development which, before the fifteenth century was out, would transform fortresses into châteaux. This process coincided with the burgeoning of the Italian Renaissance, from which France, and especially the architecture of the Loire Valley, took its inspiration. The military exploits in Italy of Francis I and his predecessors, Charles VIII and Louis XII, created little political capital for the French monarchy. On the other hand, from a cultural standpoint the encounter with the Italians and their art was a turning point. Examples of early Renaissance influence are the Louis XII extensions at Blois, Amboise and the inner courtyard at Chaumont. The previously large number of individual buildings now gave way to a clear-cut order. At the same time, however, the legacy of the late Gothic can be seen in the ornate balustrades, the decorative window surrounds and the sharp pinnacles above the gables, windows and towers. Overall, buildings dating from between 1490 and 1510 are somewhat austere, not least because of their uncomplicated structure.

During the thirty-year reign of Francis I, the Renaissance came into full flower. Early Renaissance buildings were designed by French artists, but Francis summoned a host of Italian architects to his court. Their creations on French soil combined with the traditional French vision to produce a unique architectural language. The Francis I Wing at Blois and the Château of Chambord are the most striking examples of this blend of styles. Now the classical architectural elements – ledges,

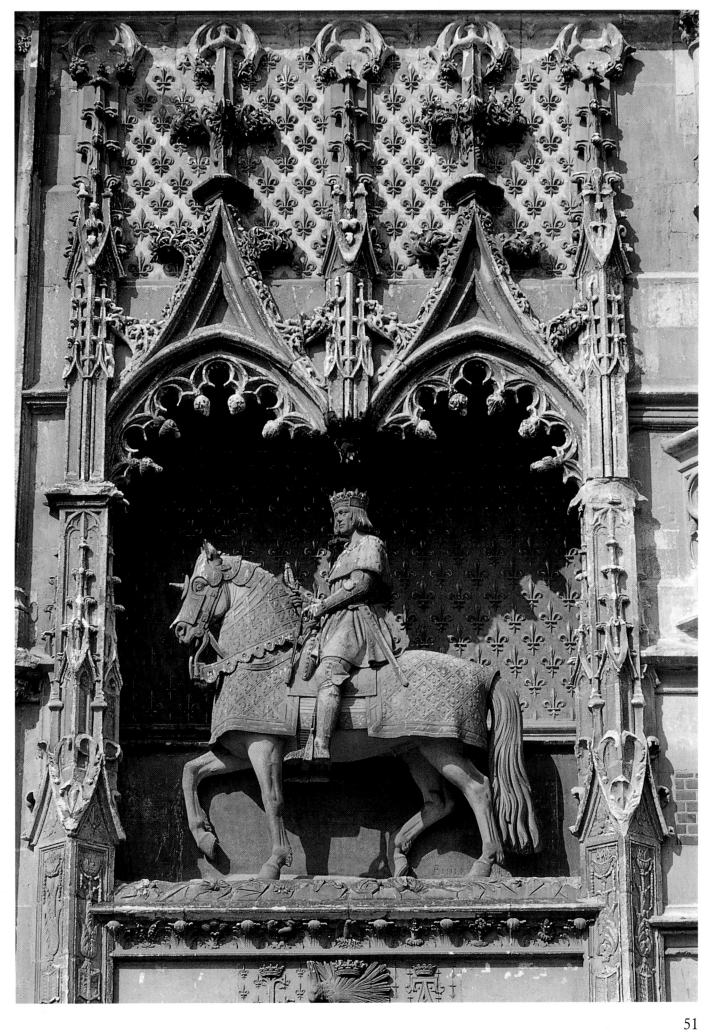

pillars and pilasters – were integrated into the structure of the buildings so that, despite their huge dimensions, they were quite home-like. There was also a continuing and increasing tendency towards the extravagant use of ornamentation. The roof of Chambord resembles a forest of stone, with its hundreds of pinnacles, turrets, lanterns and chimneys. Other aspects of Chambord make it clear that château architecture belongs to an established tradition. The early medieval principle that the keep should be the centrepiece of the entire complex remained, albeit with variations. The Renaissance châteaux are the result of a fusion of design innovations adopted from Italy and the Loire Valley's own, deep-rooted tradition.

As well as the mighty constructions commissioned by the sovereign, the purpose of which was to glorify the monarchy, many small châteaux were built during the reign of Francis I for senior court officials. Most of these were commissioned by the men who dictated financial policy. Chenonceaux (the older part) and the enchanting Azay-le-Rideau are prime examples, both of which demonstrate how, in the sixteenth century, the water which had surrounded medieval bastions as a means of defence came to be exploited to aesthetic advantage. Reflected in the moat, the exquisite architecture looked even more stunning.

The turmoil of the Wars of Religion and the slow decline of the last Valois rulers meant that very little building went on in the middle of the sixteenth century. Chenonceaux, completed at this time, forms a bridge between the two banks of the River Cher, an obvious allusion to Venetian architecture. France's most brilliant examples of late Renaissance architecture are not in the Loire Valley, but, reflecting the changing political situation, in Paris and the Ile de France. The most important among them are the Louvre, Anet and Fontainebleau.

But even after the French monarchs turned their backs on the Loire, some outstanding buildings were still erected there and the Loire Valley boasts a number of fine châteaux dating from the seventeenth and eighteenth centuries. While in the late fifteenth and early sixteenth centuries, the French, in their thirst for new ideas, had drawn inspiration from Italy, they were rather less enthusiastic about seventeenth-century Italian Baroque.

Nevertheless, they still liked to create a show. Luxurious interiors became ever more artistic and refined, but the flamboyant emotionality of Roman Baroque was alien to the French. Built on more classical lines, the Gaston d'Orléans wing at Blois or the charming Château of Cheverny are much closer to the Renaissance than to the colossal contemporary style of Italy. Thus, the expression *style classique* is often applied to seventeenth-century architecture. The central projection (the part protruding in front of the main building), as seen in the Gaston d'Orléans wing at Blois and at Cheverny, seems to hark back to the donjons of the early Middle Ages. The principle of subordinating lateral wings to a dominant main section is not only a concrete symbol of the self-confidence of the hierarchical feudal society, it also identifies the fortresses and châteaux along the Loire and its tributaries as members of one big family.

RELIGIOUS ART

For many who travel to the Loire, there is no doubt that their main purpose is to visit the châteaux. Although it is very important to consider these in the context of the entire history of art, we should also take a closer look at the religious art of the Loire Valley and the artistic abundance of the region in all its variety. As we survey the array of châteaux and churches, of secular and religious architecture, it becomes clear that the Loire Valley is home to some of the finest art in Europe.

The Château of Chaumont. Two famous Frenchwomen spent some time within its walls: Diane de Poitiers, mistress of Henry II was forced by Catherine de Medici to exchange Chenonceaux, her favourite residence, for Chaumont. The château also provided a refuge for Madame de Staël when Napoleon banished her from Paris in 1810. Hand-painted lithograph by Laurent Deroy (1797-1886) from 1860.

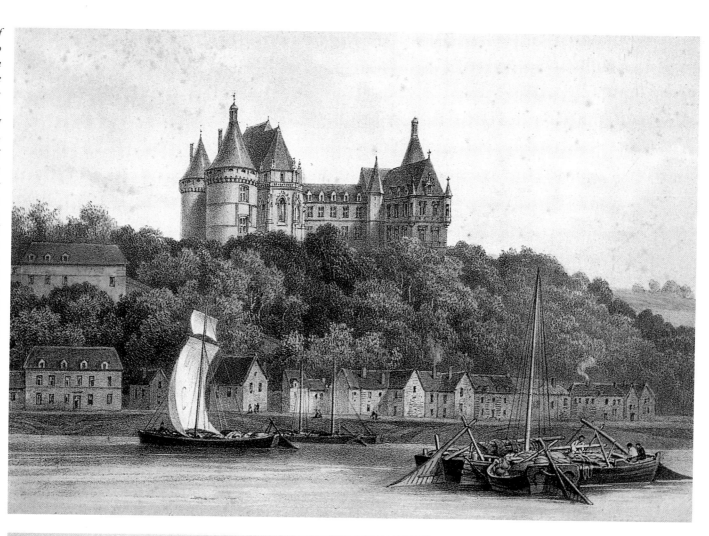

This view of the Château of Chambord clearly shows the structure of the monumental building complex. In the distance is the River Cosson. Francis I, who commissioned the construction, ordered the river's course to be diverted so that it could be seen from the château. Hand-painted lithograph by Laurent Deroy from 1860.

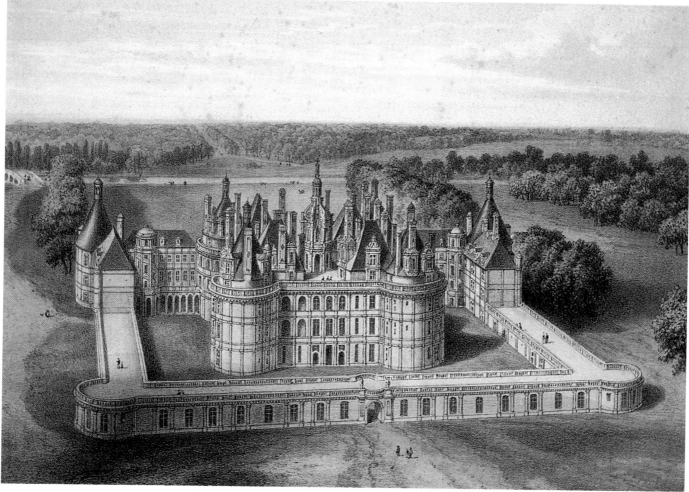

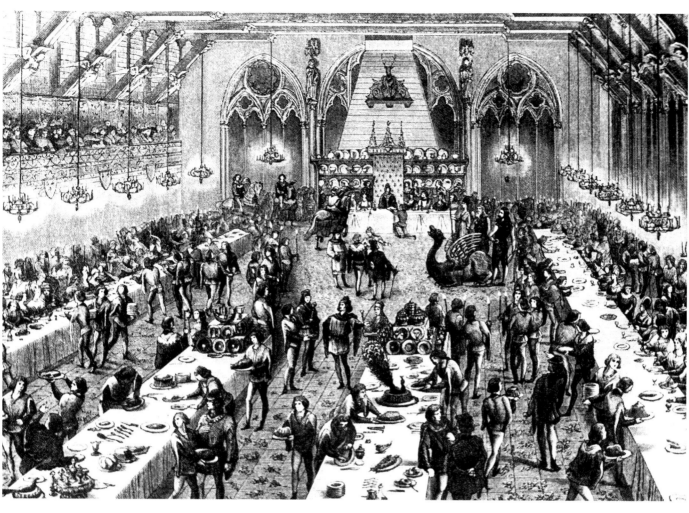

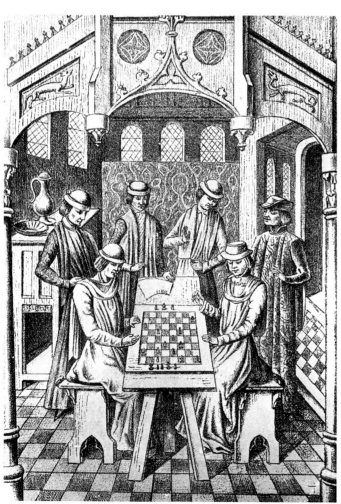

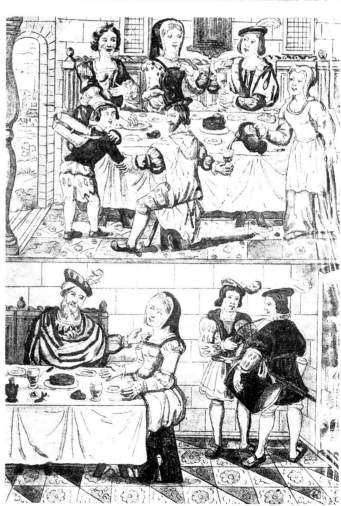

Left page:
Top: Representation of a royal feast in the fourteenth century.

Bottom left: A game of chess during the reign of Louis XI. Fifteenth-century miniature. Chess was brought to the Christian west in around 1050 by the Moors in Spain.

Bottom right: Members of the nobility enjoying the pleasures of the table. Sixteenth-century illustration.

Right page:
Top left: Philip IV, the Fair (1268-1314), receives Guy de Dampierre. Fifteenth-century miniature.

Top right: Departure of the hunt. Fifteenth-century illustration.

Centre: Hunting was for centuries the favourite sport of kings. In the centre of the picture, on horseback, Louis XIII as a child. Contemporary engraving.

Bottom left: Scene at court in the days of Catherine de Medici. Engraving from a painting by Bernard Amsterod.

Bottom right: Contemporary representation of Henry II with his mistress, the legendary Diane de Poitiers.

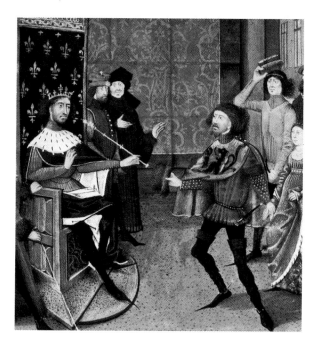

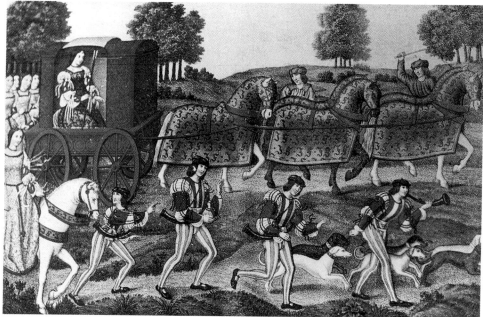

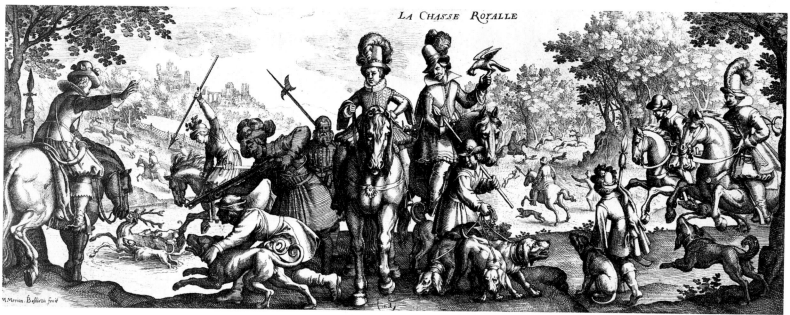

La Chasse Royalle

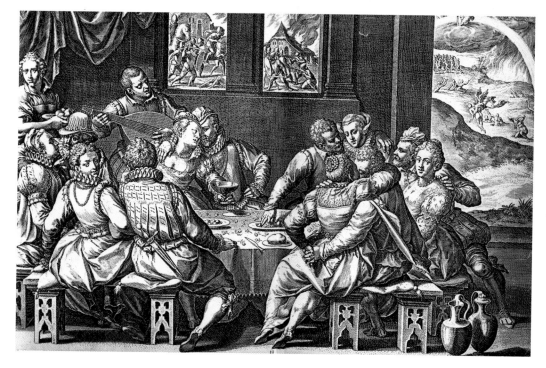

Even in the days of Charlemagne, the region's monastic schools had become bastions of culture. The ninth-century church at Germigny-des-Prés, one of the most ancient places of worship in France, bears eloquent testimony to the excellence of Carolingian art. The surviving parts of the building, whose original floor plan was in the shape of a Greek cross, contains some fine mosaics. Another architectural example of the Carolingian era is in the extreme west, at Saint-Généroux, almost on the border with Poitou.

The real heyday of the Middle Ages was the period when Romanesque art flourished. In the twelfth century, the king was still considered *primus inter pares* (first among equals); powerful territorial rulers, like the Dukes of Burgundy, Normandy or Aquitaine, were in practice regarded as his peers. In this atmosphere of political harmony, every province had its own particular character. All the larger provinces had their own schools of architecture and developed individual preferences in matters of decoration, painting and construction. However, these distinctive local styles were by no means rigid, but were completely inter-changeable.

This exchange of ideas brought about the development of the High Romanesque style, in which the Loire basin was to play a quite special role. As pointed out in earlier chapters, the Loire exerts a unifying rather than a divisive influence. In the twelfth century, the Loire was like a funnel through which many different trends were filtered. Fundamentally, when we talk about the evolution of Romanesque architecture, we can say that in France's northern provinces ecclesiastical buildings predominated in the basilican form. These were three-naved churches, whose central nave was higher than the aisles. In the south, meanwhile, hall churches were more prevalent. Here, whether the halls had one or several naves, the nave and aisles were the same height.

The two architectural styles meet in the Loire Valley. Fontevraud Abbey is the most northerly example of the domed churches typical of south-western France. By contrast, Saint-Benoît-sur-Loire, the region's second most important Romanesque church, is a classic basilica. Elsewhere in Poitou, there are hall churches such as Cunault. Occasionally, one comes across ecclesiastical buildings whose architects seem to have borrowed ideas from Burgundy, nearby Normandy or even distant Auvergne. It was this openness to ideas from all sides that for many years prevented the Loire Valley from developing a distinctive local style.

There are, nevertheless, two early historical monuments which proved to be highly influential. One is the west tower of the abbey of Saint-Benoît-sur-Loire. When he commissioned its construction in the first half of the eleventh century, the ambitious Abbot Gauzlin intended it to be 'an example to all Gaul', and his wish was, indeed, fulfilled. Imitations of Saint-Benoît's west tower can be seen as far away as the Auvergne and Limousin.

The other influential work was the choir of the tenth-century Saint Martin's Church in Tours, since destroyed. Built at around the same time as two similar churches in Burgundy (Saint-Philibert in Tournus), and Clermont-Ferrand Cathedral in the Auvergne, this was one of the first medieval French churches to have an ambulatory around the choir and radial chapels. It was to become a prototype for every High Romanesque pilgrimage church and would also have many imitators among Gothic architects.

In the mid-twelfth century, Anjou came to the fore. Amid the controversy surrounding the transition from Romanesque to early Gothic with its new technical and aesthetic accomplishments, Anjou made a quite unique contribution to the

56

Continued on page 65

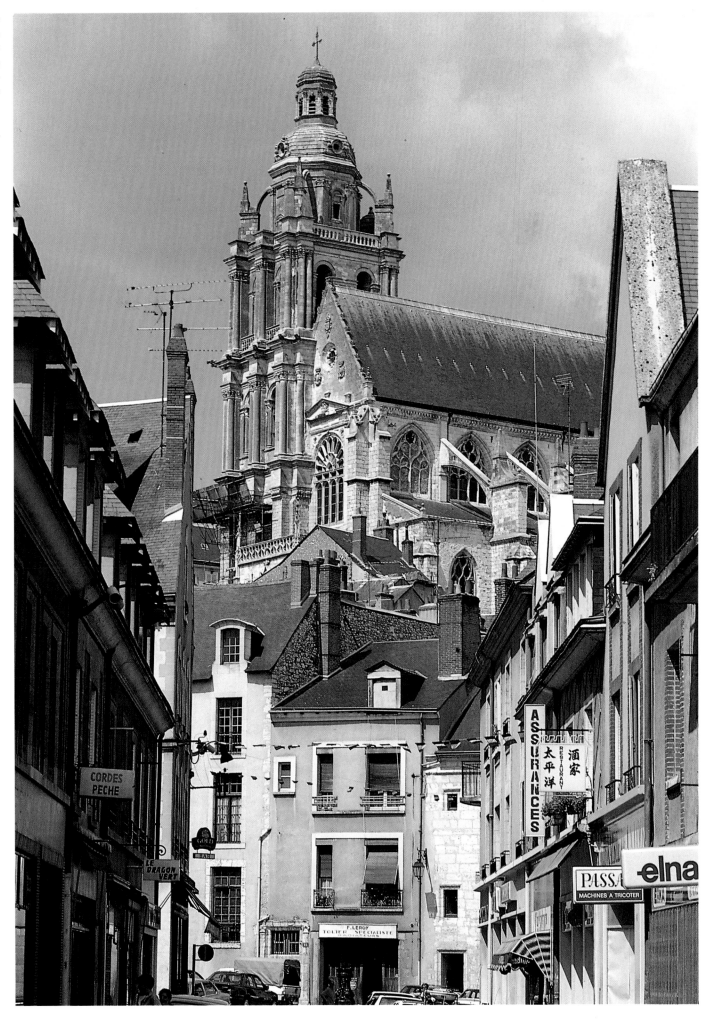

The tower of the Cathedral of Saint-Louis in Blois was destroyed by a hurricane and rebuilt in 1678. The old town consists of steep, winding alleyways, narrow streets and flights of steps.

Inside Blois: an urn decorated with a pattern of white acanthus on a blue background. The Mediterranean plant motif used in Antiquity was a popular form of decoration in Renaissance and Baroque art (left). The Calvinist Henry IV (1553-1610) led the Huguenots before succeeding to the French throne. After the Valois dynasty died out and the throne passed to the Bourbons, he converted to Catholicism in order to secure his sovereignty (right).

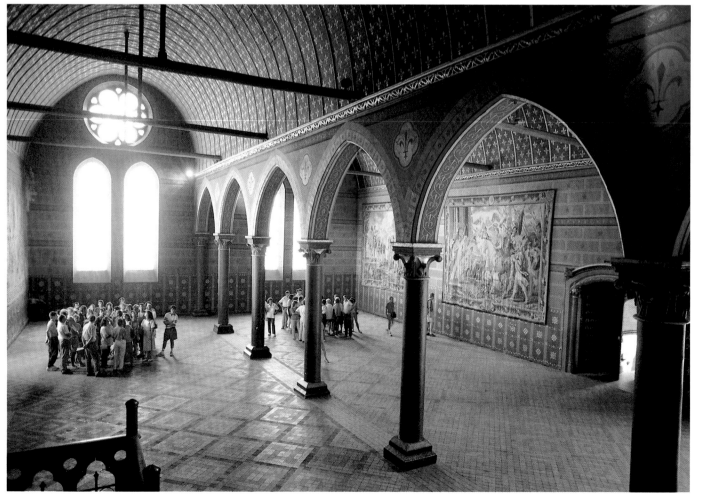

The late Gothic 'Salle des États' (Council Chamber of the Estates General) is the oldest part of the Château of Blois. The room dates back to the time before Blois belonged to the Valois monarchs.

An equestrian statue of Louis XII dominates the niche above the main door at Blois. It is a reminder that it was he who began the construction of the vast château complex. At night, the east wing looks particularly impressive by floodlight.

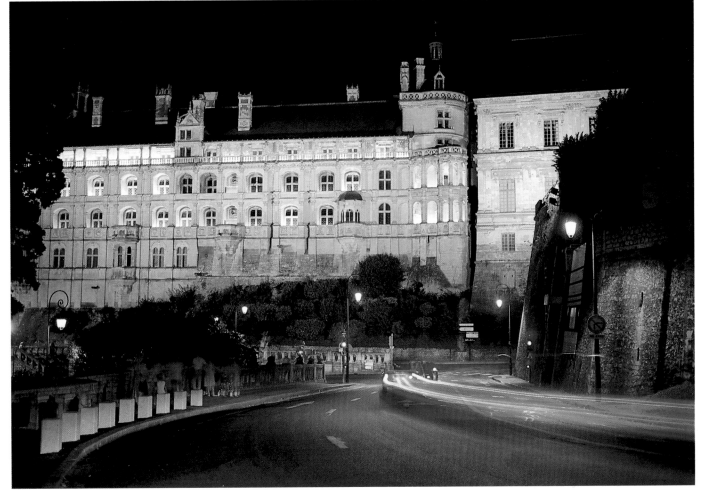

Equally awe-inspiring by day or by night, the north wing of the Château of Blois, commissioned by Francis I. Traditionalism and Italian Renaissance innovations combine to create a completely new architectural language.

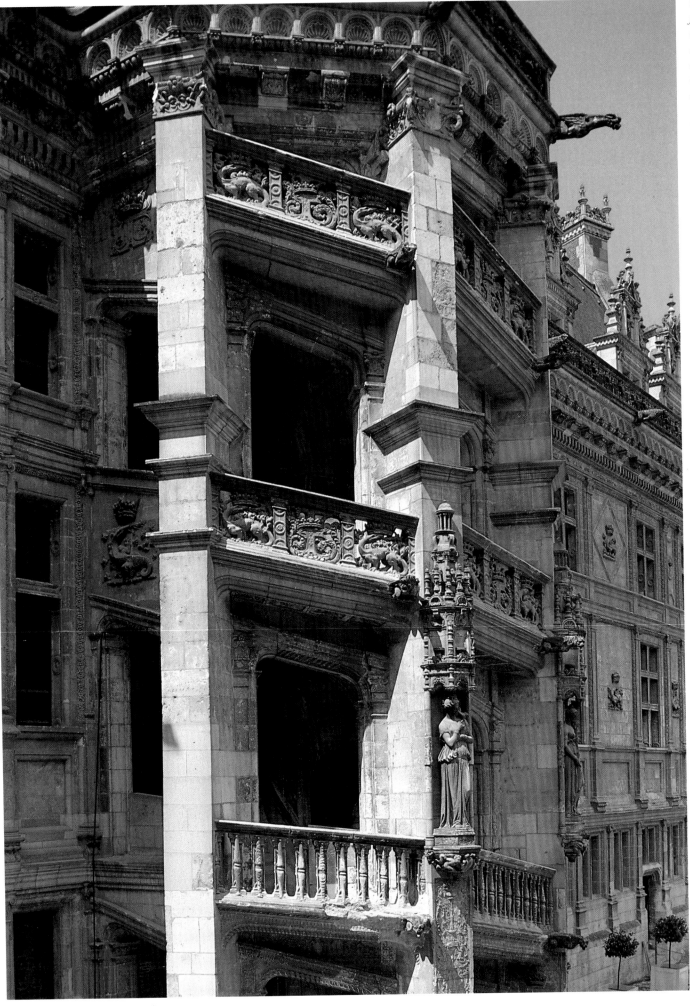

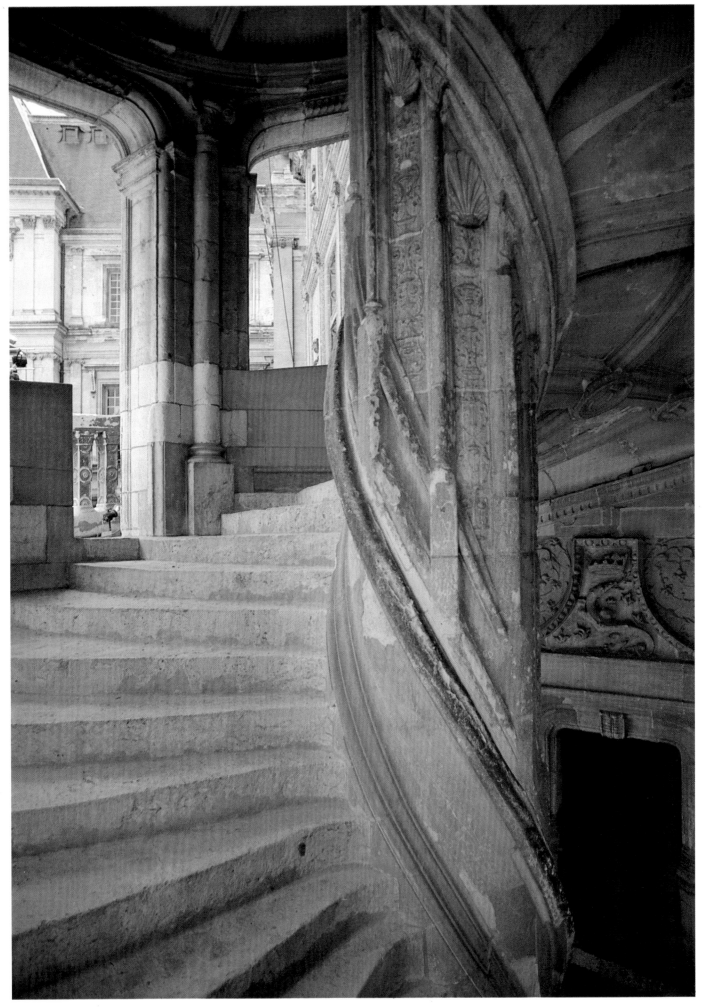

The salamander, symbol of immortality, adopted by Francis I as his heraldic beast, crops up everywhere on the staircase at Blois.

Left: Centuries-old cedars stand in the park at Chaumont. Among those who described this château's charming ambience in the early nineteenth century were August Wilhelm Schlegel, Benjamin Constant and Adelbert von Chamisso, all of whom were guests of Madame de Staël, who was banished there by Napoleon.

Right: A suit of armour recalls the days when Chaumont and other châteaux were the scene of local feuds and armed skirmishes.

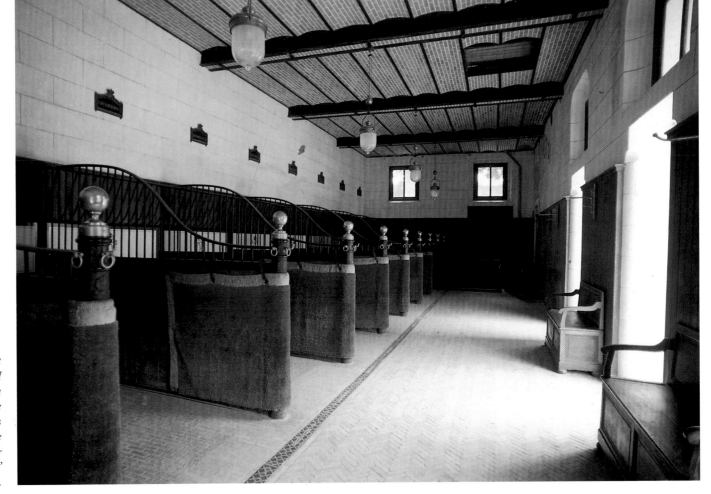

The opulent stables at Chaumont, supplied with electricity in 1906, show the exceptional efforts made to provide the best possible care for the château-owners' horses.

With a drawbridge, massive round towers with machicolations, and a narrow gateway into the courtyard, Chaumont, seen from the outside, has all the features of a knight's castle. The gateway is flanked, on the right, by the coat of arms of Charles II d'Amboise, supported by two 'savages', with the coat of arms of Cardinal Georges d'Amboise on the left. Both men oversaw the building of the fortress, completed around 1511.

architecture of the high Middle Ages. A whole series of related buildings came into being, so that it became possible to speak of a 'school' of architecture. This involved an amalgamation of the Romanesque domed architectural style of Aquitaine with the principle of the Gothic system of rib vaulting. The new ecclesiastical architecture produced a sequence of curved vaults divided into four to six sections through the use of ribs. The system differs from the classic, early Gothic arrangement, in that the keystone of the side arches is not at the same level as the point of intersection of the arched ribs and wall arches but up to three metres higher. Since this type of vaulting (the most striking example of which can be seen in the Cathedral of Saint-Maurice in Angers) was confined to the domain of the Plantagenet dynasty, it is often referred to as Angevin or Plantagenet vaulting. At the beginning of the thirteenth century, this trend quickly gave way to the Gothic cathedral architecture, whose influence spread from the Ile de France. The Cathedrals of Saint-Gatien at Tours and Sainte-Croix in Orléans are the Loire Valley's outstanding examples.

After the Middle Ages, ecclesiastic building took second place, as architects of the Renaissance and Baroque periods gave their undivided attention to the châteaux.

Sculpture, so vital an element of Romanesque design in Burgundy and the southern half of France, was represented by only occasional examples in Loire Valley churches. Only the church of Saint-Ours, in Loches, possesses an elaborately ornamented portal, and even that was the work of sculptors from Poitou. Moreover, the fact that the capitals of the columns of the Romanesque priory at Ile-Bouchard were fashioned by artists from the Auvergne obviously indicates that the Loire Valley had no sculptors of its own.

Meanwhile, Romanesque mural painting is a far richer genre, although the southern French did not regard it as highly as sculpture. Loire churches often provided mural painters with ideal working conditions, since they were slow to follow the general evolution of the Romanesque style, which tended to break up the wall surfaces with three-dimensional detail. This technique was to supersede mural painting. The most important series of Romanesque murals are concentrated in the Touraine, where seemingly insignificant churches frequently boast the most dazzling frescoes. The chapel of Montoire-sur-le-Loir remains a rare example of a church with an almost completely painted interior.

Another field of craftsmanship that should not be neglected is tapestry weaving. Not only did wall hangings serve to make fortresses feel more like home, there were often whole sets of tapestries in the churches, either as draft excluders or room dividers.

The most impressive surviving work of its kind is the Apocalypse Tapestry in the château at Angers. At the same time, tapestries were seen as a good investment and were popular as gifts in polite circles. But this artistic skill was to go the same way as architecture: as the Middle Ages came to an end, the tapestry makers came to rely on a purely secular clientele.

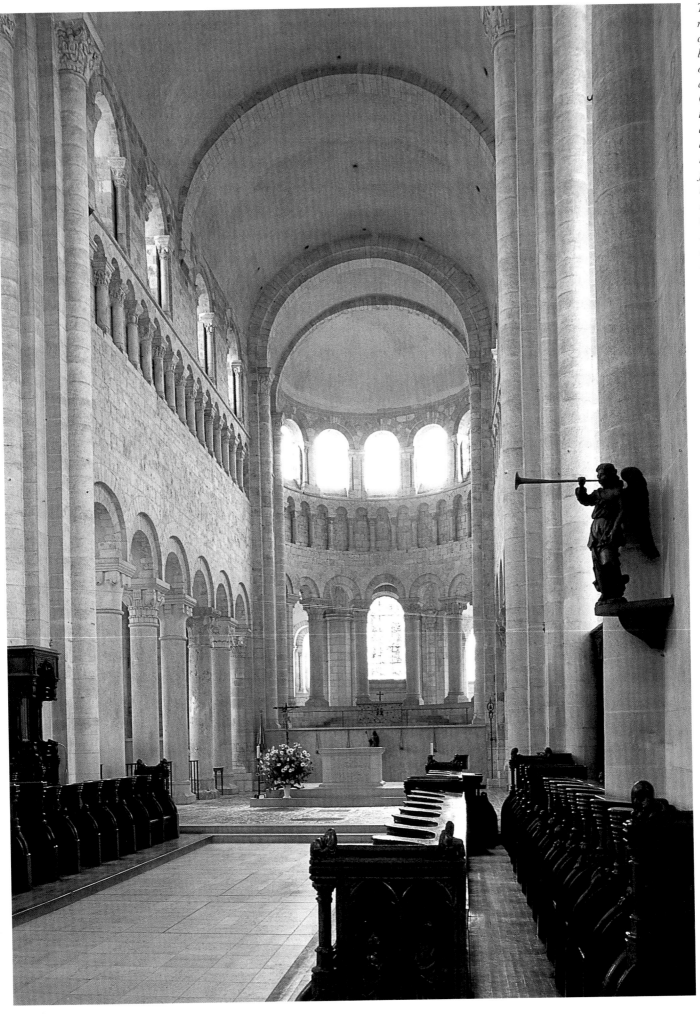

The medieval religious architecture of the Loire Valley has been unjustly overshadowed by the châteaux. Between Gien and Nantes there are many fine examples of ecclesiastical architecture, ranging from Carolingian to late Gothic. One of France's most important Romanesque buildings is the abbey church of Saint-Benoît-sur-Loire. The vaulting in the basilica dates from the Gothic period. The tomb of Philip I, who died in 1108, is in the transept. He is the only French king not to follow the tradition of burial in Saint-Denis.

The Cathedral of Saint-Maurice in Angers is a leading example of the region's characteristic Angevin architectrual style. Furthermore, the sculptures above the main door are a rarity in the Loire Valley. This group of statues, set high above the portal, between the twin towers, represent the companions of Saint Maurice.

Left: The best-preserved French Carolingian church is at Germigny-des-Prés, not far from Saint-Benoît-sur-Loire.

Right: The tombs of the Plantagenets in the vast, austere church of Fontevraud Abbey. The painted, reclining effigies are those of Henry II, King of England, his wife, Eleanor of Aquitaine, his son, Richard the Lionheart, and Isabelle of Angoulême, wife of his second son, John Lackland.

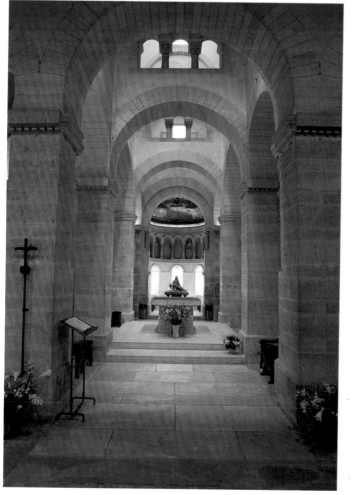

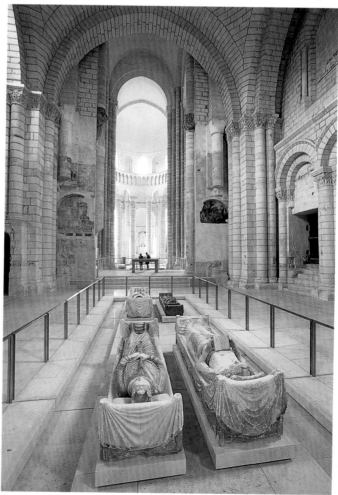

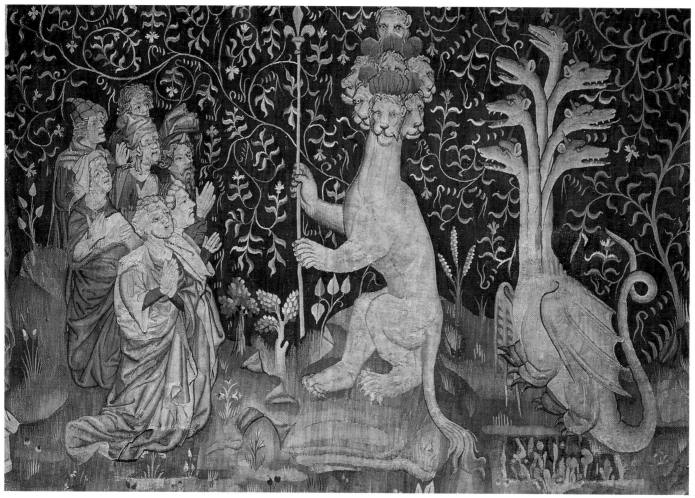

The Apocalypse
Tapestry at Angers is
the largest cycle of
medieval tapestries in
existence. Originally
168 metres long, the 70
surviving scenes still
occupy a vast length of
107 metres. This scene
shows the adoration of
the seven-headed beast
(Revelation XIII, 3, 4).

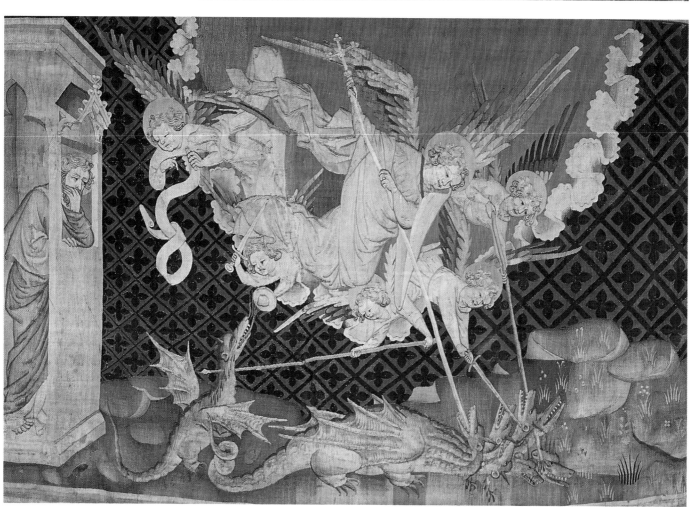

Another scene from
the Apocalypse
Tapestry: the
Archangel Michael
and his angels fight
the seven-headed
dragon (Revelation
XII, 8).

The choir and
ambulatory windows
of the Cathedral of
Saint-Gatien date
back to the thirteenth
century. The brightly-
coloured stained glass
is the Cathedral's
most decorative
feature. The windows
portray the lives of
the saints and
biblical scenes.

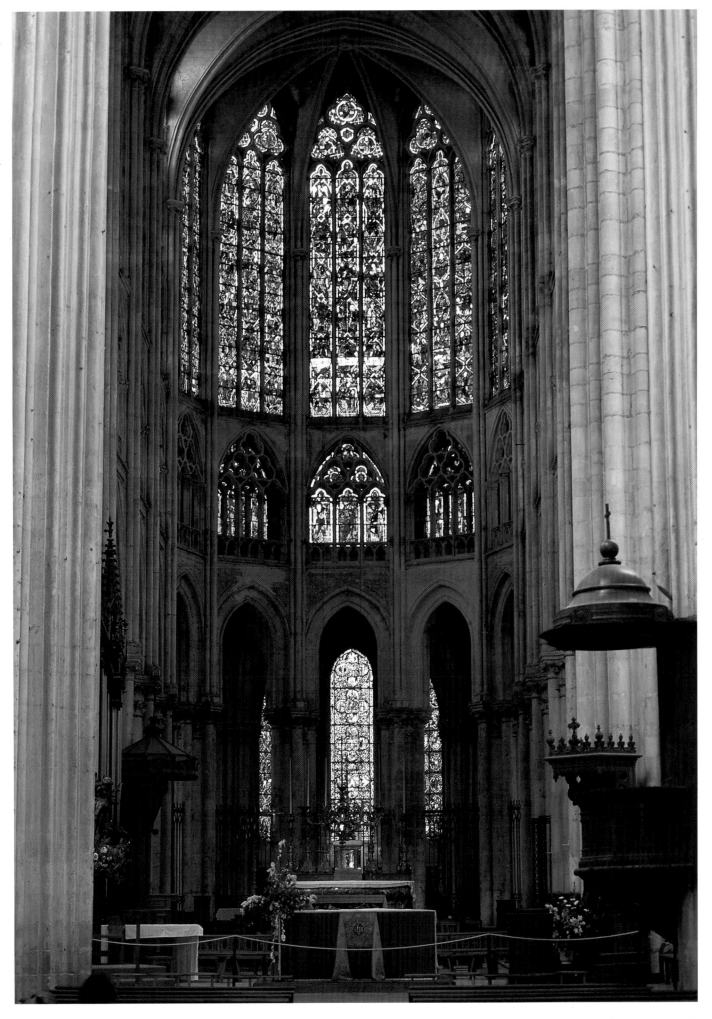

A LITERARY JOURNEY
THROUGH THE ROYAL VALLEY

In search of perfection

The streets of Blois are empty, the grass grows between the stones; long grey walls extend along either side, encircling large gardens, with small, unobtrusive doors here and there, only opened to mysterious night-time visitors. You feel that here every day is the same; but you also perceive that in this tranquil uniformity, as gentle as the striking of the church clock, the days are full of exquisite melancholy and intense longing. In this peaceful abode, you are happy to dream of some intimate tale of master and maid, of a morbid passion enduring until death, the lasting love of a pious old spinster or a virtuous wife; instinctively you imagine this as the right setting for a pale beauty with well-kept nails and fine hands, a haughty aristocratic lady, married to a grouch, a skinflint or a jealous husband, and wasting away from consumption.

Similar thoughts strike us later at Amboise, Chinon, and the other towns of Touraine; we wonder whether Balzac, who was born in the region, saw here the archetypes of his heroines, whether it was here he discovered his immortal creation the 'woman of thirty'! [...]

On its north side, above the massive walls, Château Blois displays to charming effect two arcaded storeys and a gallery; here were the apartments of Henry III. Nearby is his chapel, about which there is nothing unusual, but which is remarkable in that it was used by one whose passion was inflamed against religion, and whose cruelty was nourished by fear. Through tortuous vaults we reach the château's inner courtyard. Here life was good; each man in the garrison received a flask of wine and the soldiers brought jugs full of blue liquid and prepared to drink the health of the king, whose name day they were granted the pleasure of celebrating. [...] Before the main building stand the two most beautiful staircases in the world, a masterpiece chiselled by living hands and separated one from the other, like the high, openwork collars of the noble ladies who trod the stairs three hundred years ago [...]

Outside the château, on a platform from which one can see the entire city, the Loire, its banks lined with poplars, and the gentle, peaceful lines of the landscape stretching as far as the horizon, I saw a little tower used by the garrison as a powder magazine: here lived Ruggieri, astrologer to Henry III. Washing hung along the esplanade, the lines on which the gatekeeper's shirts were hung out to dry running in zigzags in every direction; the sentry who stood before the door of the little magazine had rested his gun across it, balancing it and playing with the priming-pan cover release as he waited to be relieved. These walls have housed illustrious guests, Valentina of Milan, Isabel of Bavaria, Anne of Britanny, Charles VIII, Louis XII, Francis I, Claude de France, Henry III, Catharine and Maria de Medici and the Guises, who spilled their blood here; it flowed on this very spot. [...]

Having been the scene of the nuptials between the Duke of Alençon and Margaret of Anjou, and those between Henry IV and Margaret de Valois, and the bloody tragedy of the Guise brothers, Blois was open to other destinies. Maria de Medici was incarcerated there and escaped through a window that is still pointed out to the visitor;

Château Brissac: from this perspective, it is easy to differentiate between the architectural styles of different periods – the medieval tower on the left and the seventeenth century apartments. Within Brissac's walls, the reconciliation took place between Louis XIII and his mother, Maria de Medici, who had been imprisoned at Blois.

in 1716, Marie-Casimir, Queen of Poland stayed here; it was here, in 1814, that Marie-Louise took refuge after the capture of Paris, and today the young infantrymen smoke their pipes and sing their bawdy songs; the bloodstains have been washed away, the sound of the saraband and minuet has died away along with the laughter of pages and the rustle of silken trains. What remains of all that history tells? And what of that on which it stays silent? [...]

The following day we saw a dilapidated ruin, namely Chambord. [...] As we entered, a young dog began to bark; the rain fell, water streamed over the roofs and through the broken windows [...]

We walked through the empty galleries and the deserted rooms, where a spider was spinning its web over the salamander of Francis I. This is not the usual ruin, resplendent with black and green remnants, with coquettish floral decorations and hanging greenery, waving like shreds of damask in the wind. This is a place of genteel poverty whose shabby walls are brushed clean in an effort to appear respectable. In this room the floor has been repaired, while in the next it is left to rot. Everywhere you can see vain efforts to preserve things that are dying and pluck from oblivion those that have already vanished. Strange! The whole thing is sad and deprived of greatness. [...] Built by Francis I after his return from Spain, where, in 1526, he had signed the ignominious Treaty of Madrid, as a monument to a proud man who wished to deaden the pain of defeat, it was first the place of exile of Gaston of Orléans, a disappointed pretender to the throne; then Louis XIV extended the single storey to three, so spoiling the wonderful double spiral staircase which led directly from the ground to the roof. One day, Molière gave the first performance of *Le Bourgeois Gentilhomme* on the second floor on the façade side, under the beautiful ceiling covered with salamanders and painted ornamentation in crumbling colours. [...] As we passed through an outer gallery towards the Orléans staircase to see the caryatids, said to represent Francis I, Madame de Châteaubriand and Madame d'Etampes, and as we turned around the great lantern at the top of the staircase, we looked back again over the balustrade. In the courtyard a little donkey was nuzzling his mother, who was suckling him; he shook his ears, snorted and leapt to his feet. This was in the *cour d'honneur* of Château Chambord, and these were now its guests: a dog playing in the grass, and a donkey, sucking, snorting, screeching, shitting and sporting on the king's doorstep!

The weather had brightened, the rain had stopped and a pale evening sun was shining as we came to Amboise. Here, too, you find the same pleasant provincial streets as in Blois: people stand chatting on the doorstep or working by the front door; the women, most of them dark-haired, have a gentle expression and are extraordinarily pretty; their truly feminine appearance holds many sensual riches. Here, we are indeed in the fertile, temperate Touraine, the land of good, light white wine and beautiful old châteaux, watered by the Loire, that most French of all rivers. Their manners and gait have something of the tranquillity of the north, but when they laugh their faces light up with southern vitality. [...]

Château Amboise looks out over the town, lying at its feet like a load of pebbles scattered on the rocks; it has a noble, imposing, castle-like countenance, with its massive, bulky towers, broken up by long, narrow, round-arched windows; the arcaded gallery that binds it together, and the reddish yellow colour of the walls, which look even more dark and forbidding through the flowers that hang down like a plume waving over the bronze forehead of an old warhorse. We stood for a good quarter of an hour, lost in admiration before the magnificent left hand tower. Its brown hue has

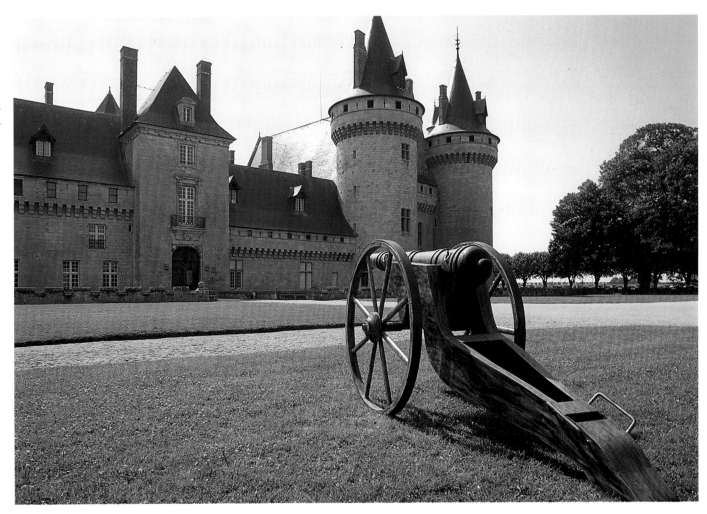

turned yellow and black in places, and wonderful wallflowers trail from the battlements; it is indeed one of those eloquent buildings that seem to be alive, rendering the onlooker dumbstruck and dreamy, like portraits whose subjects one does not know, but is nonetheless compelled to love, without knowing why. A unique calm and aristocratic serenity pervades the Château of Chenonceaux. Standing at the end of a great avenue of trees, somewhat apart from the village, which seems to hold back out of respect, surrounded by forest in the middle of a large park with lovely stretches of lawns, and built right on top of the water, it extends its turrets and its square chimneys into the sky.

In the kitchens beneath the castle vault, a maid cleans vegetables, a kitchen boy washes dishes, while the cook stands at the oven preparing breakfast in a goodly number of saucepans. The whole scene gives a pleasing impression of real château life and the intelligent way of living of a man of noble lineage. I like the master of Chenonceaux.

And are there not hanging everywhere fine old portraits, before which you can stand for hours and dream, transported back to the days when their subjects were alive, when the hips of all those rosy ladies spun in ballet dances and those noblemen with their rapiers dealt each other dexterous blows? These are the temptations of history. We would like to know if these people loved as we do, and how their passions differed from our own. We should like to unlock their mouths, so that they could tell us their innermost secrets, all their deeds, even the slightest and most insignificant, their torments and triumphs. [...]

Among others, we see two large portraits of the Beauvillers on horseback, one of them represented as an admiral, the other as a cavalry colonel. Their boots reach to their hips and the shoulders of their green ceremonial uniforms are sprinkled with white powder, fallen from their full-bottomed wigs. [...]

Above one of the doors is a canvas of the beautiful Gabrielle d'Estrées, naked to the waist; a thick string of pearls of the same blonde tone as her skin hangs down over

73

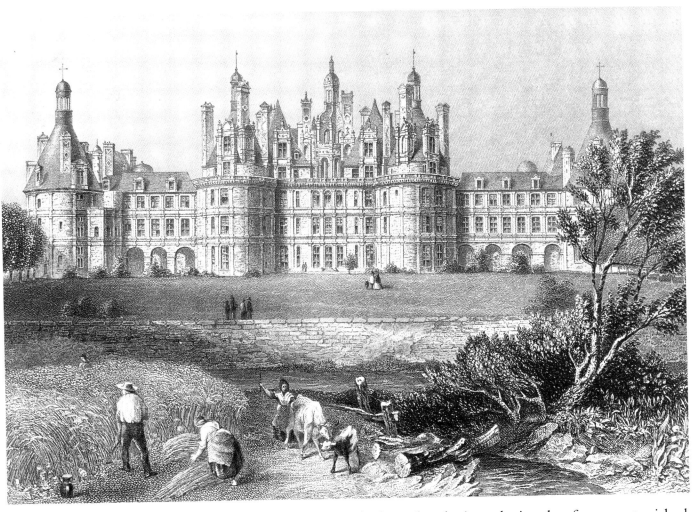

A mid-nineteenth-century view of Chambord, largest of all the Loire châteaux. At that time, Chambord had not been occupied for many years and was falling into rack and ruin. It only became state property in 1930 and extensive restoration was completed within a few years. Engraving from 1860.

her breast; her fair hair, elaborately dressed and crimped, gives her face an astonished expression, full of naïve roguishness; her sister, her back turned and also naked to the loins, turns her dark brown head to regard the observer with curiosity, while in the background a peasant woman with a red headscarf and white shawl gives the breast to a charming babe-in-arms, the Duke of Vendôme. [...]

In a room which serves as a salon and on whose table the cudgel of Francis I was kept, we noticed a fine portrait of Rabelais, a swarthy, cheerful, full-blooded, strong face, small, vivacious eyes, sparse hair and a beard and chin like a satyr that was obviously the model for all likenesses of the great man. The portrait of Isabel of Bavaria, underneath to the left, is remarkably expressive. [...]

On all the walls hang many more paintings, which you would like to savour at leisure, without the attendant, keys in hand, close on your heels and with a gesture urging you to make haste. I recall a full-length portrait of Louis XIII, represented as Apollo, with pointed chin and small, straight moustache and the large, black wig falling to his shoulders and shadowing his melancholy face. I have never been able to think of Louis XIII without a certain sadness; he is indeed the man who suffered more boredom on this earth than any other. [...]

In the chamber of Diane de Poitiers, we saw the royal concubine's great four-poster bed, entirely covered with blue and cherry-red damask. If it were mine, I would find it hard not to lie on it from time to time. To recline on the bed of Diane de Poitiers holds more fascination than lying beside any other, more palpable reality. Has it not been claimed that in such matters all pleasure depends on the imagination? Can any man who knows a little of himself not comprehend the uncommon voluptuousness, suffused with the historic flavour of the sixteenth century, of resting his head on the pillow of the mistress of Francis I, and tossing and turning on her cushions? [...]

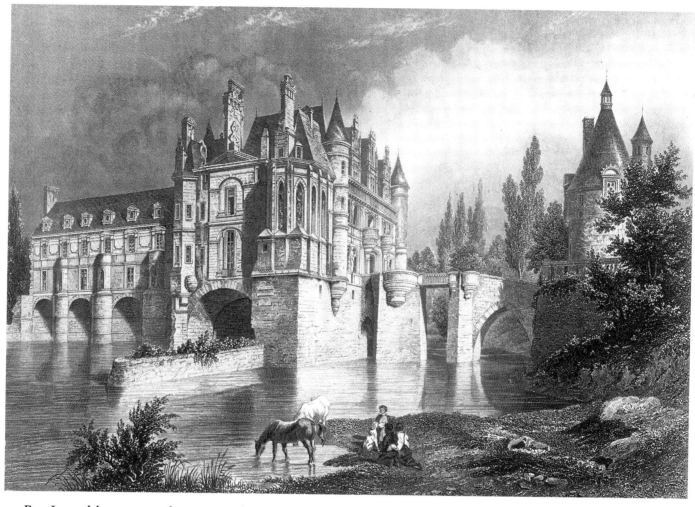

But I would not even dare to touch Catherine de Medici's porcelain in the dining room, for fear of breaking it. [...]

Finally, however, we had to bid farewell to poor Chenonceaux; with its beautiful memories, its wonderful portraits, its splendid weapons and old furniture, there it lay, as we took our leave surrounded by tree-shaded green lawns, lulled by the delicate babble of the river. In cheerful mood, our bottles full, we set out on foot towards Bléré, using our rucksacks for the first time. From there we intended to take a carriage to Tours.

GUSTAVE FLAUBERT, 1847

Gossip at the royal court

At the French court and even in most recent times, there existed the pleasurable custom of gossiping about the ladies. There were times, and I myself have experienced this, when it was considered good form for a nobleman to bring ladies into disrepute – whether by slander or by speaking the truth. Such things must be strongly condemned, for one should never impugn a lady's honour, above all that of a noble lady. This pertains both to men who enjoy their affection and to those for whom the sweet grapes hang too high and who taste naught but the sour.

As I said before, at the court of our last king we were highly susceptible to such scandal, in contrast to the court of his predecessors. In this, good King Louis XI was an exception. It is said of him that he usually sat at table in a great room in the company of many courtiers, and whoever could tell him the best and most lewd story about a lady would be fêted. [...]

His spouse, however, a virtuous and demure woman, he held in very high esteem. It was fortunate that she possessed these qualities, for the malicious and mistrustful

MONS· DE·RONSARD·

prince would otherwise have dragged her through the mire like any other. When he died, he commanded his son to love and honour his mother, but not to allow her to dominate him, 'for she is very chaste and virtuous', he said, 'but unfortunately more a Burgundian than a Frenchwoman'. He continued to love her only until she bore him heirs, and once the succession to the throne was assured, cared for her no more. She lived in the Château of Amboise like an ordinary lady of the court, with very little finery and as badly dressed as a common maid. There he left her to her prayers, while he pursued a life of pleasure elsewhere. [...]

King Louis XII had great respect for ladies. Actors, scholars and priests in the kingdom were allowed to disparage women, but not his royal consort or her maids of honour. As for the king, he was a lusty fellow who loved the ladies like any other.

The king by no means lacked a sense of humour and was well able to appreciate a nice anecdote about the fair sex. Nevertheless, he would not tolerate slanderous or scandalous tales, nor was he pleased when anyone dared to usurp his own privileges. I have been assured that he always wished his courtiers to have mistresses, otherwise he considered them fools. [...] In King Charles' day, a most scurrilous lampoon was written at Fontainebleau, which did not spare even the most noble princesses and ladies. Had the real author been discovered, it would have been the worse for him. Even at the time of the Queen of Navarre's marriage at Blois, such a lampoon appeared against a most high-born lady. Even in this case, the author could not be found. Some valiant gentlemen, who were likewise maligned, defended themselves with all force against the affront, but the thrusts of their swords penetrated nought but thin air. But then many more such libellous statements appeared, one in the guise of a song, which the pages and lackeys would sing to the tune of a dance then well known at court. [...]

Left: Jean-Baptiste Molière (1622–1673). As a playwright and leader of his own theatre group, he enjoyed the patronage of Louis XIV, despite the critical undertones of many of his plays. His comedy 'Le Bourgeois Gentilhomme' received its first performance at Chambord, in the presence of the Sun King.

Right: Honoré de Balzac (1799-1850). Deeply in debt as a result of foolhardy speculations, ill-fated business ventures and an extravagant lifestyle, Balzac was forced into a breathtaking literary career, culminating in an eighty-volume series of novels. Many of his works are set in his native Touraine.

Catherine de Medici was always splendidly attired and always had some new or pretty notion. In short, she was possessed of great beauty and so was much loved. [...]

Daily she contrived a new dance or a delightful ballet. When the weather was inclement, she would also invent games and spent her time with one companion or another, for she was most gregarious, but, when necessary, could be dignified and serious. She was also very fond of watching comedies and tragedies.

She would spend much of her time in the afternoon with her embroidery, which she did to absolute perfection. In short, this queen loved all seemly occupations and devoted herself to them, and there were none worthy of her and her sex that she did not strive to learn and practise.

ABBÉ PIERRE DE BOURDEILLE, KNOWN AS SEIGNEUR DE BRANTÔME, *c.* 1600

Amusement for His Majesty

Before the King departed for Chambord to enjoy the pleasures of the hunt, he wished to entertain his court with a ballet. Since the arrival of the Turks in Paris was still a recent memory, he was of the opinion that it would be appropriate to have them appear on the stage. His Majesty therefore commanded me, in company with Monsieur Molière and Monsieur Lully, to devise a spectacle, to which something of Turkish customs and Turkish costume might be added.

So I made my way to the village of Auteuil, where Monsieur Molière possessed a most delightful house. There we worked on the play that appears among Molière's works under the title *Le bourgeois gentilhomme*, who disguised himself as a Turk in order to win the hand of the Grand Vizier's daughter. It fell to me to arrange everything regarding Turkish apparel and customs. When the play was ready it was presented to

the King, who gave it his approval, and I spent eight days with the tailor, Master Baraillon, that he might make up Turkish costumes and turbans. All this was taken to Chambord and the play was performed in September, with some success and to the satisfaction of His Majesty and all his court. His Majesty was good enough to mention that he had clearly seen that the Chevalier d'Arvieux had taken care of many matters, to which the Duke of Aumont and Dacquin replied: 'Sire, we can assure Your Majesty that he did take great pains, and that he did seize every opportunity to achieve whatever might please Your Majesty'. The King replied that he was convinced of the truth of this, and that he had never commanded me to do anything that had not been carried out to his satisfaction and that he would be sure to remember me when the occasion arose.

Such obliging words from the mouth of so great a monarch earned me the approval of the entire court – a blessing with which courtiers are not sparing!

The ballet and the play were performed with such great success that although we repeated it many times, it was called for again and again. The playing of the actors was also beyond praise. There were those who even wanted to add the Turkish scenes to the *Ballet de Psyche*, which was being prepared for the coming Carnival, but upon mature reflection, we agreed that the two themes were ill-matched.

CHEVALIER D'ARVIEUX, 1670

Imprisoned at Blois This beautiful Château of Blois was for Catherine the most confined prison. After the death of her husband, who had always kept her on a tight rein, she had hoped to rule, but she now found herself enslaved by the actions of strangers, whose courtly manners were a thousand times more brutal than those of the jailers. No step she took remained secret. All her maids of honour, who had once been devoted to her, either had lovers loyal to the Dukes of Guise or were watched with Argus eyes.

HONORÉ DE BALZAC, 1840

French summer residences [In March 1526, Francis I] was again in France, and henceforth his will and his whims were omnipotent, for he was once more King of France.

Naturally, Louise, his devoted mother, hurried to meet him, taking all her beautiful maidens with her. Oh, she knew her son's tastes, and the young Anne de Pisseleu, later known as Mlle. de Heilly, was not left out of the entourage. La Châteaubriand was certainly left behind – the fair Anne was to distract Francis's attention from the imperious Châteaubriand. How well she knew her son's tastes, how romantic fortune came to her aid! Francis stood transfixed before the young woman. This moment decided the second half of the king's life, for it was to develop into a lively and, it seems, deep and mutual affection, which – apart from the king's clandestine adventures – was to last for the rest of his days. [...] For this fortunately talented young woman also shared the king's good taste and became a champion of the arts and sciences, a champion of the glorious Renaissance. Thus she earned the name *la savante des Belles* – the connoisseur of beautiful things.

She was also good to the Protestants, she became – a rare occurrence – a beloved, acknowledged member of the family. The king's mother loved her, his sister Margaret loved her, and all the discord that had prevailed under Châteaubriand was no more. Ten years later, Francis married her to one Monsieur de Brosse and created him Duke of Etampes – and it is as his duchess that she is known to history.

Detail of Château Blois, the 'Tour du Moulin'. Photograph from 1910.

While she was of more cheerful disposition than Châteaubriand, she was not a nobler character, and it may be that, in the latter, Francis had lost a prouder and greater love. Whether because of her own petty jealousy and the envy common to mistresses, or because she was urged on by the queen mother, I do not know, but she was foolish enough to compel Francis to send a message to Châteaubriand ordering her to hand over all his letters and presents, all the mottoes and rings that betokened their vanished passion.

I am ill now – Châteaubriand replied – I shall search for them, in three days you shall have them. Meanwhile, she ordered all the rings and bracelets and other metal jewellery to be melted down into lumps, and when, after three days, the messenger returned, she handed him the mass of metal and said: Take these to the king, the weight is exact. The mottoes and the other things you asked for are engraved upon my heart, and it is there that he must seek them. The King, both dismayed and flattered, cried out: This woman has more courage and stature than I believed possible in one of her sex! Return the gold to her, I would have paid double for the mottoes alone.

HEINRICH LAUBE, 1876

A pleasant place to stay

In 1747 we spent the autumn in Touraine, at the Château of Chenonceaux, a royal house on the Cher built by Henry II for Diane de Poitiers, whose monogram can still be seen there, now in the possession of the farmer-general Dupin. In this beautiful place we were well contented; the food was good, and I became as fat as a friar. There was an abundance of music. I composed several trios for voice, full of quite strong harmonies, which I may discuss further in my addendum, if I ever write one. They put on plays there. I wrote, in fourteen days, a three-act play entitled 'The Rash Promise', which may be found among my papers, and which has no merit other than that it is most amusing. I wrote some other small works, among them the poem 'Sylvia's Avenue' named after one of the avenues in the park which leads along the bank of the Cher, all this without interrupting my chemistry or my duties for Madame Dupin.

JEAN-JACQUES ROUSSEAU, 1747

Grander, larger, dearer!

About this time was built, under the direction of Messire Bohier, general of the finances, the Château of Chenonceaux, which, in sport and by caprice, was so built as to bestride the river Cher.

Now, the Baron of Semblençay, seeking to outdo the said Bohier, boasted that he would build his at the bottom of the Indre, where it stands today, like the jewel of that beauteous green valley, so solidly was it built on piles. Thirty thousand crowns did Jacques de Beaune expend thereon, in addition to the labour of his own retainers. Doubt not, therefore, that that castle is one of the noblest, prettiest, daintiest, most elaborately decorated castles in lovely Touraine, and hath at its feet always in the Indre like a princely courtesan, gaily bedecked with its pavilions and delicately carved windows, with pretty soldiers on its weathercocks, veering with the wind as all soldiers do. But hanged was honest Semblençay before finishing it, nor hath any one of his successors found himself sufficiently well supplied with *deniers* to finish it.

And yet, his master King François, first of the name, had been his guest there, and the royal chamber may still be seen.

HONORÉ DE BALZAC, 1832

Continued on page 97

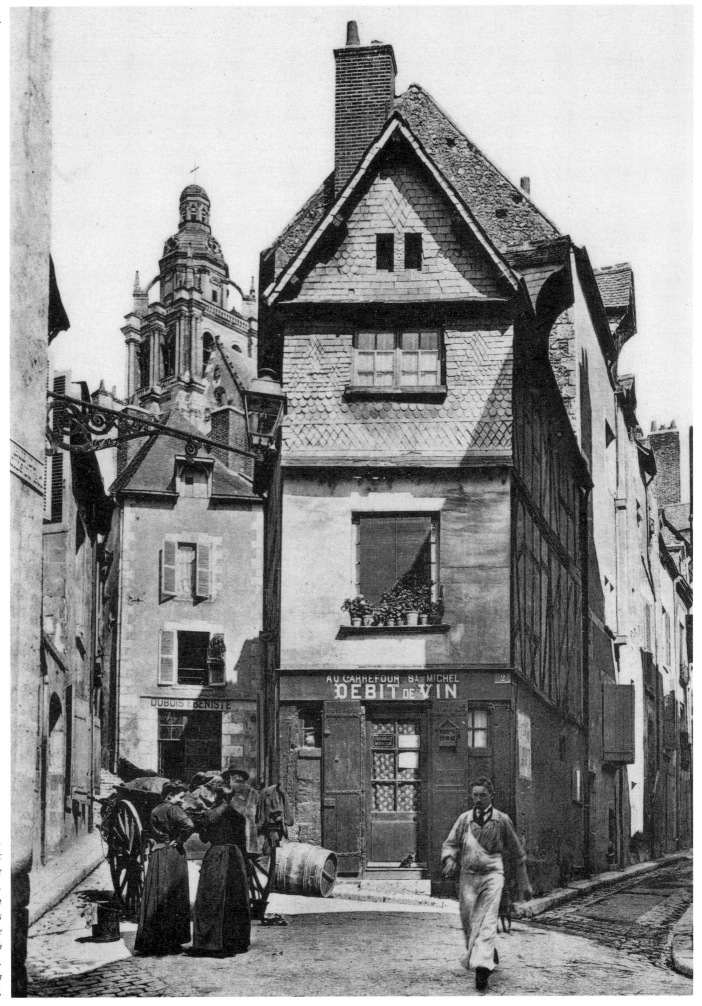

Blois. The bell tower of the Cathedral of Saint-Louis seen from the old town. Since the area became a pedestrian zone, life in the narrow streets is once again as tranquil as it was a hundred years ago. Photograph from 1905.

Overleaf: Orléans. The Rue Jeanne d'Arc was not built until the nineteenth century. One of the city's main thoroughfares, its focal point is the cathedral façade with its twin towers. Photograph from 1890.

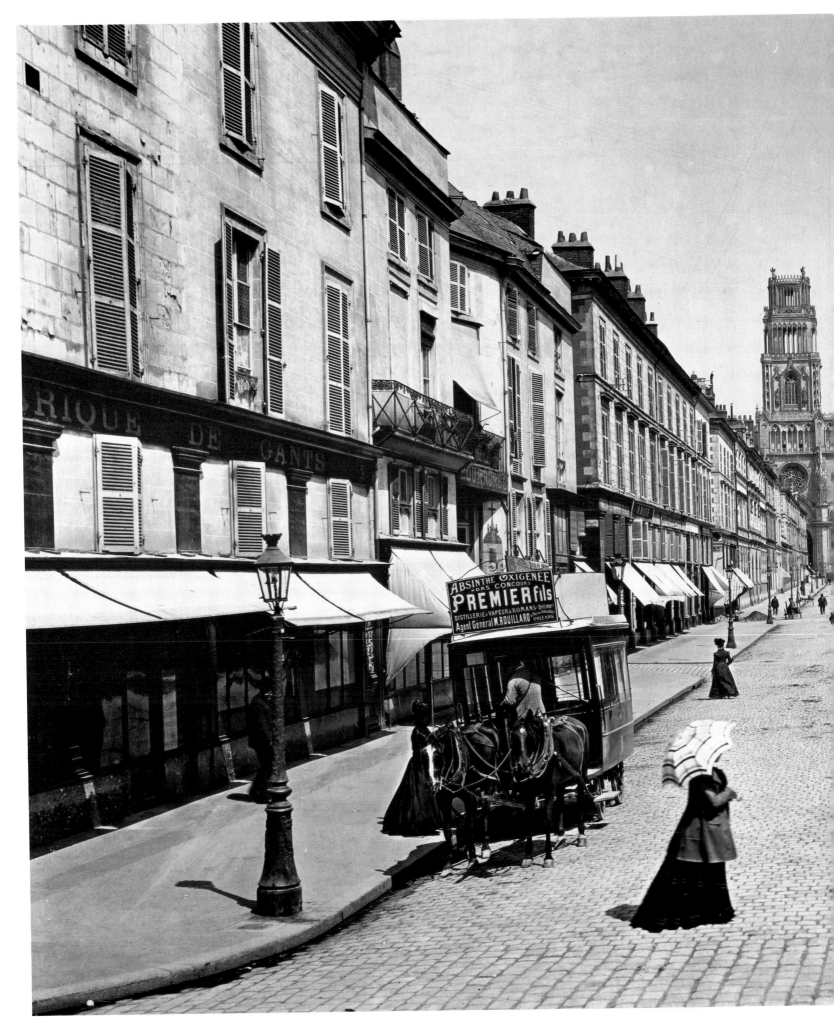

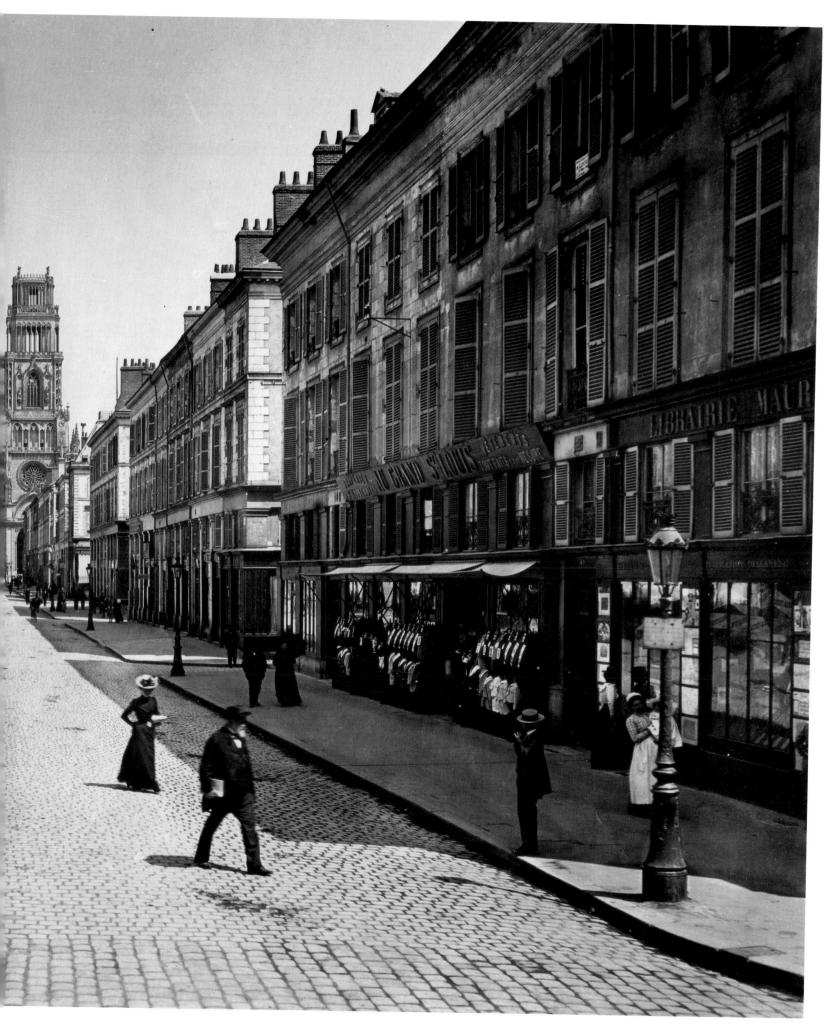

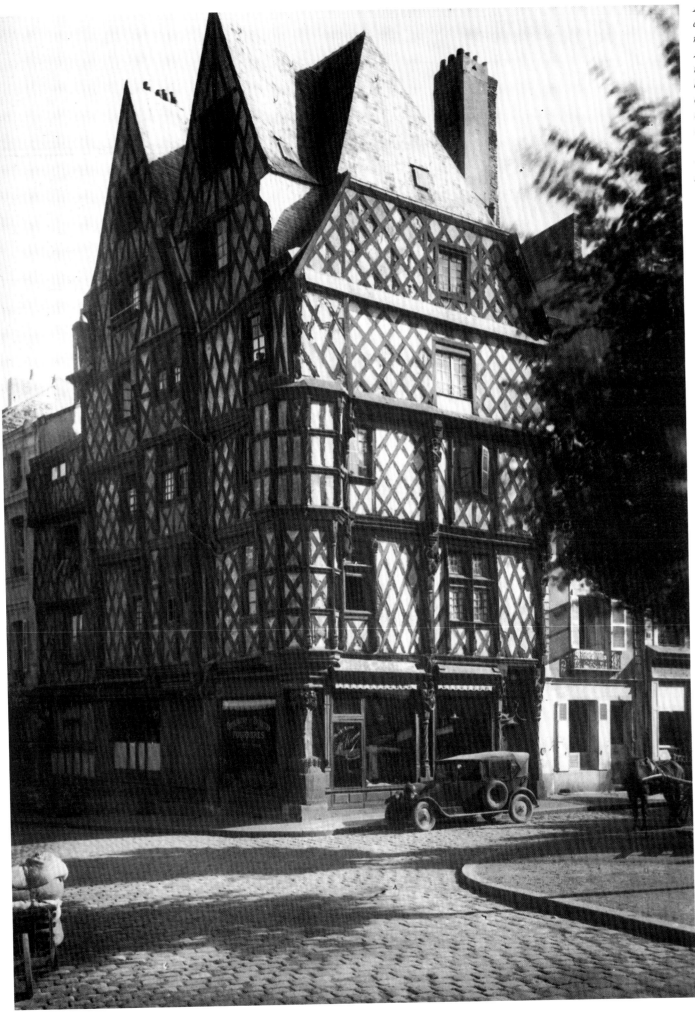

As well as the great château and array of medieval churches, Angers also boasts a number of historic houses. One of the city's finest half-timbered buildings is the fifteenth-century 'Maison d'Adam', seen here in a photograph from 1920.

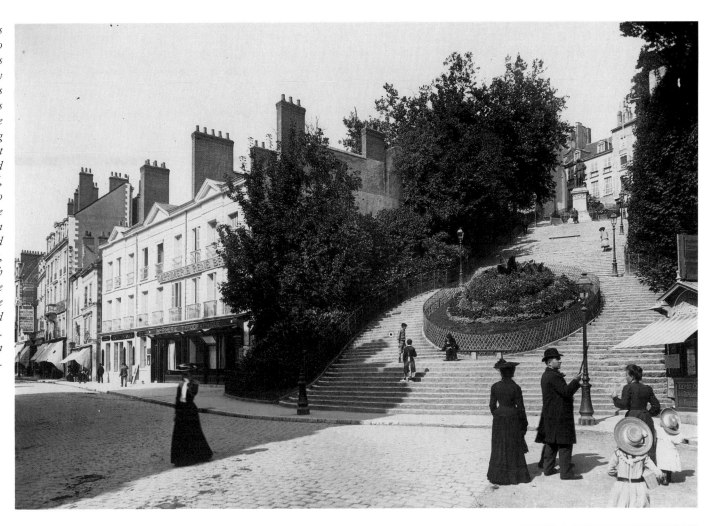

Blois. Flight of steps with the memorial to Denis Papin. This famous son of the city was born in 1647. As a Huguenot, he was forced to leave France in 1685, following the repeal of the Edict of Nantes. He lived first in England, moving later to Germany, where he died in 1714. An astoundingly gifted doctor and naturalist, Papin is credited with having invented the forerunners of the pressure cooker and the steam engine. Photograph from 1900.

Blois. The seventeenth-century church of Saint-Vincent stands to the north of the château, opposite the Francis I Wing. Photograph from 1910.

Overleaf: Chenonceaux. At the beginning of the twentieth century, the fairy-tale château was still surrounded by idyllic countryside – now it is thronged with thousands of tourists. Photograph from 1910.

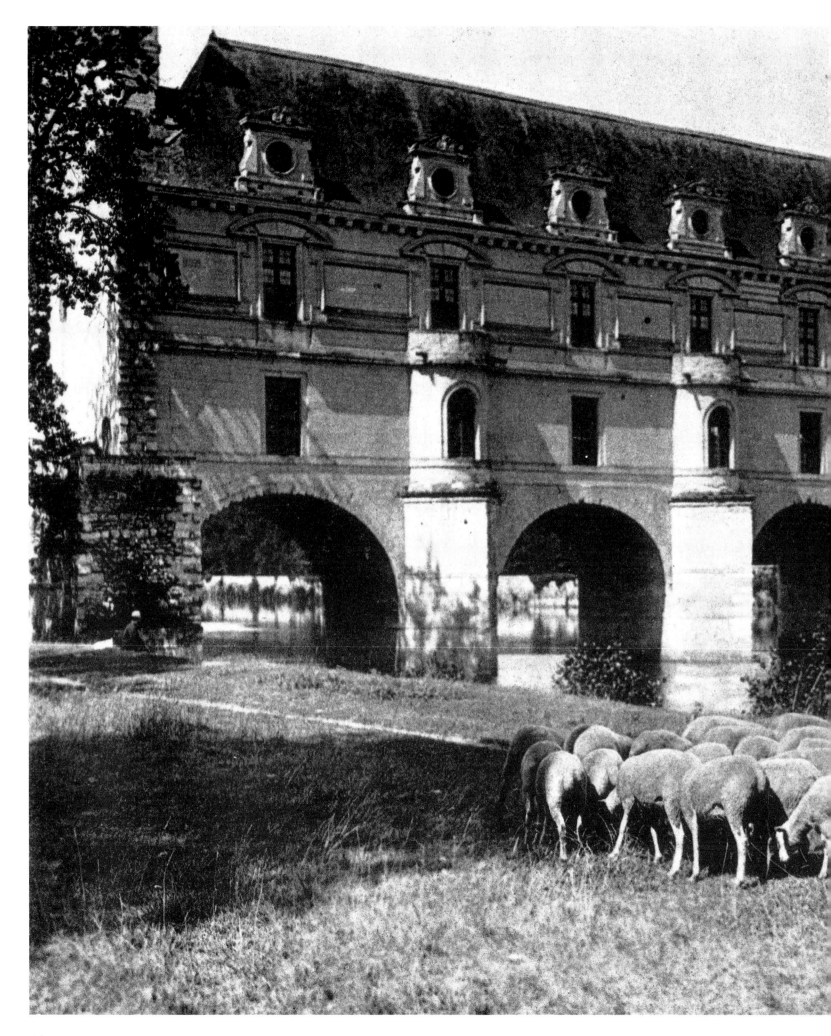

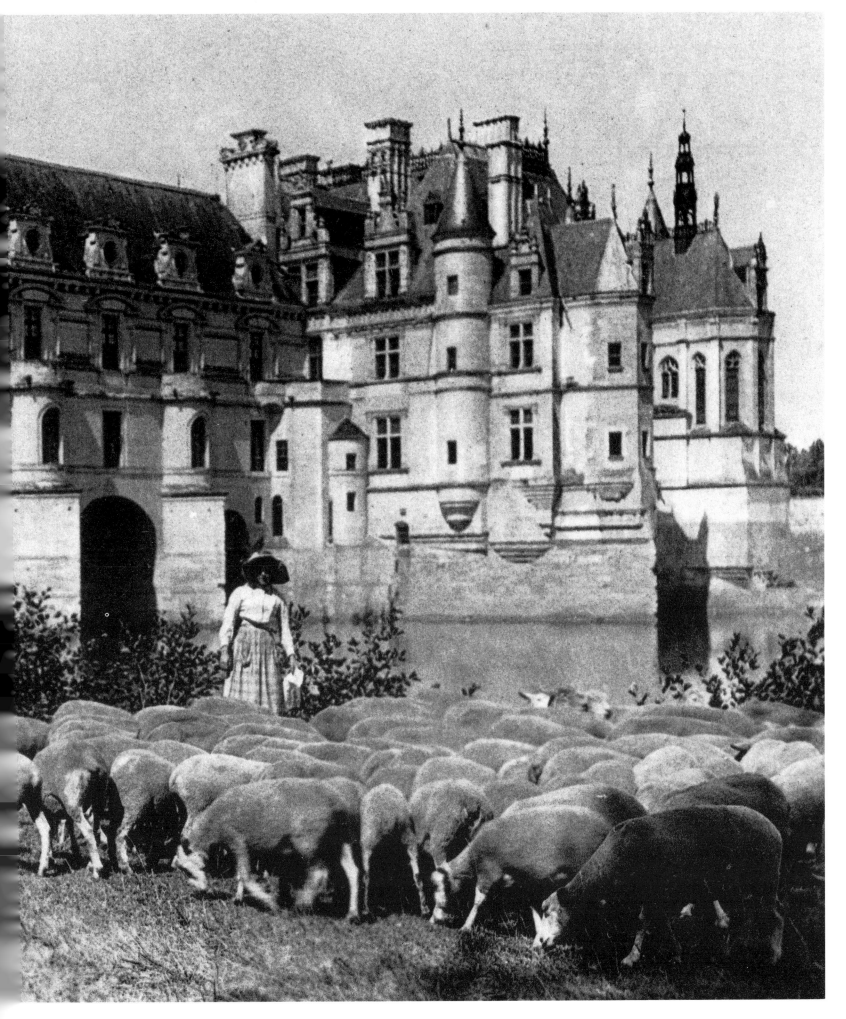

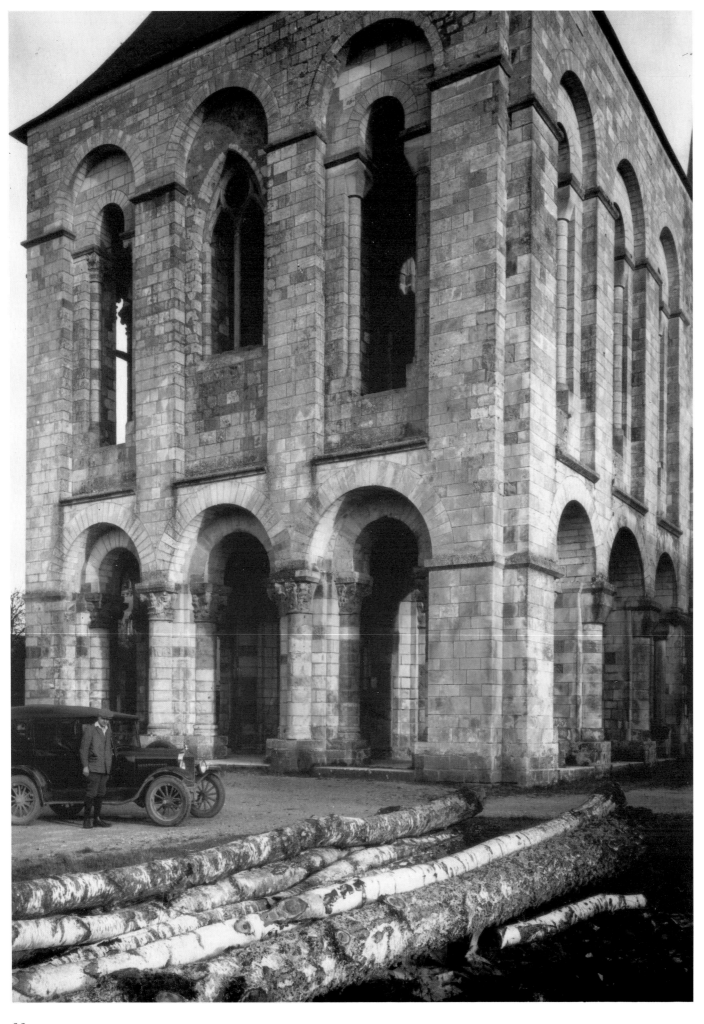

Saint-Benoît-sur-Loire: the west tower, commissioned by Abbot Gauzlin in the eleventh century. So proud was he of his architectural creation, that he declared the wish that it should be 'an example to all Gaul'. In fact, imitations of Saint-Benoît's west tower can be seen as far away as the Auvergne (Ebreuil) and Limousin (Saint-Léonard-de-Noblat). Photograph from 1920.

The Manoir Clos
Lucé on the outskirts
of Amboise, where
Leonardo da Vinci
spent the final years of
his life. In the cellar,
there is a museum
containing models,
recreated from the
great genius' technical
drawings. Old
photograph.

Near Amboise. Cave
dwellings hollowed
out of the soft rocks,
some of which are still
inhabited even now.
They are found all
over the Loire Valley.
Photograph from
1910.

Overleaf: Tours. At
the junction of the
city's main
thoroughfares stands
the Place Jean Jaurès
with the nineteenth-
century law courts.
Today, quite a
different type of
horsepower circulates
here. Photograph
from 1890.

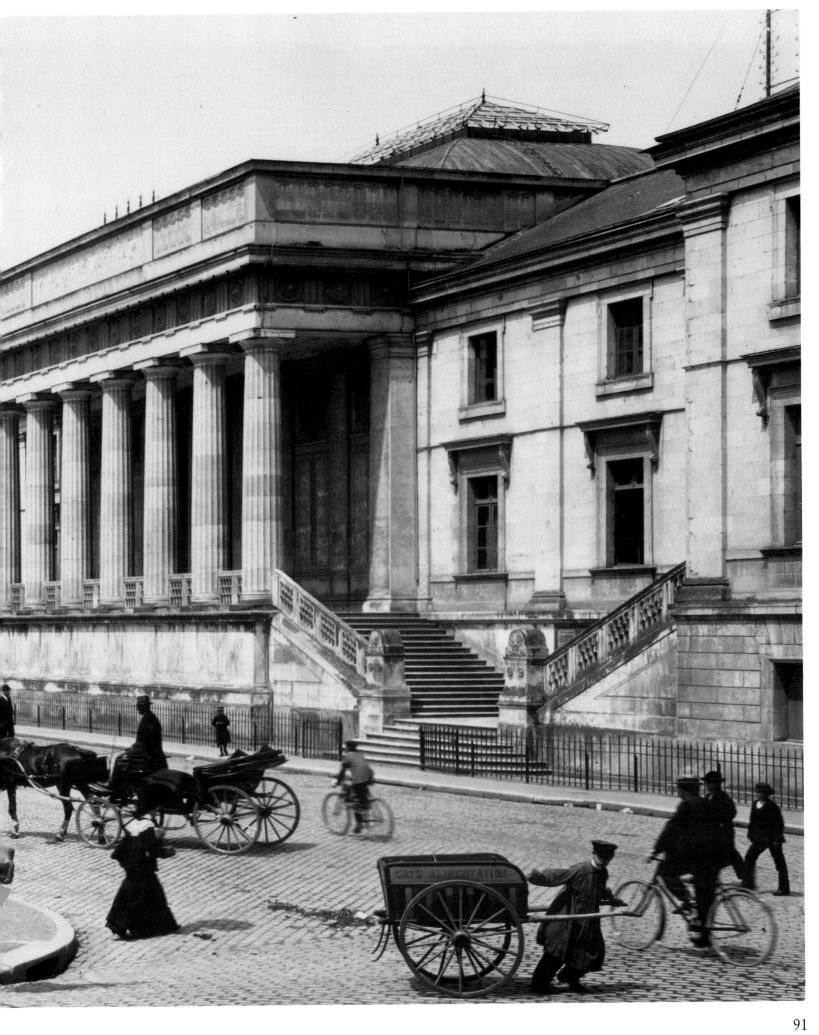

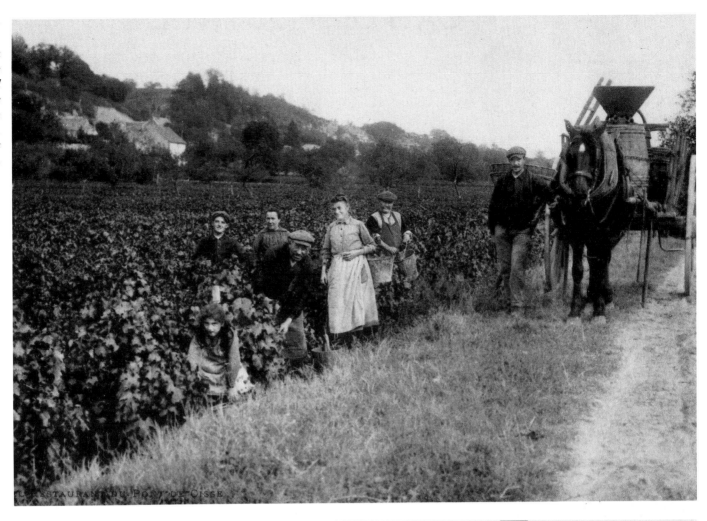

The Vouvray vineyards near Tours. For generations a sparkling white wine has been produced here, using the 'méthode champenoise'. Photograph from 1910.

Château du Moulin, near Lassay-sur-Croisne in southern Sologne. Surrounded by water, away from the main tourist routes and elegantly laid out, this little château is one of the jewels of the Loire Valley. It is unusual in that it has remained in the hands of the same family for centuries. Photograph from 1900.

Overleaf: Angers. View across the Maine from the fortress of the Dukes of Anjou. The Cathedral of Saint-Maurice rises in the distance. Photograph from 1890.

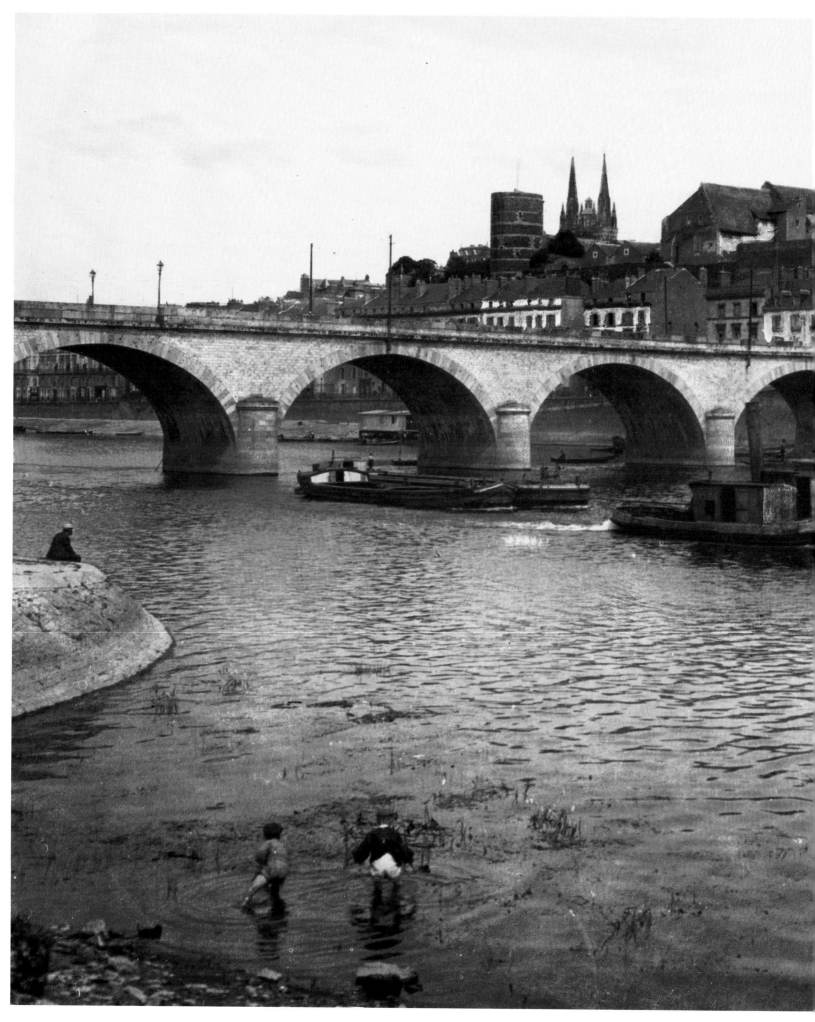

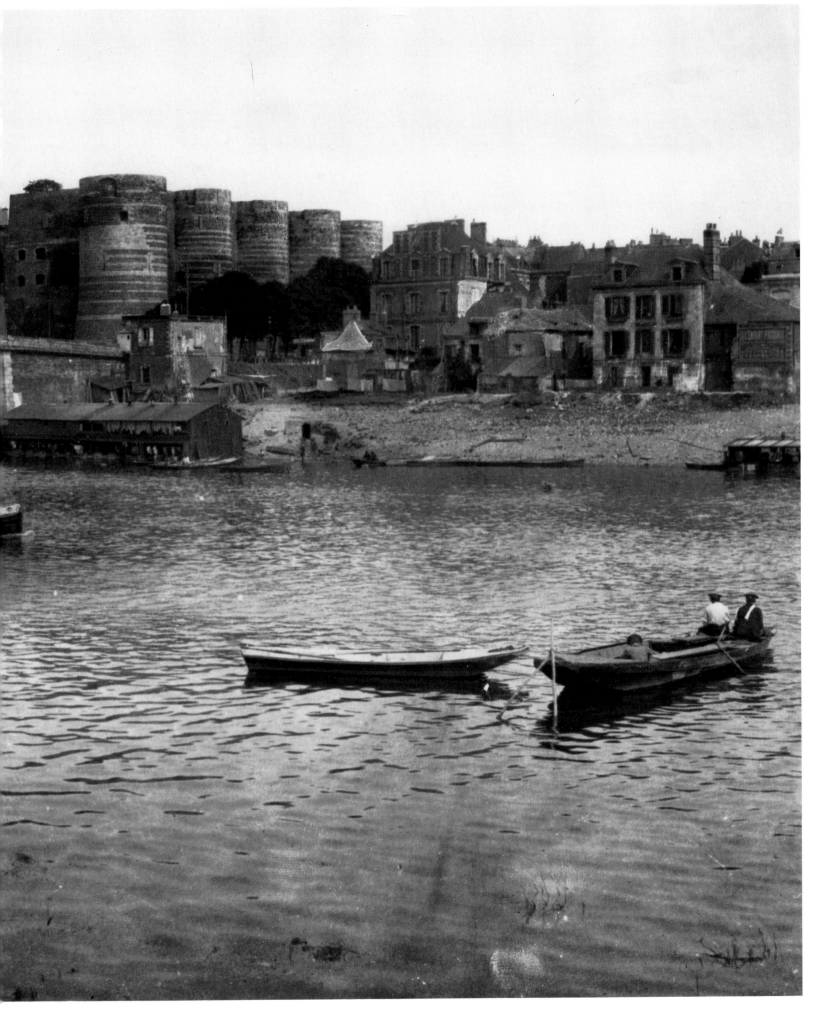

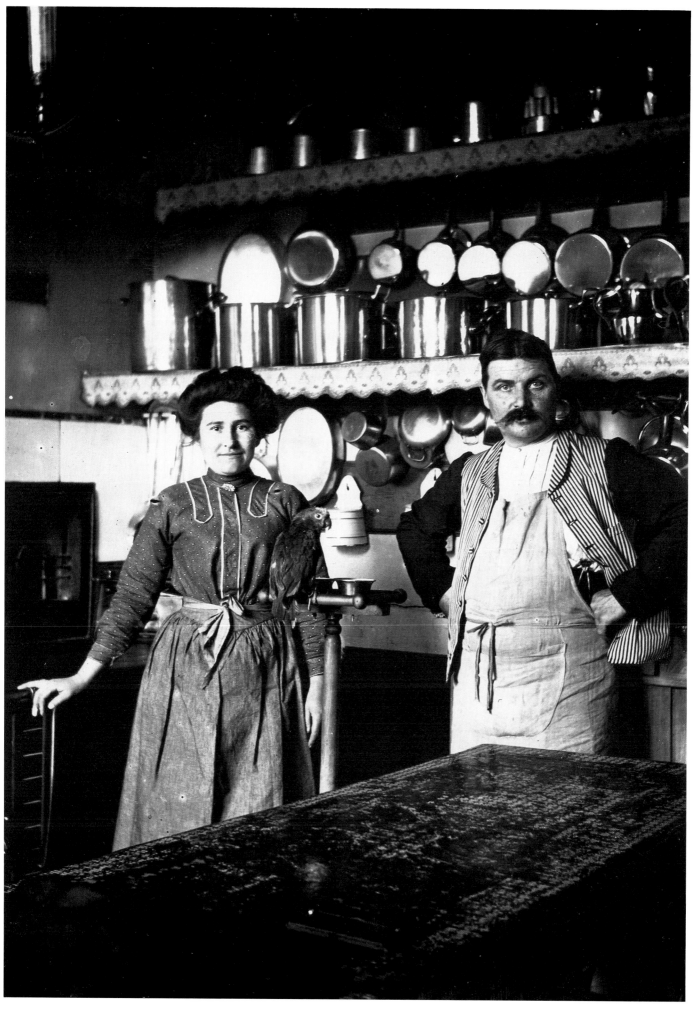

'Don't you want to see Chenonceaux?' the landlord asked me.

'What is it?'

'Good heavens, it is one of the most interesting things in France, the château that Francis I built for Diane de Poitiers, and most of it is preserved just as she left it.' [...]

The château, a charmingly irregular shape in a picturesque setting, consists of two buildings linked by a wall and a bridge. The first, whose main section is a wide, square tower, decorated with a fine Gothic portal and the insignia of Diane de Poitiers, is used as a gatehouse and is the home of the gatekeeper and his family. From here, one passes over the aforementioned drawbridge to the main building, which, in accordance with the tastes of the times, is furnished with many projections and towers, and, in a most singular way, stands on a wide stone bridge with six arches, extending across the River Cher.

As one enters, one first sees a narrow hall, hung with ancient weapons. This leads into the drawing room of the present owners, Count Villeneuve and his spouse, who with the greatest courtesy allow strangers to visit all the château's remarkable treasures. [...]

...Opposite the aforementioned drawing room is the way to the most historic part of the château. The first *pièce* is the *Salle des gardes* of Francis I, which, like the subsequent ones, has been carefully preserved, as it was in his day. One feels one is looking into an old painting. In front of the doors hang closely woven tapestries. A richly gilded leather covering adorns the walls, on which four paintings in the medieval style are hung, portraying scenes of battle. The wooden ceiling is painted in sky blue and gold; on the mantelpiece above the fireplace, which reaches almost to the ceiling, stands a golden bust of Francis I, and in several places we once again find the salamander and the Gothic F and the royal crown and the girdle of Saint Francis; and there, where the two ends of the girdle join, sits a sweet little cupid. Benches and a few worm-eaten tables are the only furniture.

The second room is the chamber in which the king held audience. Here the ceiling is unusually richly and artistically carved, the floor is tiled and the wall coverings are of linen with large, red velvety flowers with gilded spaces in between, the furniture is likewise made of gilded wood, some pieces covered with crimson silk, others with velvet or cloth of the same colour, while the backs of the armchairs are embroidered with the letter F, and in the centre of the room is a tall baldachin. Next to this room is a kind of boudoir, with panels in pale blue with yellow tracery; the furniture is ebony with black velvet and closely woven gold braid. In this room there is a goblet of great beauty, belonging to Francis I, made of coloured Venetian glass. There is also a chair and a mirror with an exquisite tortoise-shell frame and beaten metalwork, both belonging to the unfortunate Mary Stuart.

PRINCE HERMANN VON PÜCKLER-MUSKAU, 1835

There remained only the monk to provide for. Gargantua offered him the Abbey of Seuilly: he refused. What about the Benedictine abbeys of Bourgueil or Saint-Florian, among the richest in France: he might have either or both? Again the offer met with a flat refusal: Friar John did not seek the charge or government of monks. [...]

The notion delighted Gargantua: he forthwith offered his estate of Thélème, by the Loire. Here indeed he could institute a religious order contrary to all others.

But, said Gargantua, no wall must be built around it, for all other abbeys are solidly enclosed. – 'Quite so,' agreed the monk, for those who cower behind walls soon become envious and resort to plotting.' [...]

Similarly, because all monasteries and convents on earth are compassed, limited and regulated by hours, here no clock or dial of any sort should be tolerated, but time should be governed by what occasions and opportunities might arise. As Gargantua sagaciously commented: 'I can conceive of no greater waste of time than to count the hours.' [...]

Furthermore, since the religious usually made the triple vow of chastity, poverty and obedience, here all had full leave to marry honestly, to enjoy wealth, and to live in perfect freedom.

As for the age of initiation, they stipulated that women were admissible between the ages of ten and fifteen, men between twelve and eighteen. [...]

To build and furnish the abbey, Gargantua paid in cash twenty-seven hundred thousand eight hundred and thirty-one shiny crowns in current coin. He undertook to pay yearly, until the project was completed, sixteen hundred and sixty-nine thousand crowns with the sun on the obverse and as many again with the seven stars. For the foundation and maintenance of the abbey, he settled in perpetuity twenty-three hundred and sixty-nine thousand nobles bearing the rose of York, free of all tax, burden or fealty, payable yearly at the abbey gate. These privileges were all corroborated by letters patent. [...]

The building was hexagonal; in each corner rose a great, circular tower, each identical, sixty yards in diameter. To the north, the river flowed past. [...]

The roof, of finest slate, was lined with lead and bore merry little figures of manikins and animals. The gutters jutted out from the wall between the casement arches; they were painted blue and gold down to the ground, where they ended in pipes which carried the water down to the river below.

This building was magnificent beyond measure. There were nine thousand three hundred and thirty-two suites, each with a salon, a study, a dressing room, an oratory

Between 1773 and 1775, Field Marshal Louis Georges Erasme de Contades commissioned what had once been a medieval manor house to be converted into the Château of Montgeoffroy. The château survived the French Revolution and is still privately owned. Some of the rooms are open to the public. The beautifully-preserved furniture and wall decorations allow visitors to see for themselves the exquisite taste of the former owners.

Overleaf: The eighteenth-century kitchen equipment at the Château of Montgeoffroy has also been preserved. The countless copper pots and pans in every imaginable size give some idea of the skills of the cooks who once worked there.

99

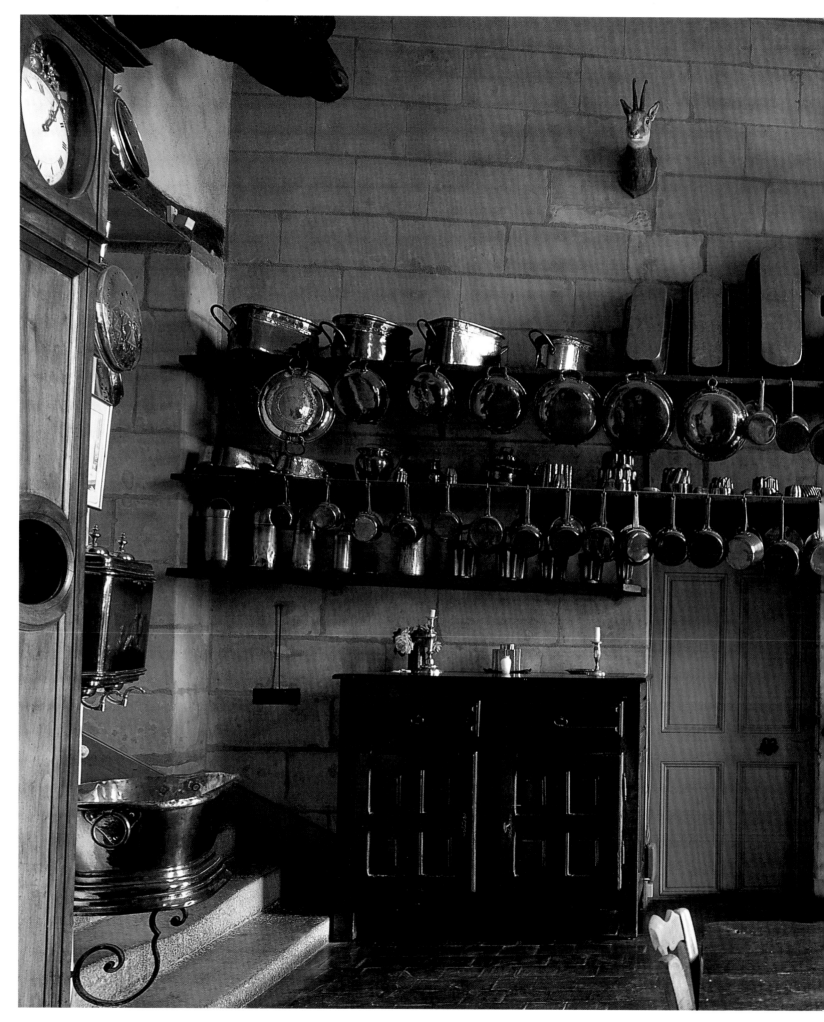

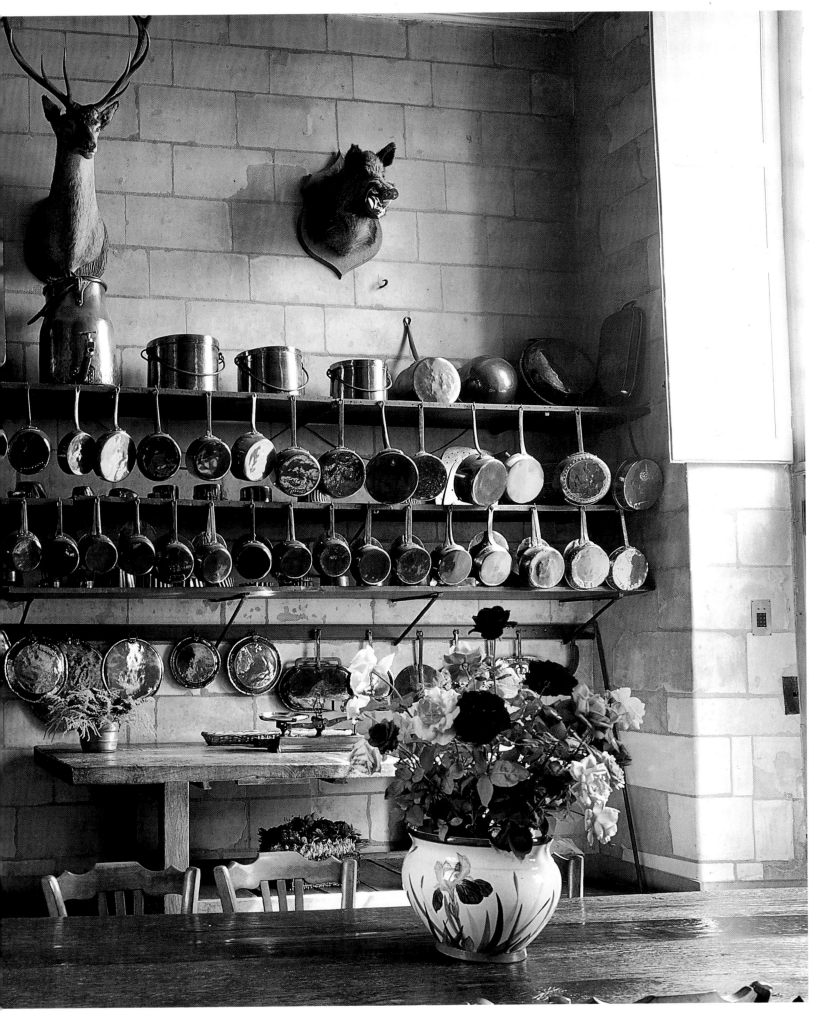

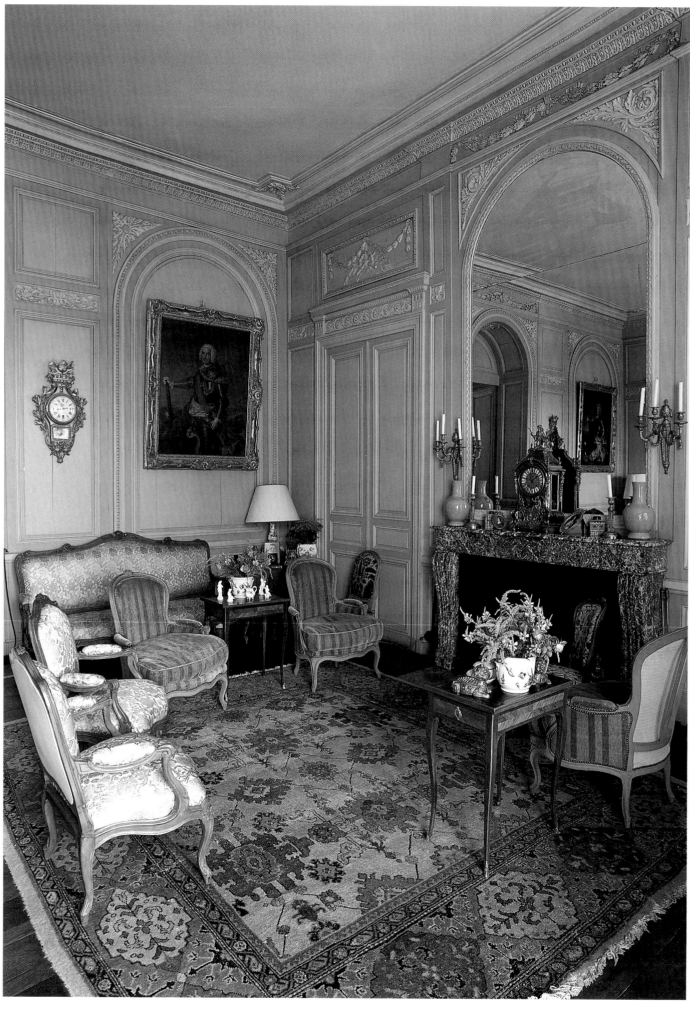

Montgeoffroy offers visitors an excellent impression of the refined and sumptuous interior decoration of a French château at the end of the reign of Louis XV.

and an exit into a great hall. In the wing between each tower was a winding staircase. The steps, grouped in units of twelve between each landing, were of porphyry, of Numidian stone, or serpentine marble, twenty-two feet long and three fingers thick. [...]

The ladies' quarters ran from the tower called *Arctice* to the *Mesembrine* gate; the rest of the abbey was reserved for men. For the recreation of the sisters there was, in front of their apartments between the two towers, the tilting yard, the riding school, the swimming pool and the theatre.

Near the river was a fine pleasure garden with a wondrous maze in the middle. Between the two nearest towers were playing fields and tennis courts. Close to the tower called *Cryere* an orchard offered a mass of fruit trees with, at its end, a great park abounding in venison. By the third tower were targets for longbow, crossbow and arquebus. Beyond were the stables, the venery with hounds and beagles and the falconry, under the charge of expert handlers and falconers. Every year new sparrowhawks, goshawks, gerfalcons, lanners, bitterns, and other birds of prey were supplied from Crete, Venice and Sarmatia. [...]

Their whole life was not ordered by law, statute or rule, but according to their free will and pleasure. They arose when they pleased. They ate, drank, worked and rested when the spirit moved them. No one awakened them, no one forced food or anything else upon them. So had Gargantua decreed. The only rule of the house was

'Do as Thou Wilt'

Thus when the time came for a man to leave the abbey he took with him the maiden whom he had chosen as his bride and they were married. And they lived together, as once they had lived in devotion and friendship in the abbey, loving each other as on the day of their wedding.

FRANÇOIS RABELAIS, 1532

A valley of the kings

I know of three valleys in the world which in the course of time have taken on a similar role, by which I mean a royal or imperial role: the Valley of the Nile in the days of the Pharaohs, the Rhine Valley and the Loire Valley.

There may be more but I personally do not know of them. In any case, I should think that there are only two which could possibly lay claim to such a high title: the valley of the Yangtze Kiang in China, and that of the Ganges in India.

When I say 'royal or imperial', I refer not only to the fact that at certain times political figures have chosen these valleys as their base, and displayed all their magnificence there. In my opinion the first three valleys mentioned have one thing in common; each was the kingpin of a culture, the place in which the splendid achievements of that very culture took shape. The Loire did not fulfil this role for very long. After the golden age, the sixteenth century, this extravagant way of life very soon declined, perhaps even disappeared altogether. Fortunately, however, it left behind some glorious traces: the châteaux. Furthermore, by some miracle these châteaux have, with the passage of time, escaped the ravages of the weather, the devastation wrought by man, and the terrible destruction of war. In this respect, the Loire Valley was more fortunate than the other two.

So it is that today we can survey this incomparable array of masterpieces, Azay-le-Rideau, Villandry, Amboise, Chenonceaux, Chaumont, Blois and Chambord, at close quarters and see their unaltered forms exactly as their builders saw them.

I said an incomparable array. And that is the absolute truth. For I know of no other collection of such important edifices squeezed into such a small space and yet so

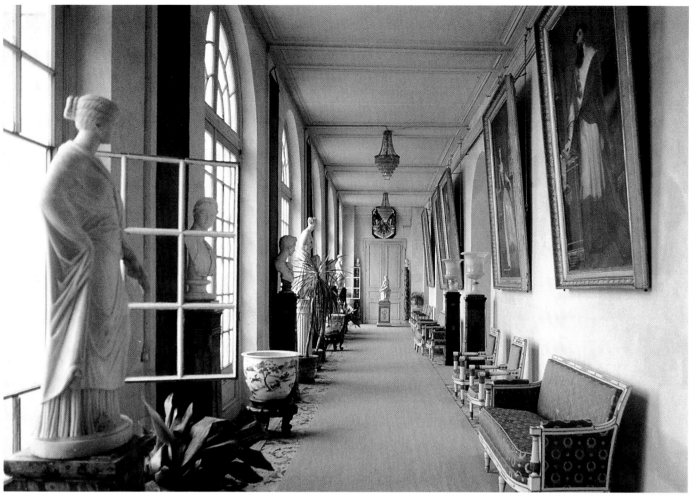

Above and below: Because of the remarkable state of preservation of its interior decor, the Château of Valençay occupies a special place among the Loire châteaux.

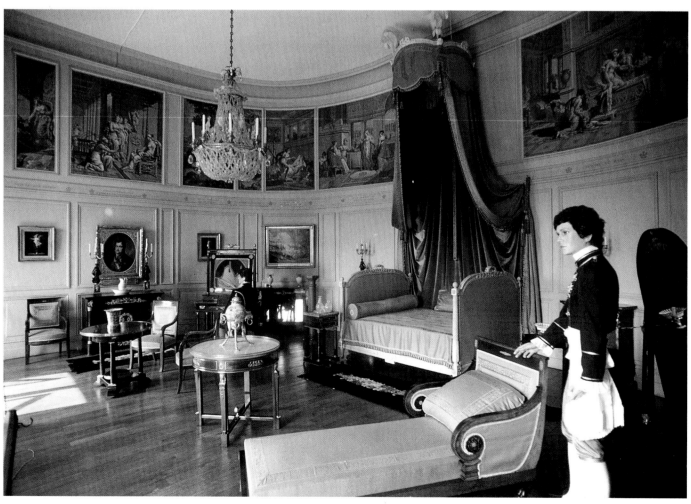

harmoniously arranged. Secondly, these châteaux do not conflict in period or style, but together make up an astonishing united family whose inherited features are much stronger than their differences. Finally, and in my view this is the decisive factor, this family only exists here, it is only here that it can be seen and appreciated by the onlooker. [...]

And, try as I may, I can think of nowhere else in Europe, and certainly not outside Europe, that can stand alongside the châteaux of the Loire. They embody the highest achievement of the Renaissance, that era that coincided with humanism. And it is worth noting that it was at this very moment that the French monarchy felt the need to identify itself with this valley, to reveal its splendour and its aesthetic and intellectual refinement. The names of Francis I, Rabelais or Ronsard have equal meaning for us and are illuminated by the same light. The honour accorded to art and literature by the leaders of the French Renaissance was no trivial passing fancy.

JULES ROMAINS, 1957

From Paris to Blois

All I can say of our impressions of the journey from Paris to Blois is that, short as it was, it seemed too long, and was as tiresome as this futile means of travel always is. We were, moreover, bored to tears by the company of two grain merchants, great, cackling windbags who had obviously made a lot of money and were very pleased with themselves. One, who wore a medal ribbon in his buttonhole was a jovial fellow, stocky, fat and powerfully built, with full lips and a raucous voice. He was the bold buyer, the speculator on a grand scale, the mayor of his parish, the deputy for his city, who would later become a minister. His neighbour, meanwhile, was a small, thin

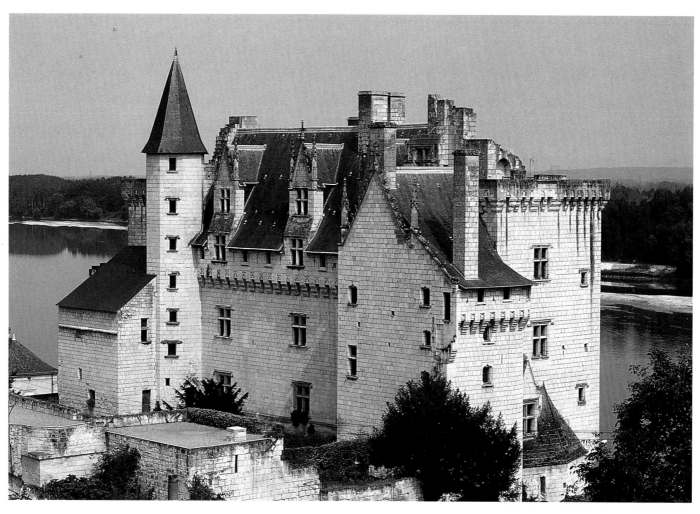

individual with wrinkled face, sunken mouth and prominent nose, who with an indescribably smug and malicious smile, tossed a sample of grain in the hollow of his hand. He was far more the grasping, shady dealer, the dogged worker, who scrapes the bottom of the money bag after he has taken out all the pennies, the obdurate man who loves money for money's sake and delights in trade for trade's sake; a very common type today, whose ambition is to cultivate grapes, but has no wish to drink the wine! Next to us sat a poor, sick, lame Englishman who seemed to be in the thrall of quite another metal than money; his little girl whose ugly face bore the mature aspect one often sees in motherless children, who was reading the *Vaudeville du Palais-Royale et du Gymnase*, in order to acquaint herself with the language, customs and tastes of France.

At Orléans we saw Monsieur Berryer, sitting at the buffet, filling his large stomach with food, and two agreeable young men got on, who must have belonged to some department of the administration; as different from one another as a fool is from an ass, or as insignificance is from emptiness.

Arriving at Blois, we were immediately overtaken by the recollection of the young poet who spent his days here. Walking through the silent, winding lanes, we thought of how, some twenty years before, he had sauntered here, observing the houses in order to set his Marion Delorme in one of them. From the air, the trees, the walls, the vague continuities and the individuals attached to a place that give it its colour and make up its soul, we sought to learn the secret of the great man in his prime; the time when his first collections of unknown poetry spilled out, its voluptuous stanzas entwining like creepers, its metaphors shining like the sun in their multiple rhythms and unbroken harmonies. How many thoughts transmuted to literature, how many realized dreams saw the light of day on this spot, on that river bank, under that tree,

Châteaudun has two faces: from the façade it looks like a fortress, while rebuilding during the Renaissance resulted in the much friendlier appearance of the side facing the courtyard.

The Château of Rivau also dates from the Middle Ages and was remodelled during the Renaissance. Rivau marked an important staging post for Joan of Arc on her way to Orléans, for it was here that her brave troops were provided with urgently needed horses.

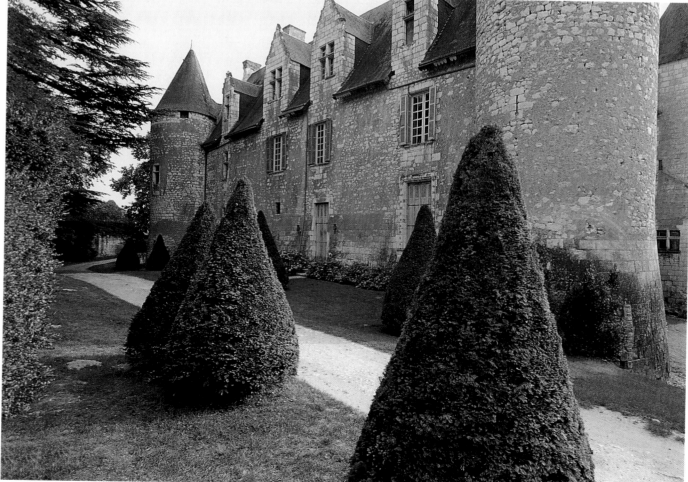

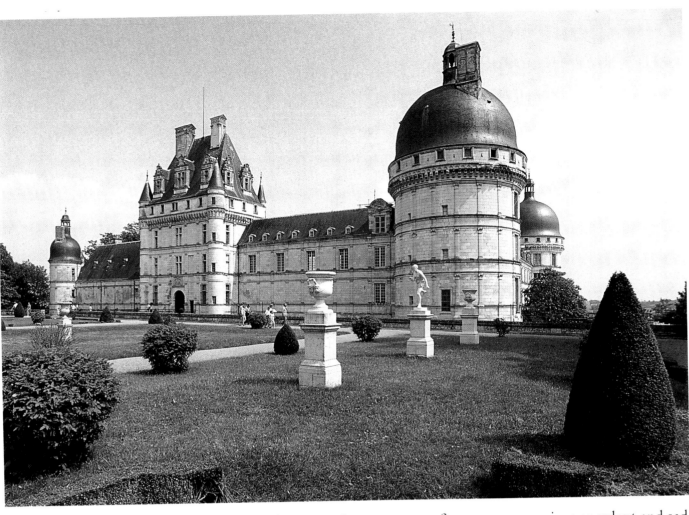

on damp grass one dewy morning, or even on fine summer evenings as ardent and sad as first love, when the sky displays great, broad streaks of light and flocks of birds cross the sky like fringes of gold!

Was this why Blois enthralled us? At the landing stage there is also a great avenue of elms with thick bushy foliage and strong branches, which seem deliberately to grow up from below, so that bagpipes can be hung from them. Real eighteenth-century elms, their branches spread so that one can dance in their shade to the violin of the village musician, who stands on a barrel, his foot tapping in time, while skirts fly in the wind, the buckles of dusty shoes come undone and the young fellows grab the girls around the waist, making them laugh with fright and grow dizzy with desire.

GUSTAVE FLAUBERT, 1847

Why I love Touraine...

The country, that eternal remedy for complaints of which medicine has no knowledge, was looked upon as the best means of rousing me from my apathy. My mother decided that I should go and spend a few weeks at Frapesle, a château on the Indre, between Montbazon and Azay-le-Rideau, with one of her friends, to whom she doubtless gave secret instructions. [...]

And so, on Thursday morning, I left Tours by the barrier of Saint-Eloy. [...]

In going to the Château of Frapesle, pedestrians and horsemen shorten the way by crossing plains known as *les Landes de Charlemagne*, waste land, situated at the top of the plateau which separates the valley of the Cher from that of the Indre, whence leads a short cut to Champy. [...] This road, which runs into the road to Chinon well beyond Ballan, skirts an undulating heath with no particular unevenness as far as the

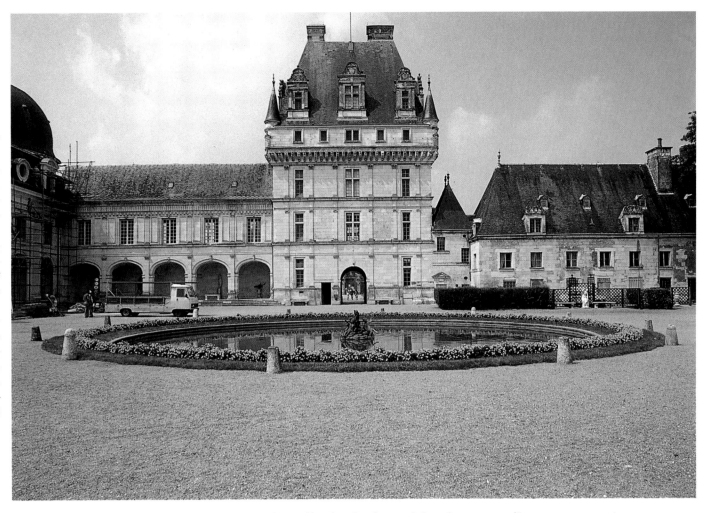

little district of Artanne. Here is disclosed a valley beginning at Montbazon, ending at the Loire, and apparently starting beneath the châteaux perched upon these double hills; a magnificent emerald basin in the bottom of which winds the Indre with serpentine movements. At the sight of this, I was overcome with a delighted astonishment. [...] At this moment, the mills situated on the falls of the Indre were giving voice to this quivering valley, the poplars were swaying in their glee, there was not a cloud in the sky, birds were singing, grasshoppers chirping, everything there was melody. Do not ask me again why I love Touraine. I do not love it as one does one's birthplace, or as one loves an oasis in the desert. I love it as an artist loves art. I love it less than I do you, but without Touraine, maybe I should not live any longer. Without knowing why, my eyes kept returning to the white spot, to the woman gleaming in this immense garden, as the bell of a convolvulus might flash amidst green thickets, only to wither at a touch. With soul astir, I went down to the bottom of this clump, and soon saw a village which the poetry overflowing within me disposed me to think incomparable. Imagine three mills set among gracefully outlined islands, wreathed with several clumps of trees in the middle of a meadow of water. What other name can be given to those aquatic vegetations, so tenacious, so beautifully coloured, that cover the river, surge above it, undulate with it, abandon themselves to its caprices and bend themselves to the river's storm as it is lashed by the wheel of the mills? Here and there rise masses of gravel where the water breaks, forming fringes in which the sun glistens. Amaryllis, water-lilies, bulrushes and phlox deck the banks with their gorgeous tapestry. A quivering bridge composed of rotten planks, the piles covered with flowers, the handrail set with clinging grasses and velvety mosses hanging over the river and never falling. Worn-out barges, fishermen's nets, a shepherd's monotonous chant, the ducks that were sailing amongst the islands or preening themselves on the coarse sand; millers' boys, their caps over their ears, busy loading their mules.

Left: Early twentieth-century postcard with a view of the little town of Vendôme.

Right: Early twentieth-century postcard of a street scene in the small town of Loches.

Each of these details gave wonderful charm to the scene. Imagine beyond the bridge two or three farms, a dovecote, some turtledoves, about thirty huts divided by gardens and by hedges of honeysuckle, jasmine and clematis; pungent dungheaps flourished in front of all the doors, some chickens on the paths – such is Pont-de-Ruan, a pretty village crowned by an old church full of character, a church from the time of the Crusades, such as painters seek for their pictures. Encircle the whole with ancient walnut trees and young poplars with pale yellow leaves, put some graceful buildings in the distant meadows where the eye grows bewildered beneath a hot, misty sky, and you will have an idea of the thousand points of view of this beautiful countryside.

I followed the path to Saché on the left of the river, while observing the details of the hills that adorn the opposite shore. Finally, I came to a park of trees, centuries old, that disclosed the Château of Frapesle. I arrived just as the bell was ringing for luncheon. After the meal, my host, never dreaming that I had come from Tours on foot, showed me over the environs of his estate, whence on all sides I saw the valley in all its aspects; here a peep, and there the whole of it.

My eyes were often drawn to the horizon by the beautiful gold ribbon of the Loire, where the sails appeared as fantastic figures which vanished, swept away by the wind.

By ascending a ridge, I was able for the first time to admire the Château of Azay, a diamond cut with facets, set in the Indre and mounted on piles hidden in flowers. Then, in the background I saw the romantic masses of the Château of Saché, a melancholy abode full of harmonies, too serious for superficial people, dear to poets with aching hearts. And so, I later learned to love the silence of it, the great hoary trees and that indescribable mystery pervading its lonely valley. But each time I recognized the tiny château – noticed and singled out at my first glance – on the slope of the neighbouring hill, I stopped there with delight.

HONORÉ DE BALZAC, 1836

The 'Tour de l'Horloge' in Amboise. Charles VIII had the clocktower built over the medieval city gate. Today, it marks the start of the pedestrian zone. Old photograph.

111

Orléans. Rue des Carmes ('street of the Carmelites') at the beginning of the twentieth century.

Blois. Early twentieth-century street scene.

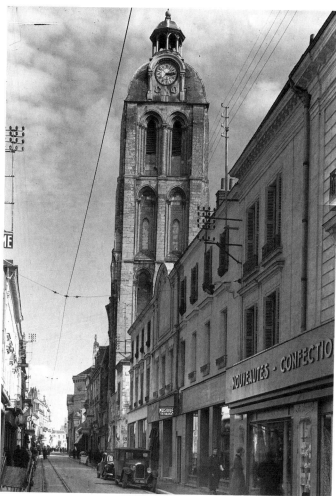

'Ah, my dear fellow!', said Balzac thoughtfully, 'if only you knew how little one knows!'

A handful of grass

He devoured another two macaroni pies and said: 'When I was thinking about writing *Le Lys dans la Vallée*, I wanted to create in my book a wonderful picture of the countryside, as Cooper does. I was so taken with the idea that like some pantheistic pagan I immersed myself in nature. I completely convinced myself that I was a tree, a horizon, a spring, a star, even light itself. And now that science provides us with so many tools, I tried to find out the names and characteristics of all the many plants that I might slip into my descriptions. My greatest interest was in the little grasses that we walk on, without giving the matter a thought, whether by the roadside, in the fields, or wherever it may be. First of all I asked my gardener. 'Ah, Monsieur,' he replied, 'nothing simpler.' 'Well, then,' I said, 'if it is so simple, tell me about these grasses.' 'This here is lucerne grass, this one is clover, and that one is butterfly weed...' I stopped him: 'No, no, that is not what I mean! I want to know what all these millions of blades of grass are called – here, I've pulled up a handful of the stuff!' 'Yes, Monsieur, that's grass all right.' 'But what do you call each of these myriad grasses, long or short, straight or crooked, smooth or prickly, hard or soft, wet or dry, pale or deep green?!' 'It is just as I told you, all grass!' It was simply impossible to get any other explanation or indication out of the man! The following day a friend visited me, one of those persons who have travelled around the world. I asked him the same as I had asked the gardener the evening before: 'You are a botanist and a globetrotter. Do you know about the varieties of grass on which we step every day?' 'But of course', he replied. 'So tell me the names of these!' I said. I pulled up a handful of grass and gave it to him. 'That is – er... well, you know,' he said, after studying the little clump for a few minutes, 'the only subject of which I have a thorough knowledge is the flora of Malabar... If we were

in India I could tell you at once the names of thousands upon thousands of plants, large plants, small plants, but in this case...' 'In this case you know as little as I do!' 'In this case, I must admit it is so,' said my well-travelled friend. 'Then you should be ashamed!' I retorted. The words simply slipped out. Infuriated, the next day I hurried to the Jardin des Plantes. There I consulted one of the institute's most learned professors. 'But Monsieur Balzac', the famous naturalist replied, 'what do you wish me to say? Here we are only concerned with the genus *larix* and the no less interesting *tamarix*, and were we to spend our time on these paltry, insignificant grasses our lives would never be long enough. This is more a matter for the greengrocer. Joking apart: where is your novel to be set?' 'In Touraine.' 'Well, then! Any farmer there will tell you what no professor here possibly can.' So I went to Touraine. But I have to say that the farmers there were just as ignorant as my gardener and my well-travelled friend, but no more ignorant than the professors at the Jardin des Plantes. Thus, when I wrote *Le Lys dans la Vallée*, I could not describe those green meadows as exactly as I might have wished, and I would so much have liked to picture each little blade of grass in the deliberate and colourful way of the Flemish. And now you are advising me to rely on seasoned travellers to tell me what I need to know if I want to describe a seascape! [...]'

LÉON GOZLAN, *c.* 1850

A journey through France

The Loir divides into many arms, embracing rural and built-up islands. In the eccentric but homely, friendly but stern, narrow but broad town of Vendôme with its ivy-covered walls, at the old wash-houses on the river, women even now kneel to do their washing and plunge their arms into the beautiful water. [...] Then I walked through the

narrow streets, listened to the presses working in a small printing works and thought of Balzac, who went to school in Vendôme and described it in *Louis Lambert*. In front of a café, the square was sandy and sunny: there was not a soul in sight. I observed the French universities' printing works. A girl in a leather jacket came along on a bicycle and disappeared through the gateway to the printing works. I found the Lycée Ronsard. I could sense it: this was still a strict school. The heavy door was closed. Beside it was the beautiful commemorative plaque to Ronsard, glorifying him as the father of modern French poetry, an honour that many poets might question, but the school seems to agree. I knocked and asked to be let in. In an archway leading to the school yard was the head of Balzac as a schoolboy. A small but eloquent wall plaque, a rebellious face. [...] An arch led to a basketball court on the old parade ground of the former mounted rifle regiment. A war memorial showed the colonel riding out through this very gate for his final engagement: the colonel and his men fell in 1914 in the defence of Lille. Time and again in France one is confronted with the horror of the First World War. It afflicted far greater suffering on the country and haunts the memory of the French far more deeply than the second tragedy, despite all the humiliations, atrocities and destruction. The defeat of 1940 saved the life of the nation, it did not bleed to death, and the Resistance during the Occupation testified to the proud spirit of the French.

Orléans, city of glorious renown! I thought of the Maid, of Schiller's idealized creations, I was expecting the Middle Ages, a castle, Christianity, French kings. I had forgotten that Orléans was decimated. The roads leading into the city are still handsome, grey walls, white walls, plebeian walls, aristocratic walls, estates behind flower-festooned walls, like ancient graveyards where manor houses sleep. But then it turns into an ugly, misshapen, muddled, almost chaotic, urban sprawl. Commonplace, imperfect, very ordinary, drawing-board buildings seem to yawn with boredom. The surviving streets

are dominated by 1900-style office buildings, like chamber pots decorated with lilies. The restaurants serve the kind of food one might expect from an up-market station buffet. They only exist because a few outsiders, seduced by the legend, come to Orléans and they have to eat. The Maid of Orléans sits on her horse, leering suggestively across at the Café Rotonde. In the Café Rotonde, American servicemen, black and white, crusaders, defenders of the faith, are killing Sunday afternoon, and Joan of Arc does not remind them of the siege, she makes them think about girls. There are girls in Orléans and they all live in boarding schools, and I don't know why that is. Nuns with downcast eyes herd their young flocks past the Rotonde.

The Loire is simply a joy, a tranquil yet unrestrained waterway. For long stretches it lies like an indolent beauty on a frowzy bed who, after whoring with the kings, surrenders herself to the quiet anglers. Its sandbanks, its islands, could be home to the gods. Its colours come from the red poppy, the cornflower, the lupin. Flowers escort the river like outriders. You could compare the Loire to the French summer. It needs sunshine. Under an overcast sky, the mind recalls that its history has its dark side, its sinister moments stained with blood. The famous, much-eulogized châteaux were – with some exceptions – designed for pleasure and not fear, although some fear has to be engendered in order to indulge in so much pleasure. [...]

The ancient city of Tours, home of Rabelais, Balzac and the young Descartes, seems also to have lost forever the lustre of its golden age in the most recent devastation. The main street, the Rue Nationale, leading from the Loire, from the Pont Wilson, like a straight line drawn through the city, has been rebuilt. It is lively, but faceless. But appearances are deceptive and even the new Place du Maréchal Foch is just like the old France, at least in the evening. In front of spotless hotels and brightly-lit cafés, the citizens sit. The trees have grown again and are once more kept neat and trim. But it is in the Place Jean Jaurès that life is sweetest – a popular forum, named quite rightly after a friend of the people, a martyr for peace. Avenues of trees, cafés, brasseries, artisans, sales reps, postmen, army conscripts, young people, mothers, swarms of kids. They drink beer, they drink lemonade, and they all go home to eat. The restaurant food is bad and expensive, or just bad. Even though excellent wines are grown around Tours, the local restaurateurs stock up with miserable, factory-produced stuff. Nevertheless, I stayed in Tours, I saw the enchanting Place Plumereau, the Rue du Change, houses, weary with age but still gracious, from the days of Louis XI, lived in, loved, loathed. Rabelais' world, but still home. Smells of supper cooking. Children's voices from behind slightly-open shutters and squadrons of kids on motorbikes roaring and zooming round the tight corners. Narrow alleyways down to the river. Voices getting ready for the night fill the air like a ghostly choir. Across the Loire, wind, clouds and flashes of lightning from a distant storm. In the daytime, vegetables are trundled across Place Plumereau to the nearby markets. Beggars, stray dogs and bourgeois cats appear. Men and beasts root through the dustbins, squabbling over the bones. A bag lady finds a sunshade, opens it, promenades coquettishly and takes her place on stage. The other beggars encourage her, clapping their hands and whistling. The backdrop to all this is a tower, barely held together by crumbling mortar. Tramps sleep on the river bed left exposed after the floods recede. Bottles, newspapers, bundles on the grass and sand. The great square on the bridge across this arm of the river is named after Anatole France. A monument to Rabelais. I am surprised how monkish he looks in his white habit. On the other side of the square is the Descartes monument. He, on the other hand, is portrayed as a Baroque cavalier deep in thought, altogether the great man, and the *cogito ergo sum* on the plinth now sounds strangely presumptuous, although one might assume that it was added posthumously by some professor or other. He thought, therefore he was. [...] I drove to La Béchellerie, Anatole France's country home, now deserted.

Angers. Place du Ralliement in the early twentieth century. The spires of the Cathedral of Saint-Maurice can be seen in the distance.

Along a seemingly endless narrow path between high garden walls built of close-knit stone, suddenly there was the poet's property, and it was a real *ferme*, an authentic French farmhouse. There was a grey horse in the field. A tall gate. The bell didn't work. I clambered over the gate, looked down into the garden and was mistaken for a knight by the custodian's small son. 'Un chevalier, un chevalier', cried the little lad, but when his father opened the door and the knight was nowhere to be seen, he burst into tears. A real country garden, but there was a goddess over the well. A sleepy summer scene, like something in a French novel. The room was cool and dark; it was only when the custodian pushed open the shutters that light flooded in. Threadbare splendour, the antiques and curiosities Anatole France brought home from his travels. There was something ghostly about the casts of hands lying about all over the furniture. The poet's hand, the hand of a Nobel Laureate, his wife's hand, the hands of his many women friends. White shadows and all dead, dead, dead. Innumerable photographs, with France always striking the attitude of the great and famous man. Several studies. Servants' rooms. Plenty of vanity. But in the little room where he died only a very modest bed. But next door an opulent Renaissance four-poster from Italy lay in mourning. (France slept in it at his Paris home.) Books, busts, the past. The luminaries and enthusiasms of the turn of the century. Forgotten names, pages no longer legible. But where else could you now find anything like the faded old newspaper with Zola's article *'J'accuse'*? [...]

117

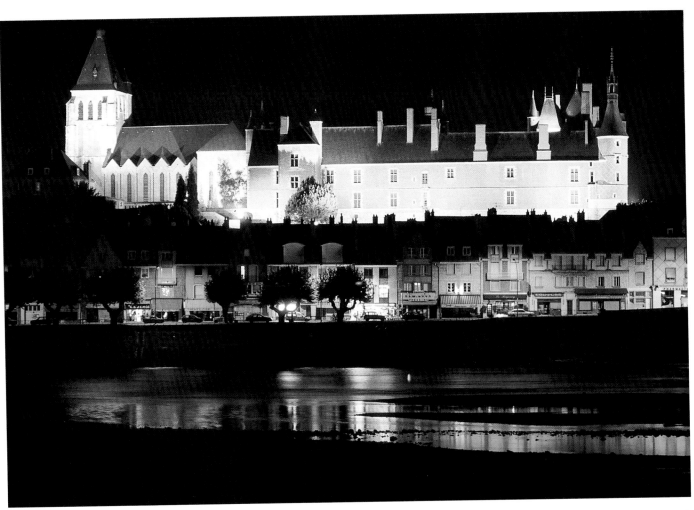

Saumur was once called the golden city, or so I had been told. Its radiance was said to have lit up the landscape for miles around. Saumur, when I saw it, surrounded by red poppies, looked grey under a cloudy sky, its old buildings dreary under their new coat of yellowish plaster. The château, of course, stands romantically on its mound as all châteaux do. You enter the fortress and are allowed to go down to see the dungeons, to breathe the air of the tomb. Above the old death chambers there are two museums: the museum of porcelain and the horse museum. Guided tours are compulsory.

In Angers, there was a gathering of the French ex-servicemen's association. You could see them in groups on every street, most of them old men. Veterans of the First World War. Countrymen, their faces reddish brown from years of working the land, stout shoes, rustic black Sunday suits, with basque berets and a badge. They looked to me like prosperous landowners, the sort who energetically champion their own interests, do deals, influence the elections, think twice about every sou they spend, like the skinflints Balzac described. They sat in the dining room of a hotel on the market square. They sat at long tables, seated according to village or interest group. A television camera was filming them. They were an important voice. They could be heard in Paris. They drank the wine that they themselves had grown, and devoured the meal produced by hard work in their fields and cattle sheds. I thought about the slaughter at Verdun, and all the great war cemeteries in the north, which these men had managed to escape. They visited the Château of Angers, whose walls and towers were thought to be invincible. I walked with them along the battlements, saw sweet France lying in the bend of the Loire, spoke to her protectors and did not understand them, these men who stood impervious before the apocalyptic imagery of the great tapestry displayed in the château's basement museum.

WOLFGANG KOEPPEN, 1979

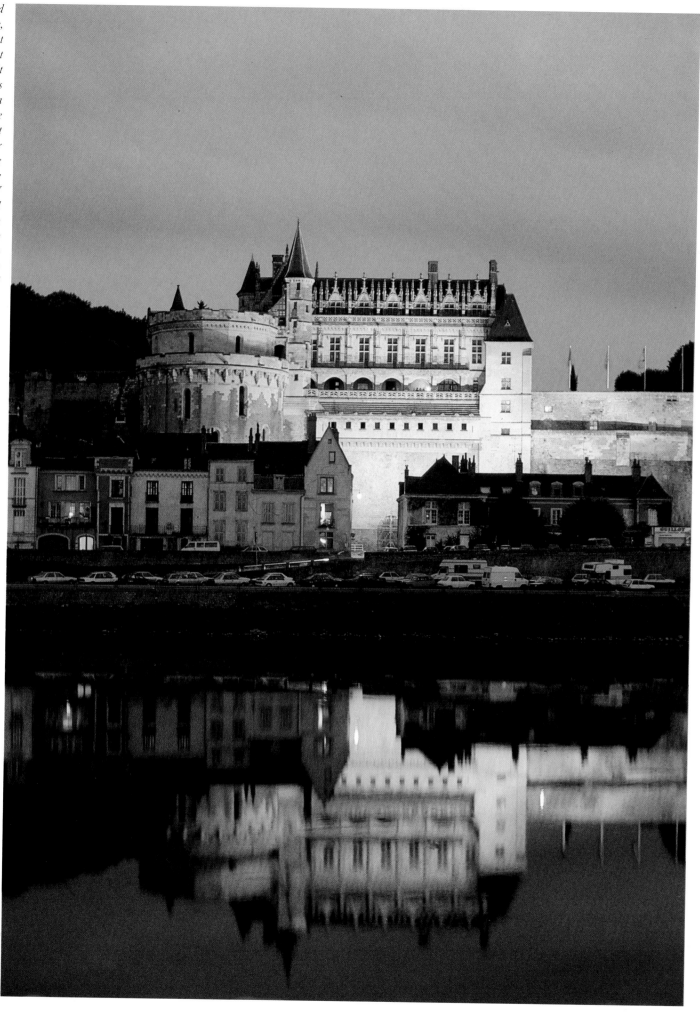

The massive round tower of Amboise, seen, on the left, set against the elegant royal apartments. At one time it was possible to drive a horse and carriage directly from the street to the château's inner courtyard high above the Loire. While Emperor Charles V was visiting Francis I in 1539, he narrowly missed death in the tower when the flame from a sentry's torch set fire to the wall hangings.

Overleaf: Celebrations on a summer night at Amboise now turn the magnificent building into a tourist attraction, at the same time providing an insight into the splendour against which life at court unfolded. Amboise was, however, the setting for tragic events. Here Charles VIII died in 1498, following an accident. And in 1560 Catherine de Medici had dozens of Huguenots brutally executed.

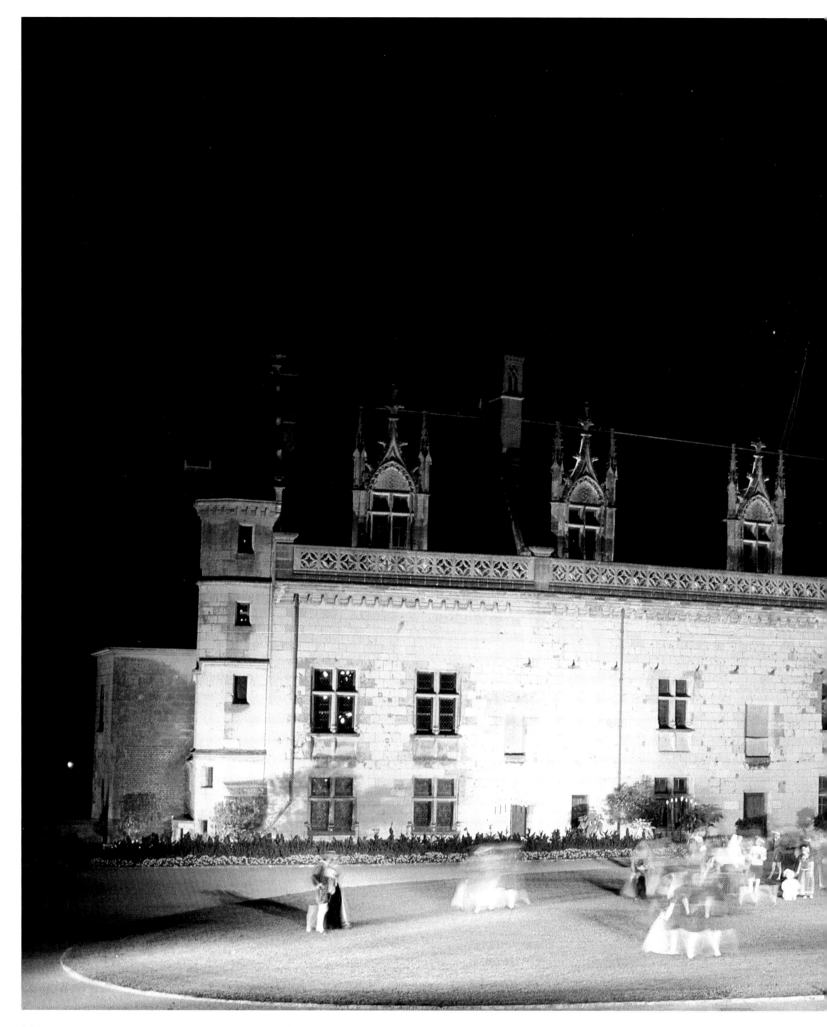

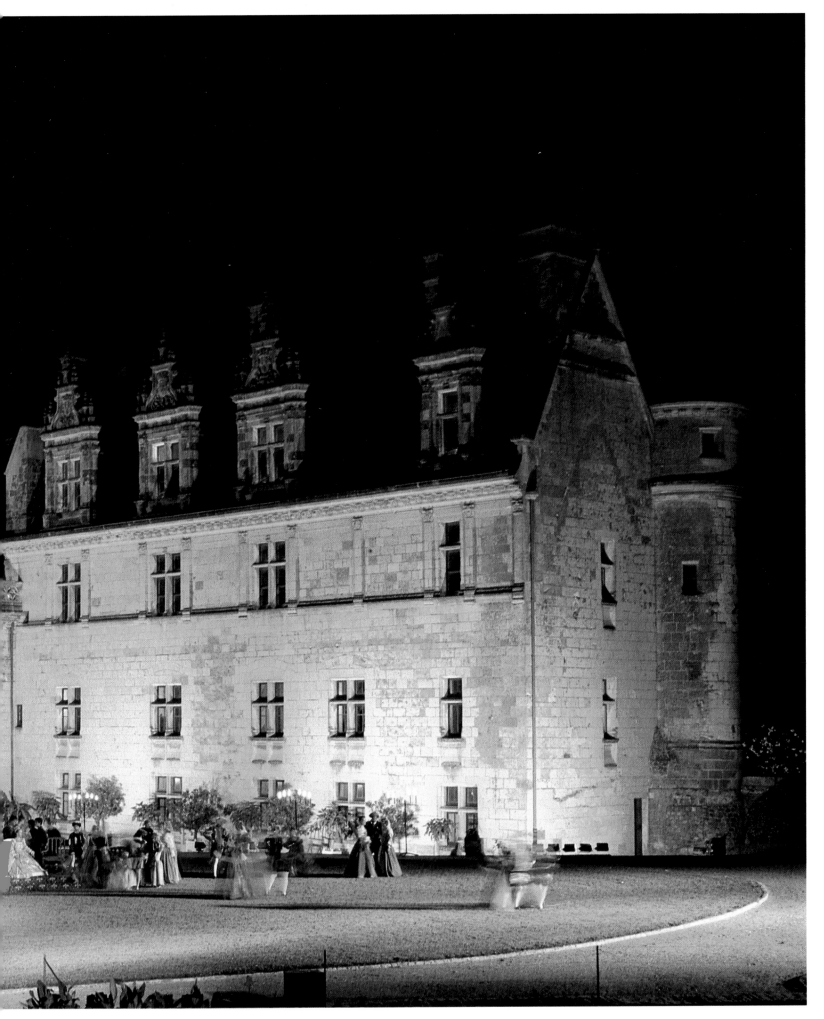

It was not only the lords of the châteaux who appreciated sought-after waterside locations. In the old quarter of Amboise, many small, elegant houses were built on more modest plots along the river.

Returning from his Italian campaign in 1495, Charles VIII brought with him architects and artists from Italy. Among them was the landscape gardener Pacello, who laid out the floral carpet at Amboise, overlooked by the 'Logis du roi' – king's apartments (left). Now set apart within the château complex, in the sixteenth century the chapel of Saint-Hubert was still part of the section of the main building housing the queen's apartments. Leonardo da Vinci is buried here (right).

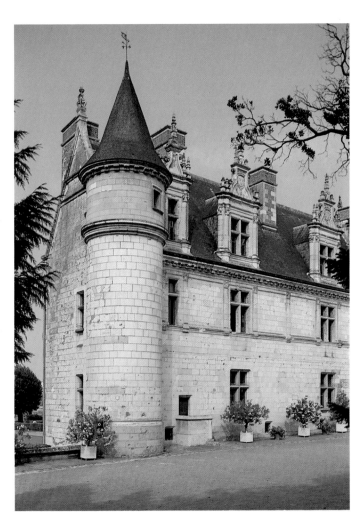 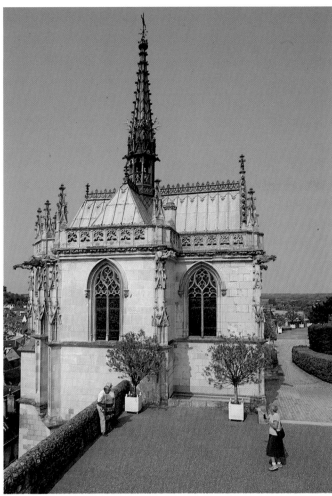

A restaurant in Amboise promises the delights of French cuisine savoured in the 'garden of France'.

123

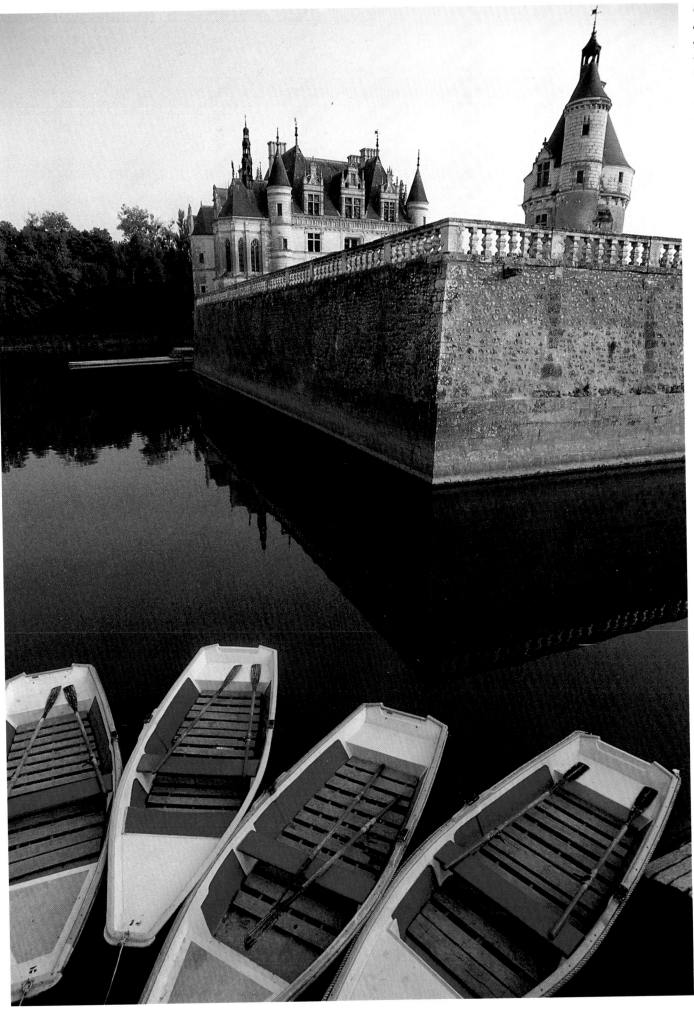

Chenonceaux. A drawbridge leads across the moat to the terrace on which the medieval fortress of Chenonceaux once stood. All that survives of the old building is a single tower (on the right of the photograph).

Chenonceaux. The Renaissance château, built for Diane de Poitiers, mistress of Henry II, was laid out on a square ground plan. This section of the building was completed before Diane took up residence. A keen sportswoman, Catherine de Medici's rival commissioned the construction of a bridge to the opposite side of the Cher, so that she could ride in the surrounding countryside.

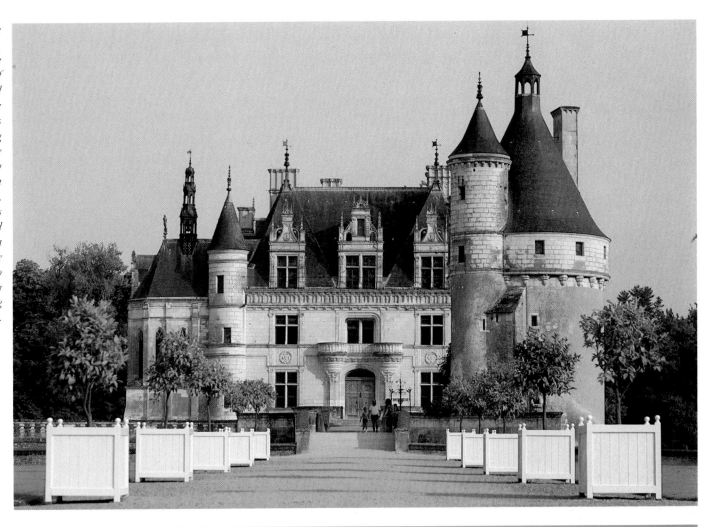

One of the most original examples of Renaissance architecture was built in several stages. After Henry II died and Diane de Poitiers was banished to Chaumont, Catherine de Medici built a gallery over the bridge at Chenonceaux, to be used for banquets and receptions.

Overleaf: In old paintings, the niches along the gallery at Chenonceaux are seen to contain sculptured figures. Now they are filled with plants. In what now seems a rather austere atmosphere, feasts of unbelievable grandeur were held in the sixteenth century.

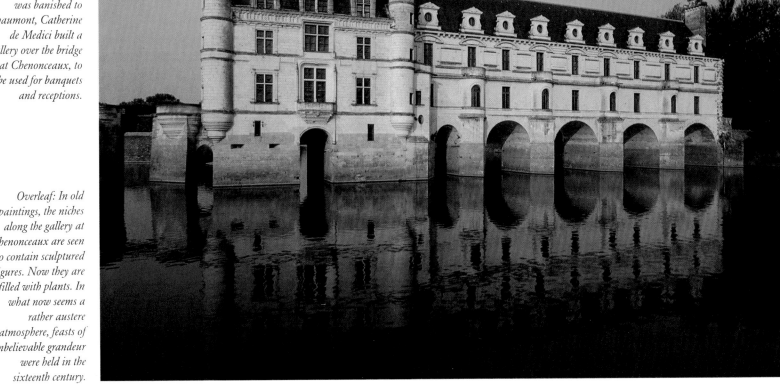

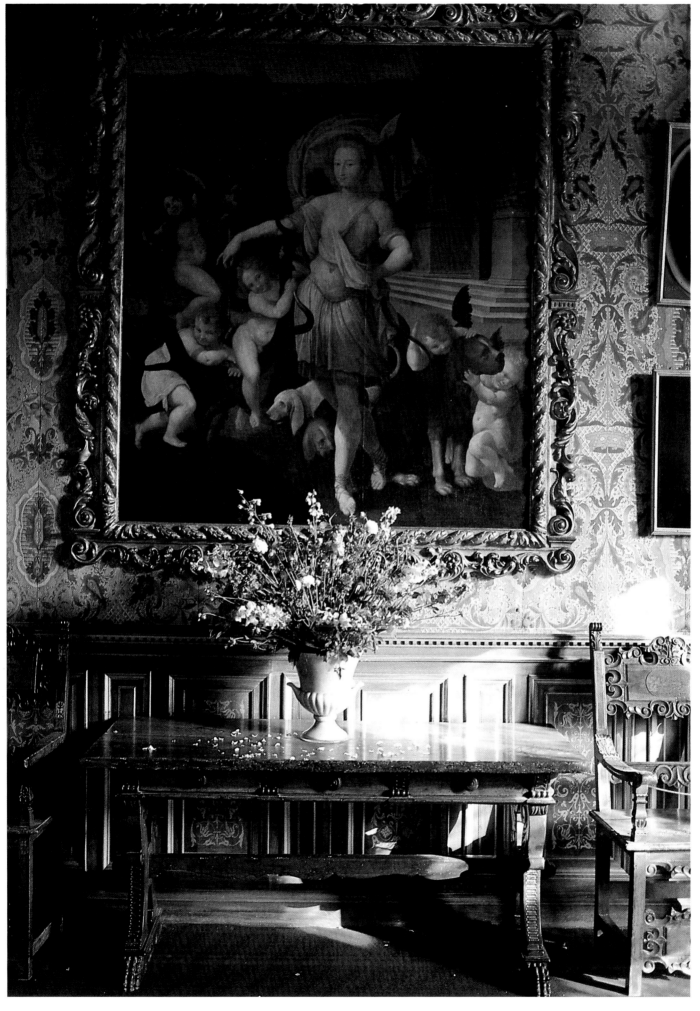

This room on
Chenonceaux's
ground floor is named
after Francis I. Off-set
by beautifully-painted
canvas wall coverings
imitating sixteenth-
century leather
panelling is a
painting of Diane de
Poitiers as Diana the
Huntress. This
portrait of the mistress
of both Francis and
his son Henry II is
attributed to the
Italian master
Francisco
Primaticcio.

Catherine de Medici's 'green cabinet' at Chenonceaux is as tiny as her library which adjoins it. A narrow door (on the right of the photograph) leads from the cabinet to the so-called Diane de Poitiers room.

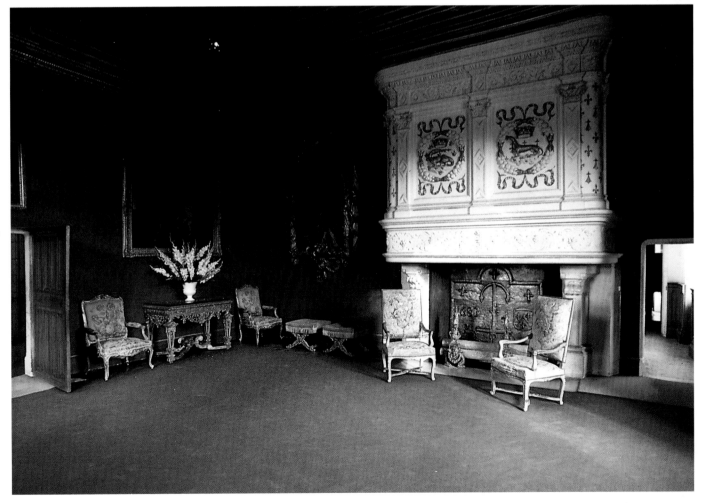

The great fireplace in the Louis XIII Salon (also known as the Louis XIV Salon), adorned with the royal emblems – the salamander of Francis I on the left, and the ermine of Claude de France on the right – was restored in the nineteenth century. Next to the fireplace, in an ornate gold frame, is a portrait of Louis XIV by Hyacinthe Rigaud.

129

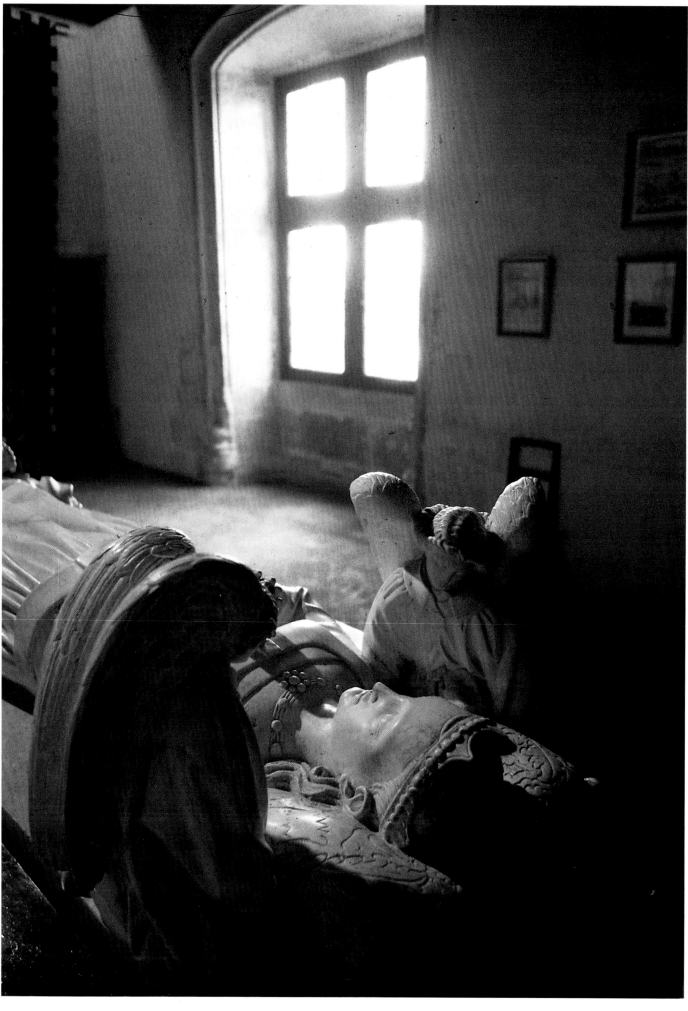

Agnès Sorel, mistress of Charles VII, is reputed to have made generous donations to the collegiate church at Loches to guarantee her burial there. When she died in 1450, the priests appealed to the king to lay her to rest in the château rather than in the church. His Majesty agreed, on condition that they repaid to him all the money Agnès had given them. Her tomb remained in the church until the French Revolution and was only later removed to the château. It shows a life-sized effigy of Agnès, watched over by two angels.

Maurice de Talleyrand-Périgord was grand chamberlain to Napoleon Bonaparte and his foreign minister. At Valençay he entertained foreign guests and diplomats, and the château, rearranged in Empire style, provided a prestigious meeting-point for distinguished representatives of the aristocracy and the world of politics.

A reproduction of the sleeping Ariadne, the original of which is in the Vatican, adorns a niche at Valençay. According to legend, the Cretan goddess of nature gave Theseus the thread which enabled him to find his way out of the labyrinth.

131

TRAVELLING ALONG THE LOIRE VALLEY

The sights in the Loire Valley line up in such a way that it is best to take an east-to-west route. If you only have a few days to spare, you will probably be limited to the most important of these. But it is well worth exploring the treasures of the Loire in a more leisurely way and making a few detours to appreciate all the wonderful diversity of the region. The suggested itinerary is for a trip of about fourteen days.

STARTING POINT: THE ORLÉANAIS

Sancerre Wine buffs might like to begin their tour at Sancerre in order to pay their respects to the fruity white wine produced here.

Gien You might like to linger a while in the little town of Gien, with its traditional porcelain factories. The château, built in the fifteenth century for Anne of Beaujeu, now houses an international hunting museum.

Sully-sur-Loire Another suitable starting point is Sully-sur-Loire. Apart from a few modifications carried out during the Renaissance, the château dates from the fourteenth century and is a typical example of the feudal architecture of the high Middle Ages: a heavily fortified castle complex with numerous towers, surrounded by water. Maximilien de Béthune, Baron of Rosny, bought the château in 1602 and changed its name to Sully. He was unfailingly loyal to Henry IV, serving as his finance minister for many years. It was largely thanks to his endeavours that the impoverished state finances were once again set on a firm footing. As a token of his gratitude, the king elevated him to the rank of duke. In the eighteenth century, when his controversial writings caused him to be banished from Paris, *Voltaire* was exiled to Sully for some time.

Saint-Benoît-sur-Loire No matter where you choose to begin your journey through the Loire region, you should not miss the famous Romanesque abbey church of Saint-Benoît-sur-Loire. In the early Middle Ages, the abbey was still known as Fleury. The name was changed in the seventh century, when the relics of Saint Benedict, the father of western monasticism, were brought here. The saint's mortal remains were carried to safety, after the Saracens destroyed the monastery at Monte Cassino in Italy. The prestigious relics soon began to enhance the abbey's reputation. In Charlemagne's day, it was one of the most respected educational establishments in the empire. After being repeatedly plundered by the Normans, the abbey launched upon a new phase in the late tenth century. Work on Abbot Gauzlin's ambitious project, the *West Tower*, began in 1026, and became one of the first early Romanesque examples of the use of masonry consisting of whole stone blocks, rather than rough, undressed stone.

As far as sculpture was concerned, the tower was also exceptional; extending over two levels is a series of 128 capitals decorated with figural and ornamental carvings. Although crude and unrefined, this is one of the oldest French Romanesque examples of three-dimensional ornamentation, which paved the way for the sculptors of neighbouring Burgundy. The second oldest part of the church complex is the eastern end with its spacious transept, rectangular choir and the ambulatory with radial chapels, running around the high, semicircular apse. This section dates from the late eleventh century. The central basilica between the west tower and the choir was built at the end of the twelfth century. With work constantly interrupted, it was not until the beginning of the thirteenth century that the church was finally consecrated. Despite the noticeable divergences between parts of the building dating from different periods, the whole church gives an impression of surprising unity. An enormous ninety metres long, it is also the largest Romanesque structure in the entire Loire region.

Germigny-des-Prés Only a few minutes away from Saint-Benoît, the chapel of Germigny-des-Prés offers art lovers France's best-preserved example of Carolingian architecture. In the ninth century, it stood in the spacious grounds of the house, built for Theodulf, Abbot of Saint-Benoît, who was also Bishop of Orléans and one of Charlemagne's closest advisors. After Charlemagne's death, however, the learned Theodulf, a member of an old family of west Gothic descent who came to the Loire from Spain, fell from grace and was banished.

The chapel is all that remains of the home that provided a refuge for Theodulf. Both the architecture and the mosaic show

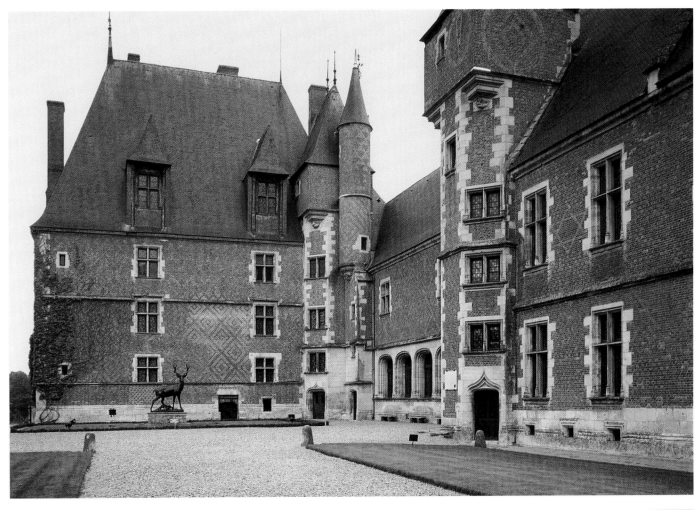

Gien. For many travellers, this traditional porcelain-manufacturing town is the first port of call on their tour of the Loire Valley. The château houses an interesting hunting museum.

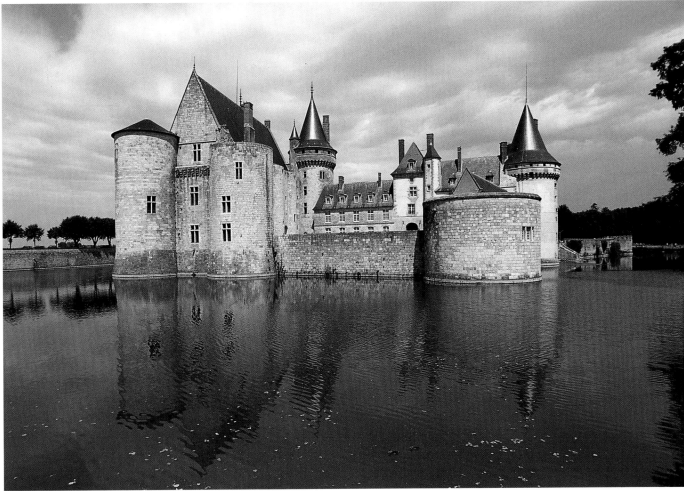

Visitors who prefer to bypass Gien can pick up the château trail at Sully-sur-Loire. The château's special charm lies in its watery location.

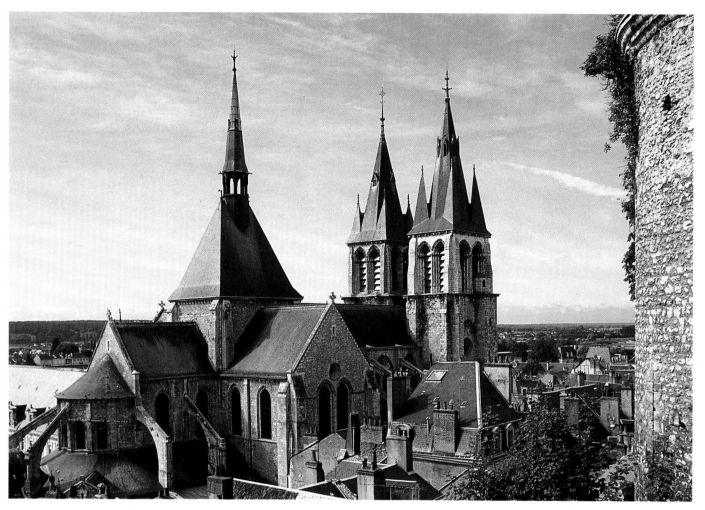

From the château of
Blois, there is a good
view of the old town
with its narrow,
winding streets and
the towering Gothic
Saint-Nicolas church.
The choir, transept
and one bay of the
nave of the former
abbey church date
from the twelfth
century. The rest of the
building is thirteenth-
century.

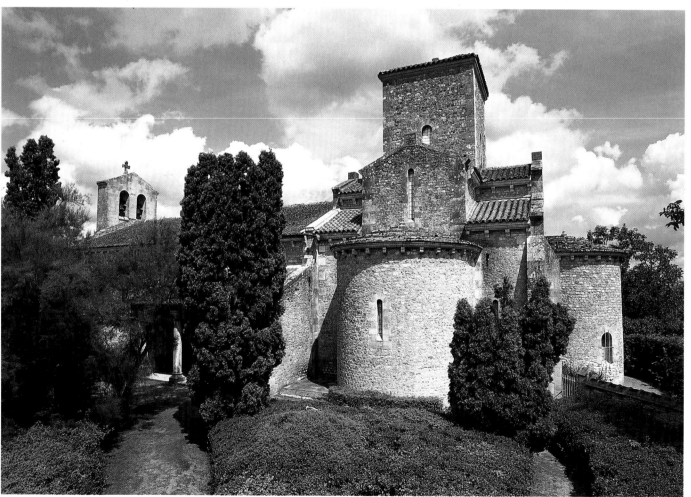

A view from the east
of the Carolingian
church of Germigny-
des Prés. From this
angle, the monument
gives the impression of
a centrally-planned
building, which is, in
fact, what it
originally was. The
nave at the west end
was only added later.

Blois. A view along Rue Denis-Papin, from the Denis-Papin steps with its colourful circular flower bed. The 121 steps lead from the lower to the upper town.

clear Byzantine influences. The *east apse* is decorated with well-preserved and carefully restored mosaic. Comprising some 130,000 coloured stones, it portrays the Ark of the Covenant, watched over by two cherubim, members of one of the highest orders of archangels.

Orléans Leaving from Germigny and taking the road through Châteauneuf, the historic city of Orléans is a half-hour drive away. Those accustomed to the fascination of the ancient quarters of some French cities will be disappointed by the lacklustre atmosphere of Orléans. While most cities in France came off lightly during the Second World War, Orléans suffered severe damage. Its reconstruction cannot be regarded as a resounding success. Nevertheless, there are places of interest that make it worth a visit. The Gothic *Cathedral* is visible for miles around. Begun in the thirteenth century, building continued on and off for several centuries, until it was finally completed in the nineteenth. Despite the passage of time, the builders stuck to the original plans, so that Sainte-Croix looks like a close relative of the Ile-de-France cathedrals on which it was modelled. Diagonally opposite the Cathedral, the *Town Hall* epitomizes the height of the French Renaissance. Within these walls, Francis II died in 1560. His young widow, Mary Stuart, Queen of Scots, thereupon returned home, where her troubled relationship with Elizabeth I of England led to her famously tragic fate.

Continuing along the right bank of the Loire, *Meung* is a pleasant place to linger. The thirteenth-century château was an alternative palace for the Bishops of Orléans until well into the eighteenth century.

Beaugency Close to the Orléanais-Blésois border, the traveller comes across Beaugency, another town steeped in history.

In 1152, the Council of Beaugency annulled the marriage between Louis VII and Eleanor of Aquitaine, so enabling the ambitious duchess to become the wife of Henry Plantagenet. Yet another memorable council met in Beaugency. It was here in 1104 that Philip I was excommunicated for disowning his lawful spouse and forcibly abducting the wife of the Duke of Anjou.

Here, historical events of the past are brought to life against a well-preserved medieval backdrop. Looming over it all is the highly evocative eleventh-century *keep*, one of the finest examples of an early fortification. Standing in its shadow is the Romanesque church of *Notre-Dame*, where both the aforementioned Councils of Beaugency met. The small château nearby (now the town hall) dates from the early Renaissance and does not quite harmonize with the keep.

Talcy Further along the road towards Blois, turn a little way northwards to the charming Château of Talcy. Although from the outside the medieval walls may appear inhospitable, the Renaissance furnishings are remarkably well-preserved. Talcy's other unusual fea-

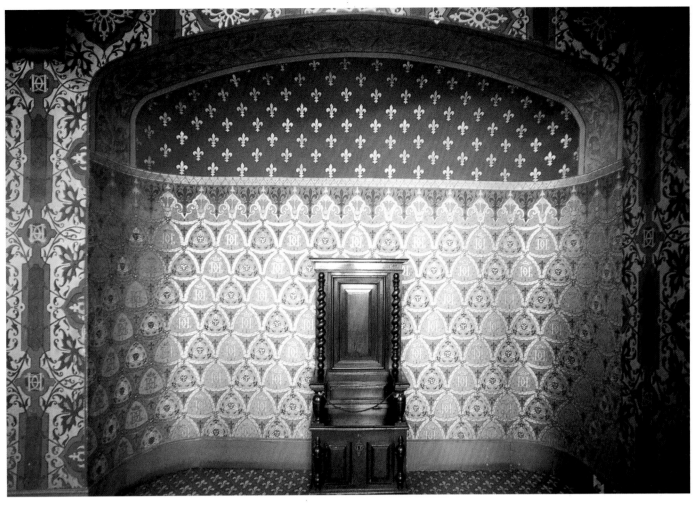

tures are its sixteenth-century *dovecote* and four hundred-year-old *wine cellar* with a wine press.

Ménars Just before Blois, the Château of Ménars rises close to the banks of the Loire. Work on the château, one of a small number built in the Baroque period, began in 1637. The building was rearranged in the eighteenth century by one of its most famous residents, the *Marquise de Pompadour*, who, as the mistress of Louis XV, was the power behind the French throne for two decades. It was at Ménars that she was able to escape the hive of intrigue at Versailles.

CHÂTEAUX WITHOUT NUMBER: THE BLÉSOIS

In order to take in all the treasures of the Blésois, it makes sense to find a base for two or three days, either in Blois itself, or in one of the comfortable inns in the vicinity.

Blois The first port of call should, of course, be the château, built in four distinct phases. The oldest part is the thirteenth-century Council Chamber of the Estates General, which was all that remained of the previous building. It was integrated into the new structure, when large-scale expansion of the château began at the end of the fifteenth century. First to be built was the *Louis XII wing*, whose outer walls still have the austere look of a fortress. On the courtyard side were the open arcades and large windows characteristic of the Renaissance. The small chapel, which adheres faithfully to Gothic lines, was also built at this time. Opposite, in the right hand corner of the Louis XII wing, the *Francis I wing* provides a splendid architectural backdrop. The most eye-catching feature is the octagonal *staircase*, adorned with sculptures and ornamentations. The whole façade is equally richly decorated and displays structural elements borrowed from Renaissance Italy. However, the lack of care in the execution of the work might have offended the sensibilities of a contemporary Italian. The windows are all of different sizes, some have mullions and transoms, while others do not, and the spaces between the windows show little respect for the laws of harmony and symmetry. But this is precisely what gives the wing its vitality and panache, when it might otherwise have appeared too severe.

Part of this section of the building was demolished when Gaston of Orléans, younger brother of Louis XIII, became Count of Blois and set about completely reorganizing the château. *François Mansart* was in charge of the project, which remained only partially completed. In 1638, after twenty-three years of childless marriage and having abandoned all hope of an heir, Anne of Austria gave birth to the future Louis XIV. This put paid to Gaston's expectations of inheriting the throne. Richelieu mercilessly cut off the king's brother's allowances and work at Blois had to come to a halt. Faced with the chilly magnificence of the *Gaston d'Orléans wing*, modern-day visitors might be rather glad it did.

During the French Revolution, the château was pillaged. However, when it was restored, the spacious interior was brilliantly reproduced. As a result, it is not hard to picture some of the dramatic events that unfolded here, above all the murder of the dukes of Guise in 1598, which happened in the king's apartments on the second floor.

The *Cabinet of Catherine de Medici* still has the old wood panelling with secret compartments, which can only be opened by a concealed mechanism. Here the woman who orchestrated the Saint

back as the Middle Ages the counts of Blois hunted there, and, on the site where Chambord now stands, there was a small hunting lodge. Francis I had the old lodge demolished in order to make way for one of his own. From these small beginnings grew the largest of all the Loire châteaux. No plan was too bold for the king: he even wanted to divert the course of the Loire to feed the moat and fountains. The architects, however, did not comply with his wishes. Even so, the Cosson, a small tributary of the Loire, was diverted to Chambord. Regardless of political failures and unconcerned by all

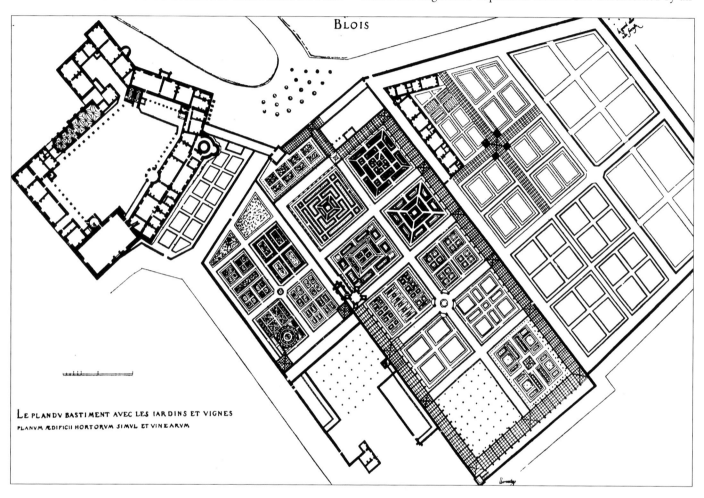

An early seventeenth-century drawing of the ground plan of the château and park at Blois.

Bartholomew's Eve Massacre (a bloodbath that occurred in 1572, during the Wars of Religion) and led many other conspiracies, kept secret documents, letters and even poison.

Only by walking right round the château complex can you appreciate its huge dimensions. The finest view, taking in the Francis I wing's rows of loggias, is from the north side.

Despite the devastation wrought by the Second World War, the town at the foot of the château has managed to preserve many of its historic buildings, as you will see if you wander around the pedestrian zone.

Chambord Only a short drive from Blois is the even more massive Chambord. A wall thirty-two kilometres long encircles an area of 5,500 hectares. About a quarter of this is parkland, the rest being forest, where Francis I and many of his successors hunted. As far

financial constraints, Francis I continued urging the builders to work non-stop. Notwithstanding, the project was on such a vast scale that the man who initiated it did not live to see its conclusion. Although Henry II allowed building to continue, work was halted before the château was completed; so Chambord became a personal memorial to Francis I. Its alleged function as a 'hunting lodge' was overtaken by the sovereign's desire for self-expression. Today's visitor might even regard it as a delusion of grandeur. In fact, a tendency towards eccentricity and ostentation was a trait shared by all the Valois monarchs. Since, in the case of Francis I, this idiosyncrasy went hand-in-hand with an irreproachable nature, history has tended to judge him kindly.

The château's main frontage faces north-west. A *façade* 156 metres long stretches before the eyes of the visitor. It consists of three sections. In the centre, the square central keep, which

A view of the old quarter of Blois. Recognizable in the distance is the tower of the Cathedral of Saint-Louis (see also page 57).

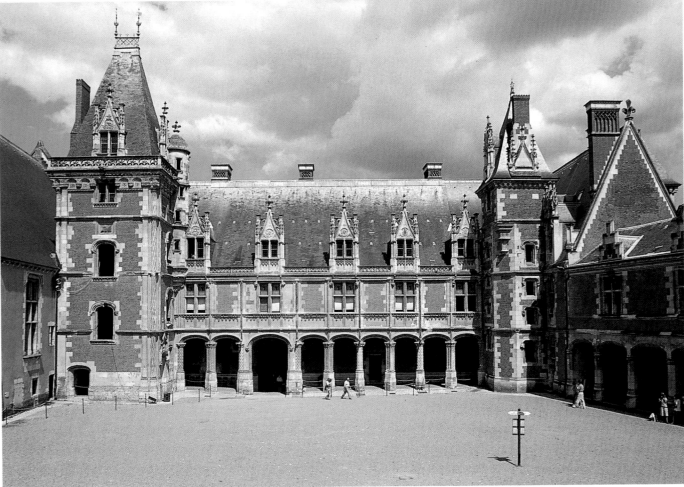

Blois. The Louis XII Wing, seen here from the courtyard side, is one of the first French examples of Renaissance architecture.

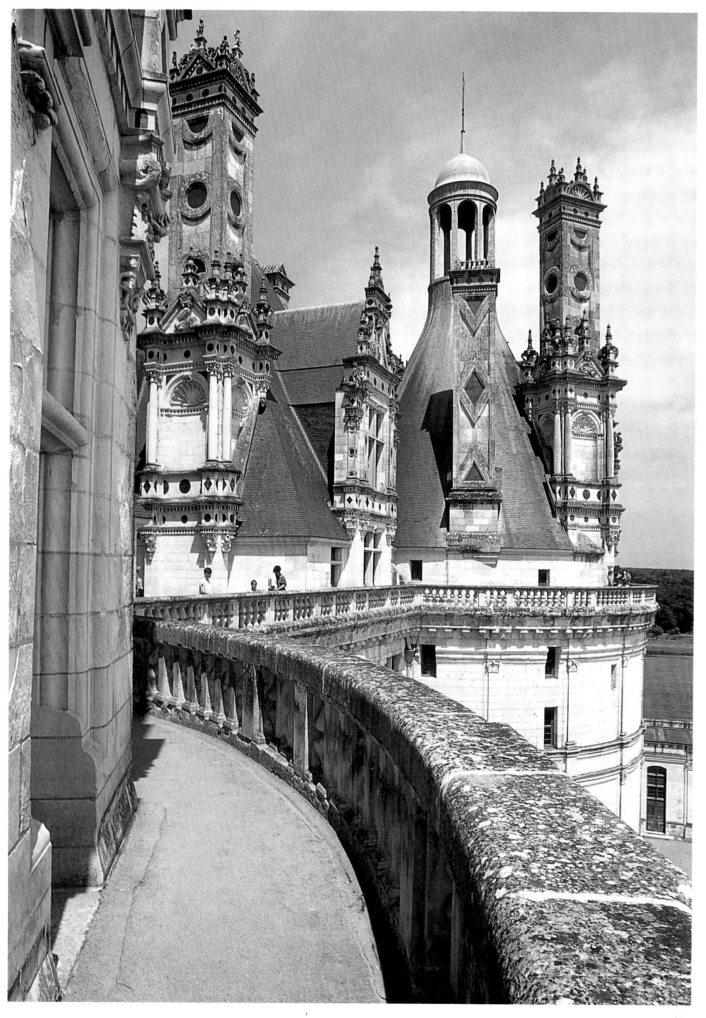

One of the most bizarre experiences on a tour of the Loire châteaux has to be a walk around the roof terrace at Chambord. Moving among the chaos of turrets, chimneys and gables is like being in a labyrinth.

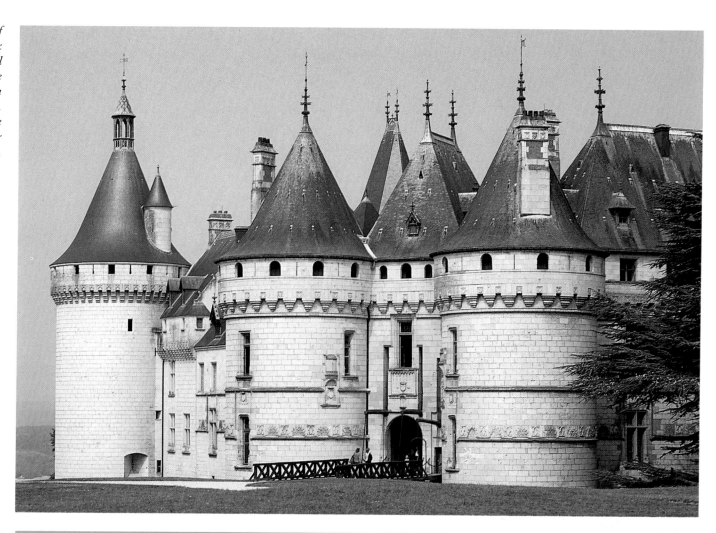

Chaumont is one of the few châteaux whose medieval origins are unmistakeable, even from the outside. Here its defensive intentions are clear to see.

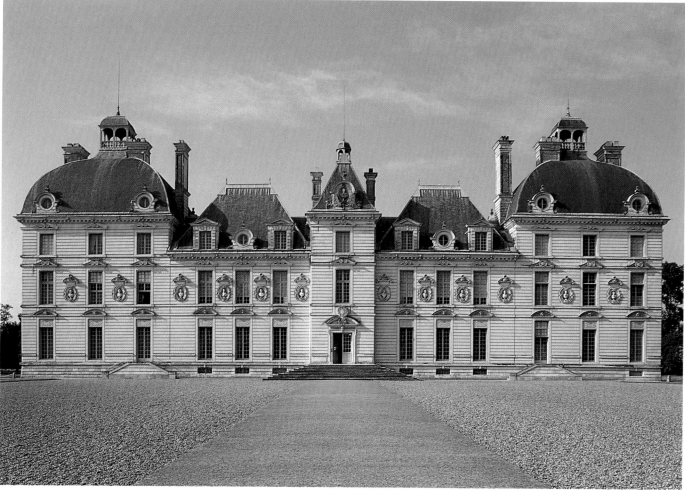

Cheverny is the most beautiful château of the Bourbon era (seventeenth century), during which only a handful of feudal buildings were built in the Loire Valley. In stark contrast to the modest depth of the building (see page 48), the main façade on the park side consists of a diverse group of five structures arranged side by side.

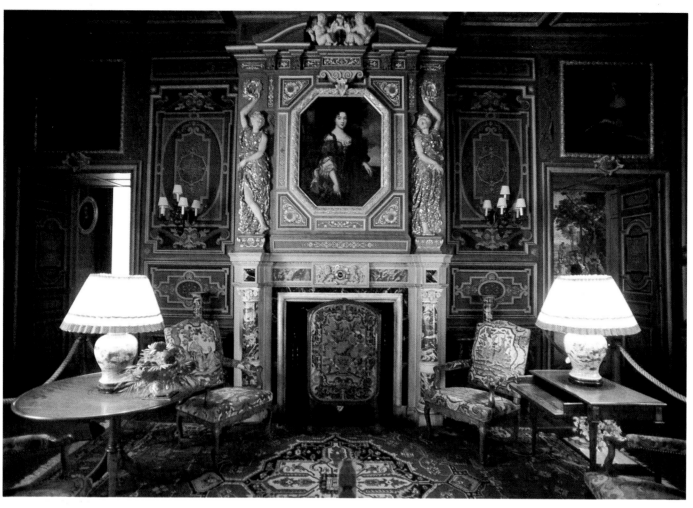

Above and below: *Cheverny is still partly occupied, so not all the rooms are open to the public. Since the château escaped the ravages of the French Revolution, it is still possible to gain an accurate insight into the lavish lifestyle of the seventeenth century. The large fireplaces are particularly sumptuous.*

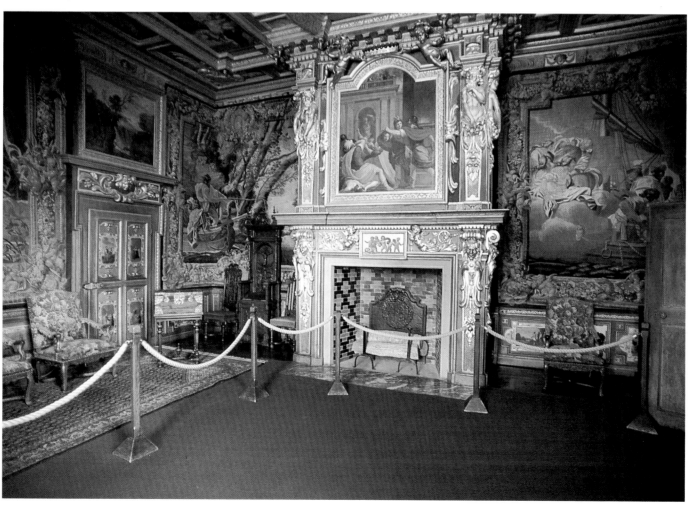

contained the living accommodation, follows the pattern of the medieval donjon. At each corner stand bulbous round towers. These are matched by two more, which join it to the two low linear buildings. The concentrated energy of these four towers lends the building a convincing unity. Only at the front are the lateral sections built to their originally planned height. The three remaining sides forming the square around the *donjon* reach no higher than the first storey.

The main door at the rear of the château leads into the completely enclosed inner courtyard, dominated by the centrally situ-

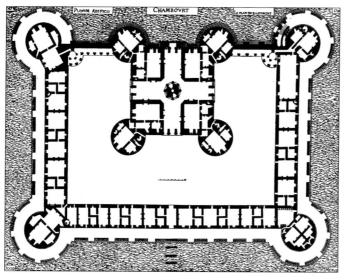

Chambord. The plan makes it clear that the 'donjon' in the rectangular courtyard was intended to form the centrepiece of the building.

ated keep. In common with the exterior, the inside of the building is strictly symmetrical. Four corridors divide the keep, creating a square in each of the four corners, where the apartments were arranged. At the core of the building a *spiral staircase*, that caused amazement even among its contemporaries, winds its way upwards. It consists of two intertwining staircases, so designed that anyone ascending the stairs would not meet anyone coming down them. Such spaciousness does not make for a homely atmosphere. This is due not so much to the château's present museum-like air, rather it is a further indication that Chambord was not intended to be practical; indeed its purpose was to lionize the king. As it happened, Francis I only stayed for a matter of weeks within the walls of his cherished project, and even his successor never acquired any lasting taste for Chambord. Nonetheless, the château can look back on an eventful past. In 1539 it was the splendid setting for the visit of the Emperor Charles V, who was suitably impressed and flattered his host, Francis I, with the declaration that 'Chambord was the embodiment of human achievement'. Louis XIV made many visits to Chambord, and two of *Molière's* comedies were given their first performances there, including 'Le Bourgeois Gentilhomme'. In the eighteenth century, *King Stanislaus Leszcynski* left Poland to take up residence at Chambord before settling permanently at Nancy. His son-in-law, Louis XV, gave him the run of the château. Soon afterwards, *Marshal Moritz of Saxony,* illegitimate son of

Augustus III who had dethroned Stanislaus Leszcynski, took over Chambord, where he presided over an extravagant court life. With his death, the dazzling history of Chambord came to an end. After several changes of ownership, it soon fell into disrepair. It became state property in 1930, by which time it was in urgent need of the restoration work which has since been carried out in exemplary fashion. The best time to visit Chambord is in the morning before the hordes of tourists descend. Rising out of the swathes of mist covering the surrounding meadows, it really does look like a scene from a fairy tale.

Cheverny In general terms, Cheverny occupies third place in the hierarchy of Blésois châteaux. Although, as far as size is concerned, it cannot match Blois or Chambord, its symmetrical and harmonious architecture and its location in an extensive park make it a jewel among the Loire châteaux. What is unusual is the excellent state of preservation of the interior, which was never plundered during the Revolution. A tour of the many rooms gives a clear insight into everyday life among the seventeenth-century nobility. Other features of Cheverny include the *trophy room*, containing more than 2,000 pairs of antlers, and the huge pack of hounds (about sixty of them) used in the shoots organized each autumn.

Chaumont The fourth obligatory stop in the Blésois is the Château of Chaumont. Together with Amboise, it is one of the few châteaux situated right on the banks of the Loire, most of them having no immediate contact with the river. There was a fortress

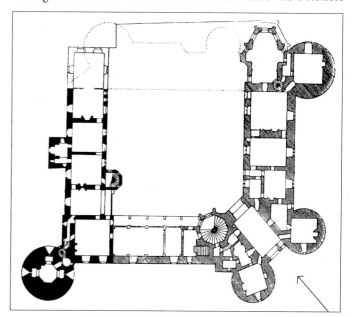

Chaumont. The château originally had a north wing, creating an enclosed, rectangular courtyard.

on this spot as far back as the eleventh century, built by the then Count of Blésois, Eudes I, as a bulwark against the territorially-ambitious Fulk Nerra. After several buildings had been decimated, the present one was erected just after the end of the Hundred Years

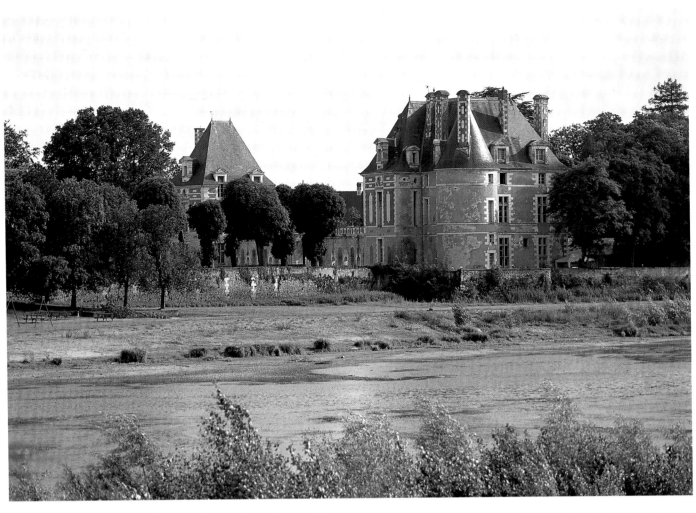

War. It took until 1511 to finish, and this relatively long delay explains the irregular mix of architectural styles. Approached across a spacious park, the château, with its hefty towers, gives the visitor the rather daunting first impression of a fortress. By contrast, the *courtyard*, reached by a drawbridge and originally enclosed all the way round, has a friendlier Renaissance atmosphere. Once protection against attack ceased to be a vital consideration, the north wing was demolished, so giving easy access from the château to the river. *Catherine de Medici* forced *Diane de Poitiers* to exchange Chenonceaux for Chaumont, but she did not stay there long. Diane fled to Anet, where she spent her declining years. In the eighteenth century, the then owner, *Jacques-Donatien Le Ray*, a ceramics manufacturer, turned Chaumont into a centre for arts and crafts, appointing the Italian sculptor, *Giovanni Battista Nini*, to take charge of the pottery workshop. Chaumont became famous for his ceramic *portrait medallions*, and many examples of his work are now on show there. When Napoleon banished *Madame de Staël* to Chaumont at the beginning of the nineteenth century, she surrounded herself with an international circle of aesthetes, among them *August Wilhelm Schlegel* and *Adelbert von Chamisso*.

Many tourists feel they have done their duty to the Blésois if they visit Blois, Chambord, Cheverny and Chaumont. The area does, however, offer further delights that are well worth visiting if time allows.

Fougères-sur-Bièvre The oldest of the three châteaux in the vicinity of Cheverny (the other two are Beauregard and Villesavin) is Fougères-sur-Bièvre, whose militaristic appearance contrasts sharply with the Renaissance and Baroque style of its neighbours. By drawing direct comparisons, it is easy to recognise the spectacular development of château architecture between the fourteenth and seventeenth centuries. The austere main portal still retains its fortress-like character.

Beauregard Built in the mid-sixteenth century for *Jean de Thier*, a secretary of state to Henry II, Beauregard takes us back to the Renaissance once more. It boasts an exceptionally well-stocked *portrait gallery* with more than 350 paintings, where the highly distinctive floor is made of Delft tiles, depicting a battle scene.

The Château of
Moulin in its idyllic,
watery setting. It was
built between 1480
and 1506 by Philippe
du Moulin, a
comrade-in-arms of
Charles VIII.

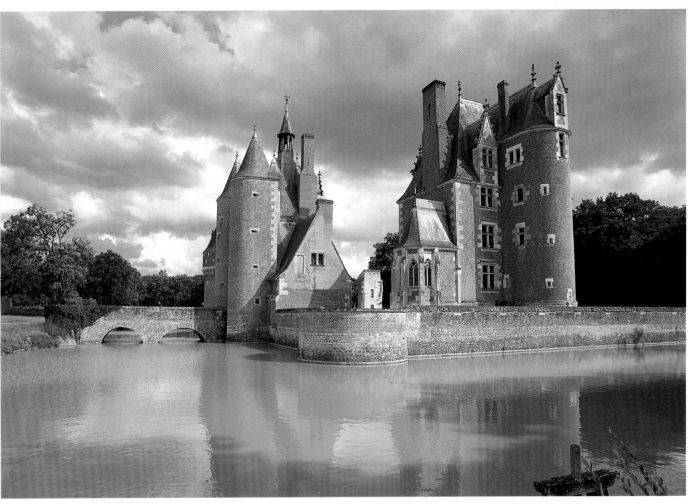

In many of the Loire châteaux, visitors will find delightful stained glass. Here is a detail from a window at Chaumont.

Villesavin The Château of Villesavin, on the edge of Chambord's park, also dates from the mid-sixteenth century. It was built for *Jean Le Breton*, who used it as a second home. His ancestral home was the Château of Villandry in Touraine.

The Sologne Turning southwards through Cheverny, we pass through the countryside of the Sologne, a region of heathland with hundreds of small lakes and ponds. The tranquillity and seclusion of this sparsely populated area come as a welcome relief from the tourist trail.

Moulin The Château of Moulin, hidden away amid woods and fields a few kilometres west of the little town of Romorantin-Lanthenay, is the jewel of the Sologne. The neat Renaissance building, raised on the foundations of a medieval predecessor, is completely surrounded by water and – unusually – is still completely furnished with pieces dating back centuries.

Selles-sur-Cher and Saint-Aignan After the excitement of visiting so many châteaux, the *Romanesque churches* at Selles-sur-Cher and Saint-Aignan make a refreshing change. The former has some unusual *reliefs* on the outer wall of the choir, while the latter has some astonishingly well-preserved twelfth-century *frescoes* in the crypt. This route leads on into the valley of the Cher, and Touraine.

CONSTANT CHANGE: TOURAINE

Montrichard Standing on the threshold of Touraine, as if guarding its treasures from its neighbours in the Blésois, the massive fortified tower of Montrichard was built in the eleventh century by the belligerent *Fulk Nerra*, Count of Anjou. Although partly demolished in the late sixteenth century, it is still awesome. From the top of the tower, there is a good view over the rooftops and narrow streets of the town, and the bridge over the Cher.

Chenonceaux While one could argue endlessly over which of the Loire châteaux is the finest, Chenonceaux would certainly be among the contenders. Blois is the most architecturally diverse;

around a central vestibule, more convenient than having them lead one into the next. Another is the straight flights of steps and landings – as opposed to the spiral staircases customary at the time –which provided a much more impressive ambience for receiving guests. After the death of the Bohiers, it emerged that the tax collector was himself guilty of tax evasion. To discharge the debt, his son and heir handed the château over to the crown. In 1547, Henry II made a gift of Chenonceaux to his mistress, the fascinating *Diane de Poitiers*. She was universally admired for her youthful looks, which were partly due to her sporting activities. She loved to swim and her other great passion was riding. In order to enjoy promenades on horseback in the woods on the other side of the Cher, she had a bridge built across the river. After Henry's death,

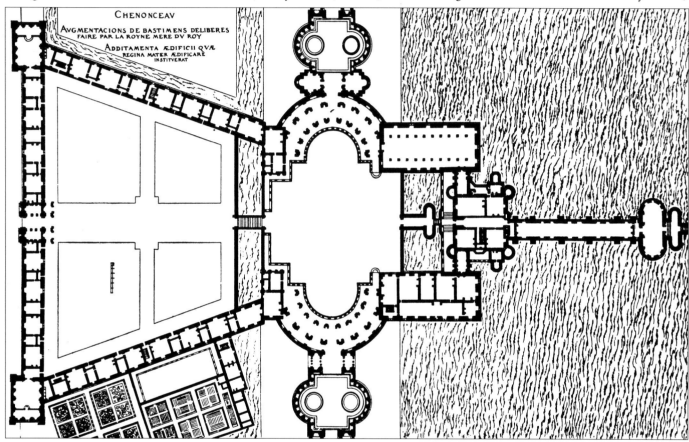

Chenonceaux. This ground plan shows Catherine de Medici's grandiose scheme to extend the château, which was never fully realized. The only part of the project to be seen through by the widow of Henry II was the two-storey gallery on the bridge across the Cher (on the far right of the drawing), commissioned by her rival Diane de Poitiers. Had the architect Du Cerceau's plans actually been carried out, Chenonceaux would have outdone the mighty Chambord.

Azay-le-Rideau is perhaps the most intimate; Villandry, with its gardens, has the most distinguished setting; Amboise, standing high above the Loire, is the most majestic; but Chenonceaux can rightfully claim to be the most original of all.

In 1512, *Thomas Bohier*, who served three French kings as chief tax collector, ordered the previous medieval structure to be torn down, apart from a round keep. His wife, *Catherine Briçonnet*, supervised the building of a new *Renaissance château* on a small, square island. Renaissance architects were indebted to practically-minded women for a number of sensible innovations. One such example that can be seen here is the arrangement of rooms

Catherine de Medici took her revenge on Diane by having her husband's favourite, whom she loathed, removed from Chenonceaux, in order to use it herself. She had a two-storey gallery built on Diane's bridge, so giving Chenonceaux its present appearance. Apart from the practical purpose of providing large rooms for court festivities, the conversion of the bridge symbolized the triumph of the widow over her long-standing rival. Chenonceaux now played host to feasts of unimaginable splendour, often lasting for days on end and culminating in the most riotous debauchery. Costumed balls, banquets, fireworks displays, and even complete naval battles on the Cher showed the carefree face of an era of profound contrasts.

Flourishing, fragrant and lovingly-tended, the gardens at Villandry were replanted by Doctor Carvallo at the beginning of this century in original French sixteenth-century style. They are the only château gardens in France that remain faithful to the original and continue to be cultivated.

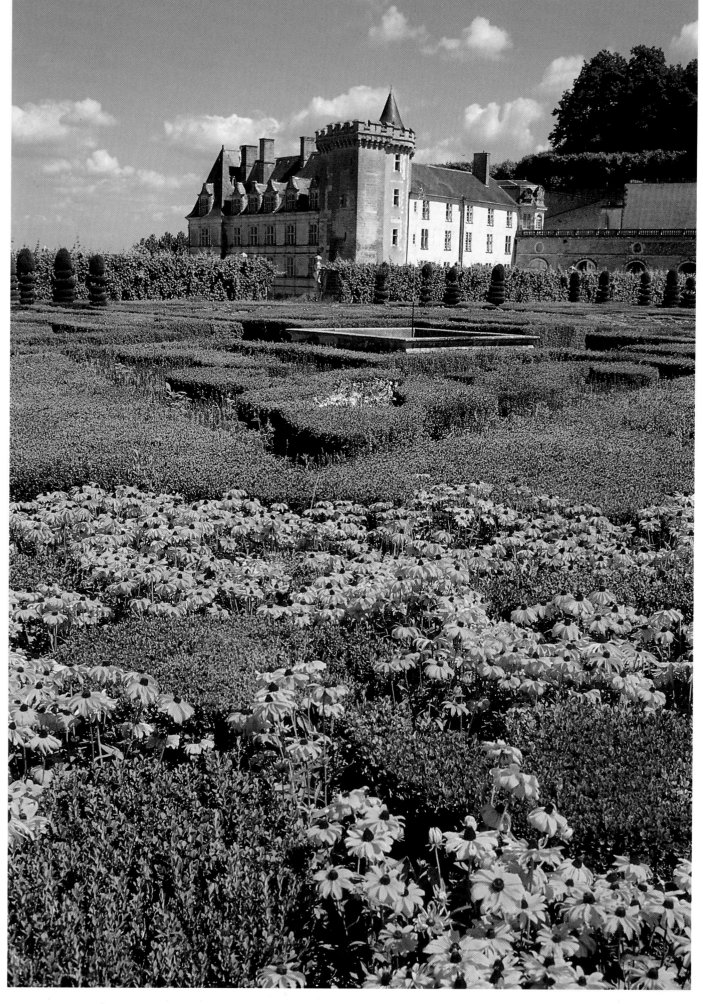

Overleaf: The flowerbeds of Villandry's ornamental gardens are arranged geometrically in four sections around the pond on the right of the photograph, and symbolize four kinds of love. In the centre of the picture, tragic love is represented by sword and dagger shapes, and red flowers. Above this, tender love is portrayed with hearts and flames and pink flowers. Above and to the right, misshapen hearts and multicoloured flowers depict passionate love. Finally, flirtation is symbolized by fans, horns, and yellow flowers.

147

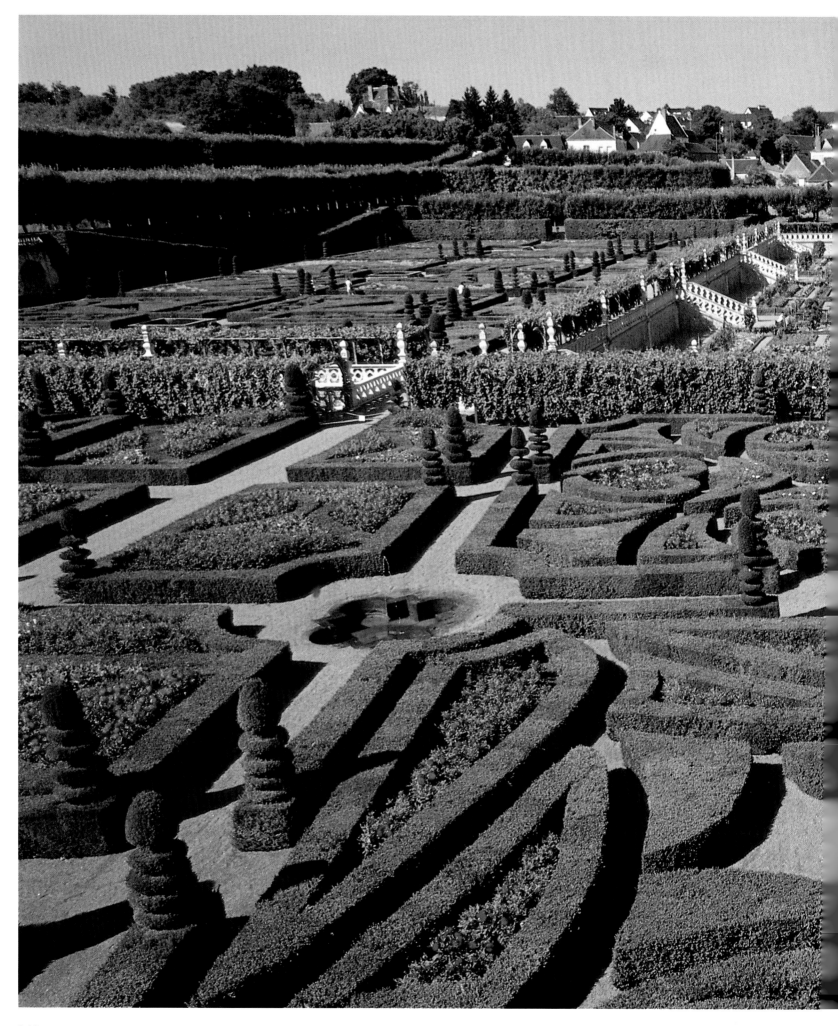

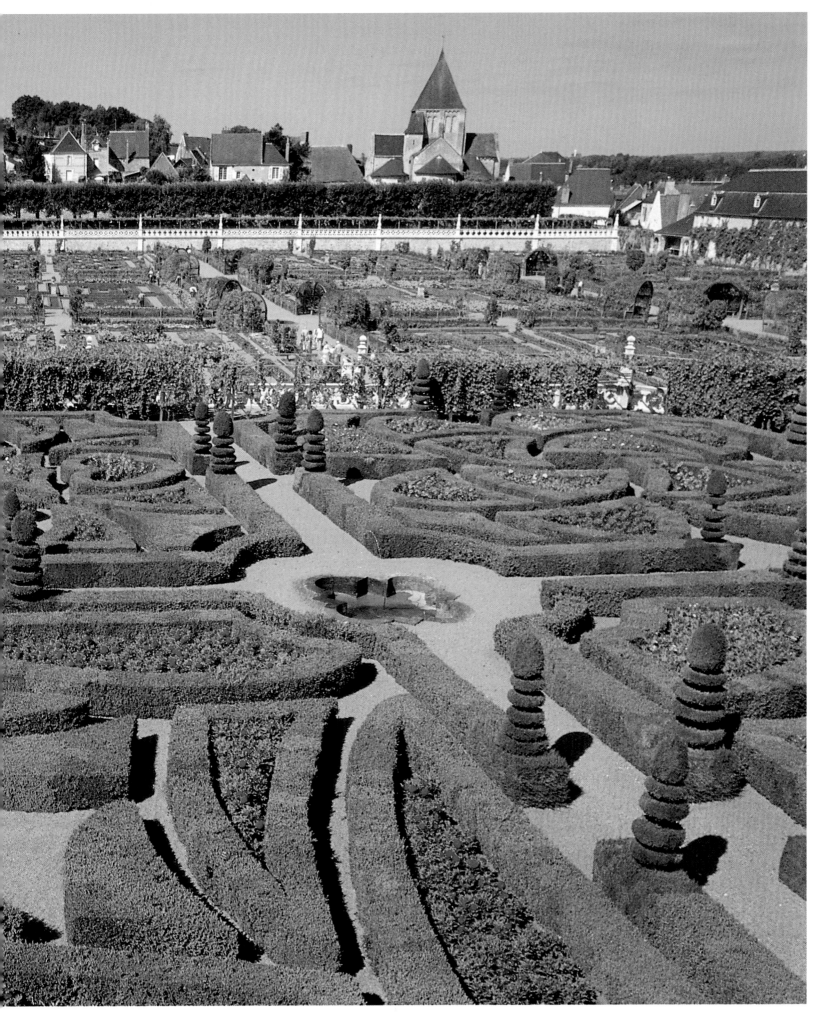

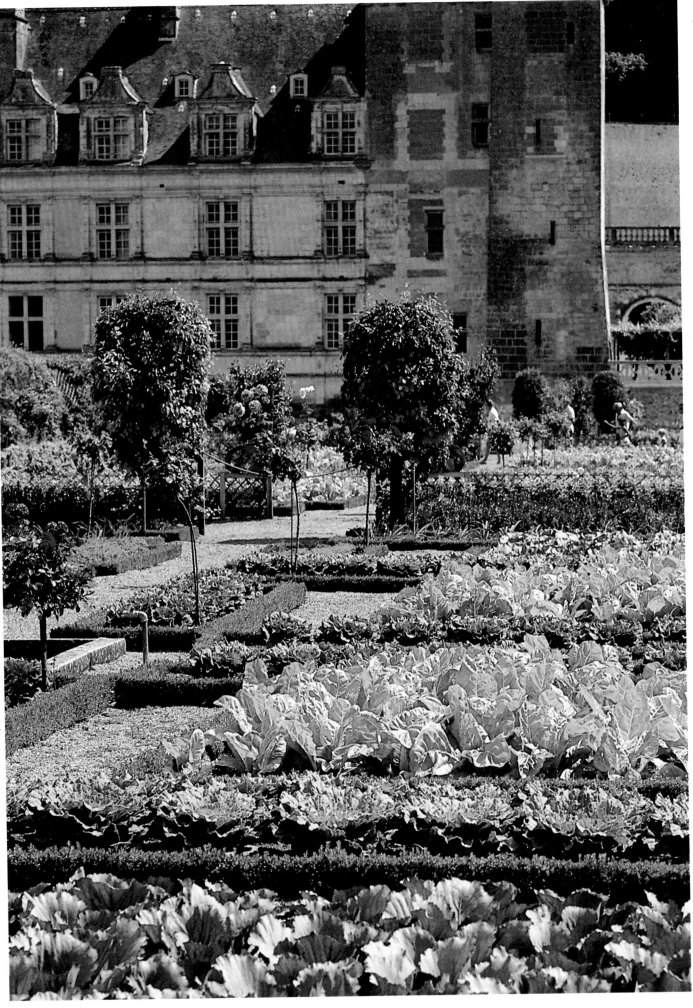

The vegetable garden at Villandry consists of rectangular beds, with fruit trees at each corner surrounded by box hedges. Even today, only vegetables known in sixteenth-century France are grown here.

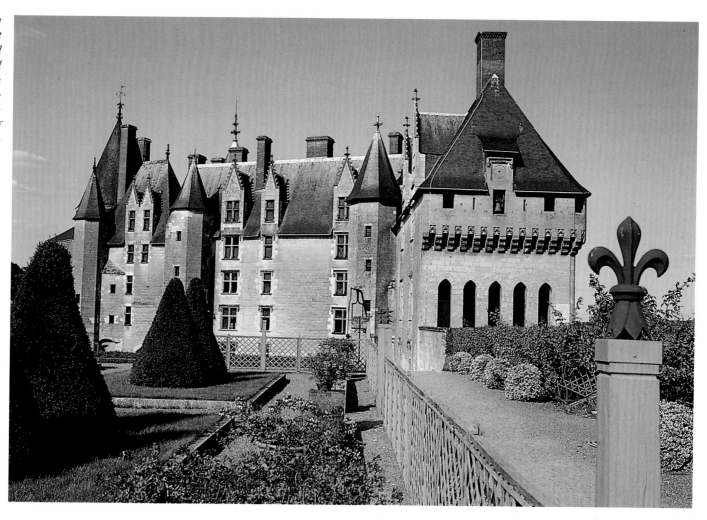

Commissioned by Louis XI and built between 1465 and 1469, Langeais had its great moment in history when the wedding of Charles VIII and Anne of Brittany took place there.

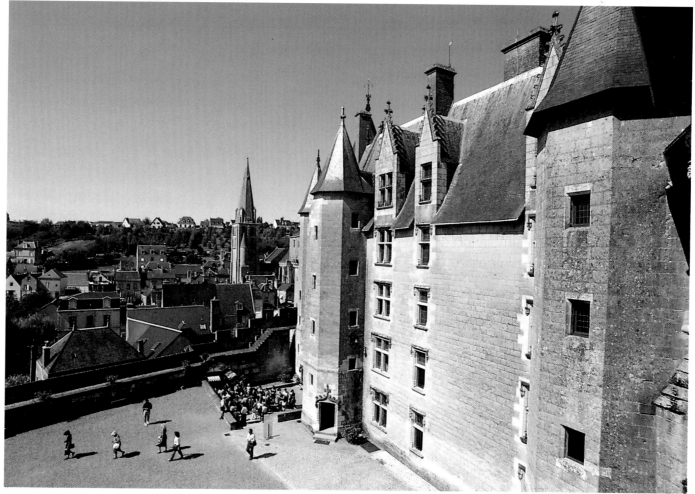

The courtyard façade in austere grey stone is relieved only by the pointed gables above the dormer windows. Since nothing has been changed or added since the fifteenth century, the coherence of its architecture makes Langeais unusual among the Loire châteaux.

Overleaf: The guardroom at Langeais is faithfully preserved and decorated with fifteenth- and sixteenth-century Flemish tapestries. The massive fireplace (in the centre of the photograph) is shaped like a fortress with crenellations and battlemented parapets.

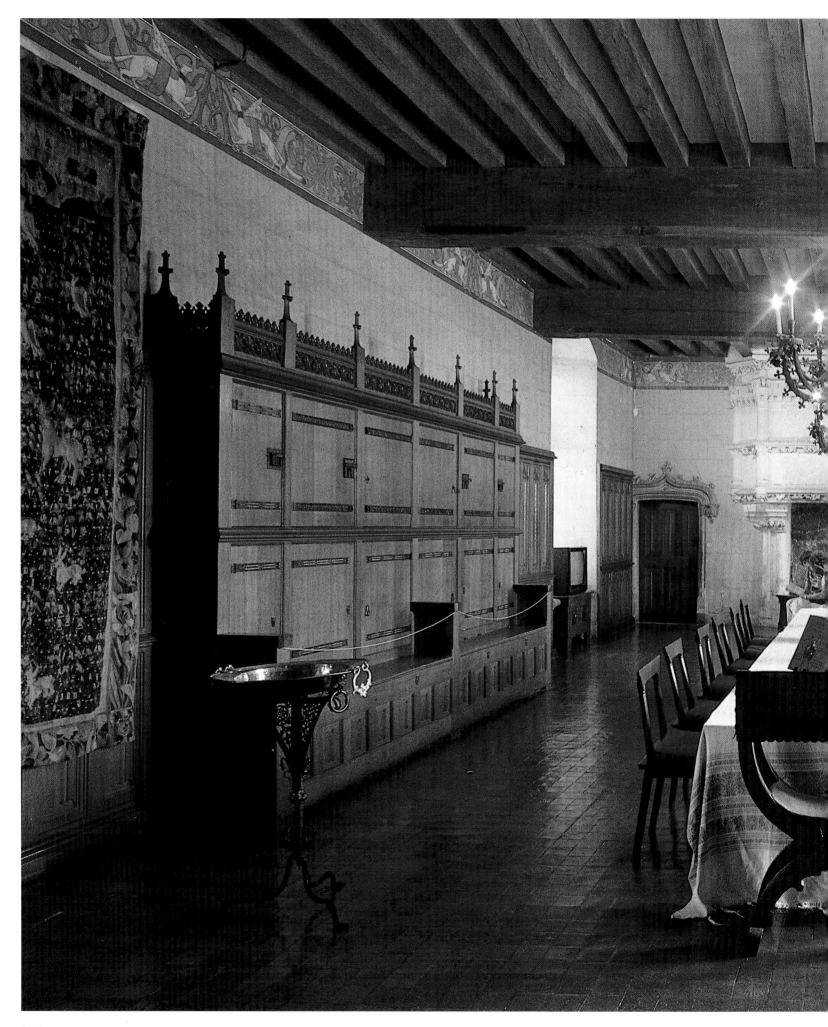

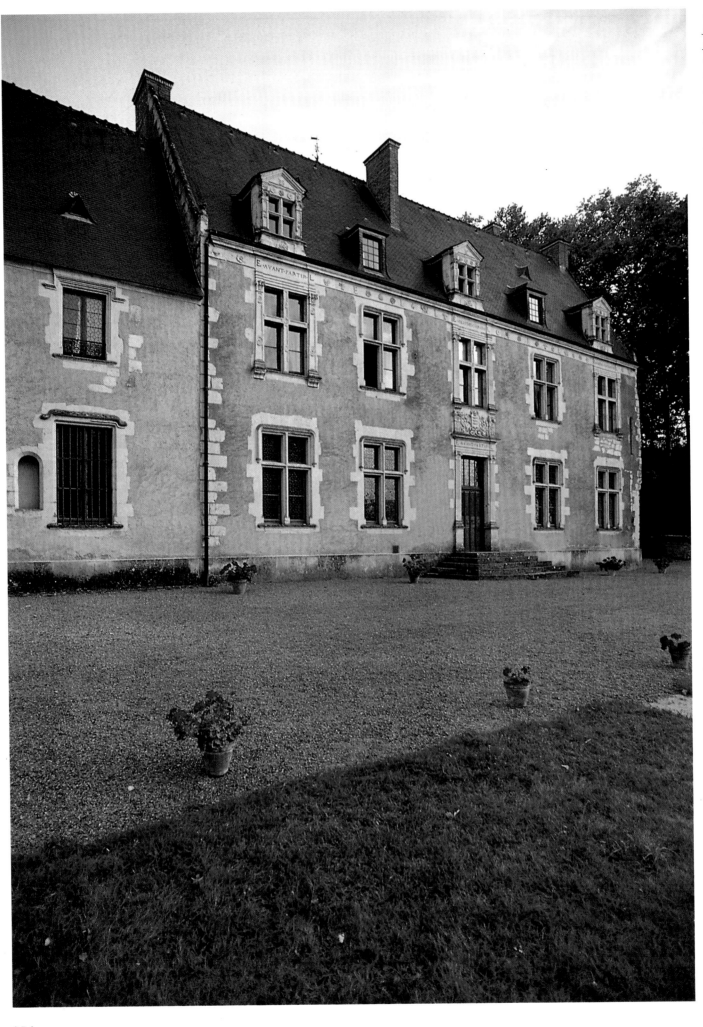

La Possonière, seen
from the garden,
justifies all the efforts
made to preserve those
châteaux situated off
the main tourist trail.
Here visitors enjoy the
kind of tranquillity
that cannot be found
within the precincts of
the larger châteaux.

Although, after Catherine de Medici's death in 1589, the château changed hands many times, it so happened that it was always women who controlled the destiny of Chenonceaux. Finally, in the nineteenth century, the artistic *Madame Pelouze* dedicated her whole life to the restoration of the building.

Amboise Only fifteen kilometres away from Chenonceaux is the next highlight of the châteaux tour, Amboise. Louis XI chose to make Amboise his royal seat, first and foremost because of its strategically advantageous location. Nevertheless, the present building was only begun in the reign of his son and heir, Charles VIII. The foundation stone was laid in 1592. The château, which

was much influenced by the Italians, since, by this time, the project was too well advanced.

Under Francis I, Amboise enjoyed its heyday as a royal seat, for at the beginning of his reign his cherished projects, Blois and Chambord, were still under construction. At this time, the opulent feasts held at Amboise were a manifestation of the ever more refined courtly etiquette of the sixteenth century. The year 1560 was the blackest in the history of Amboise. When a Protestant conspiracy to kidnap the young King Charles IX was discovered, the Catholics took brutal revenge. Some of the Huguenots were beheaded and quartered, others were hanged from the balconies, or sewn into sacks and drowned in the Loire. So deep was the scar left on the

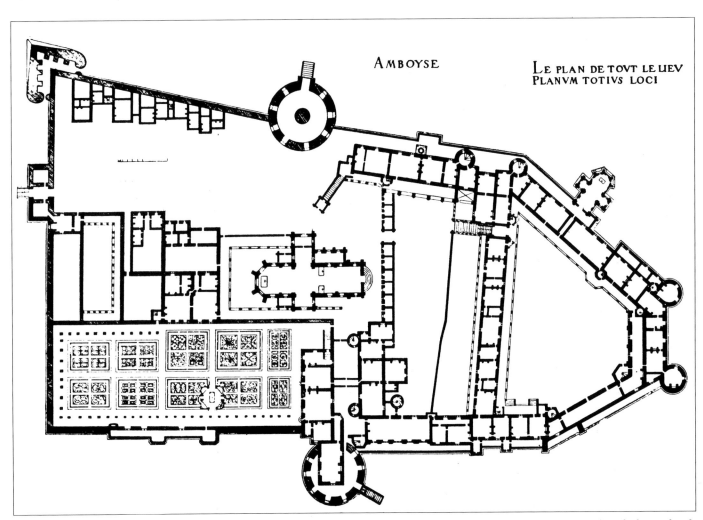

Amboise. This seventeenth-century ground plan shows that much of the building no longer exists. Among the parts that have not survived are the former chapel in the centre of the complex, and the queen's apartments, in the large section on the right of the drawing. All that now remains of this section is the little chapel of Saint-Hubert, containing the tomb of Leonardo da Vinci.

until Chambord was built, was to be the largest on the Loire, was completed at lightning speed. Even during the winter, work continued unabated, with the builders heating the stone to make it workable. Although, as we have said before, Charles' campaign in Italy of 1495 brought him little prestige, he was stimulated by his encounter with the Italian Renaissance. He returned to France with numerous Italians in his entourage: master builders, sculptors and painters, as well as tailors, furriers and even poultry farmers. This did not mean, however, that the architectural design of Amboise

château by this gruesome episode, it has scarcely been used since. After the Revolution, much of it was torn down and today only the parts of the building overlooking the Loire remain standing, among them the chapel. The *Tour des Minimes* is an architectural masterpiece. Instead of a staircase it is fitted with a spiral ramp so that even large carriages could ascend directly to the courtyard.

The interesting rooms inside the château are largely the result of restorations. The real gem is the *Chapel of Saint-Hubert*, with its fine late Gothic decorations. The greatest genius of the Italian

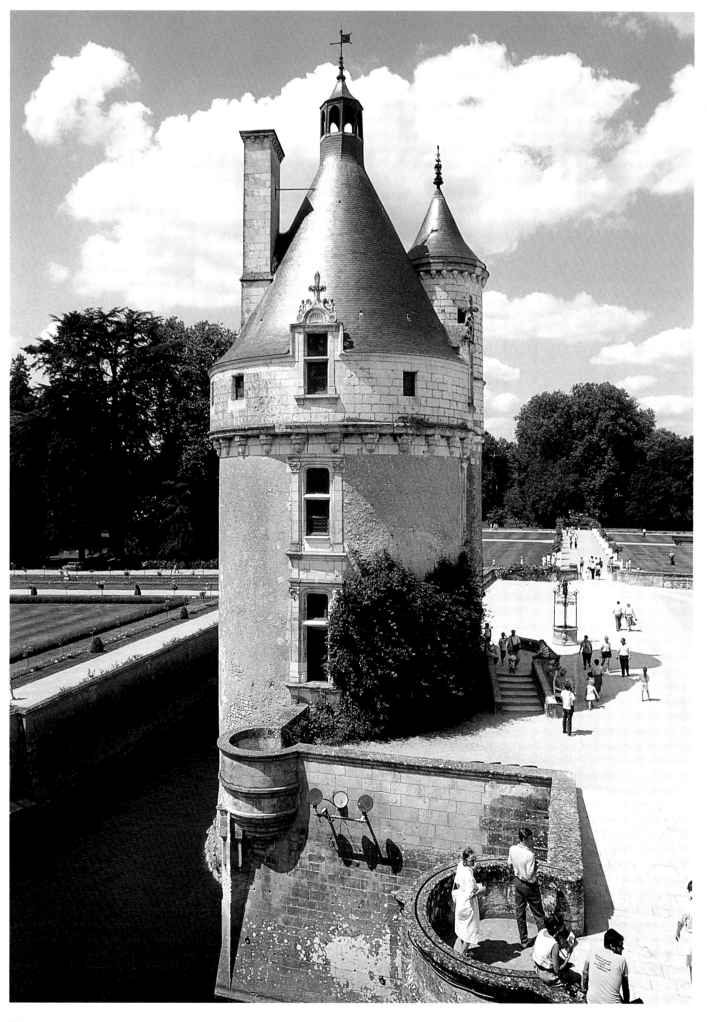

Chenonceaux. The round tower, the only relic of the former medieval structure on the site, seen from Diane de Poitiers' château.

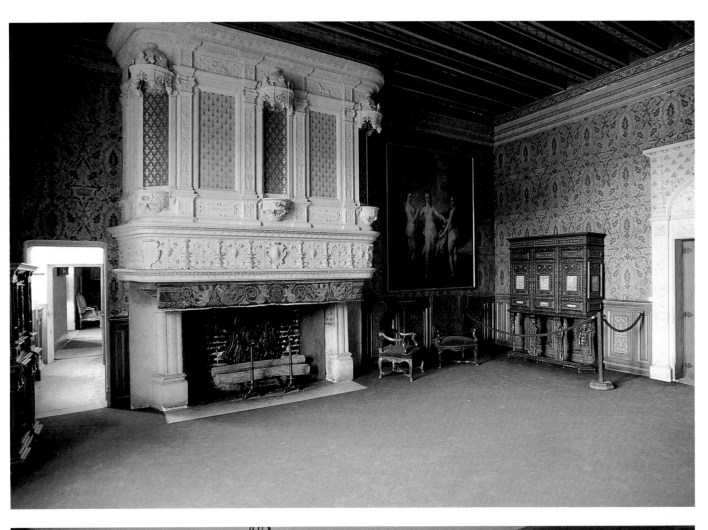

Interior view of Chenonceaux. At colder times of the year, wood fires are still lit in the magnificent fireplaces. They provide surprisingly effective heating for the large rooms and continue to burn for a considerable time; whole trunks of oak glow for up to a week without going out.

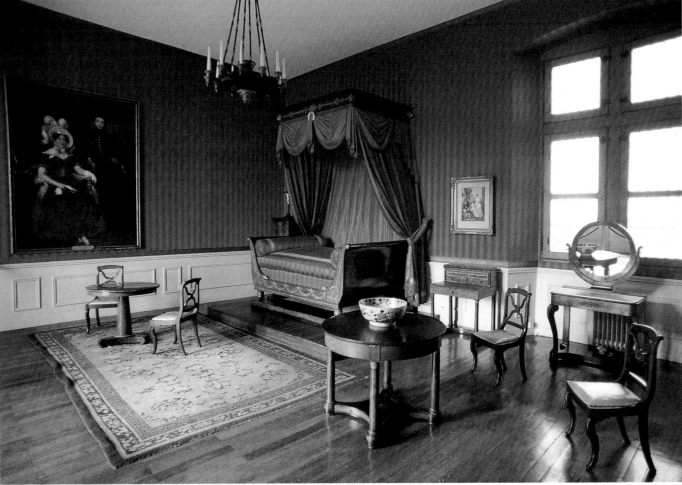

Interior view of Amboise. The château shared the fate of most of the properties of the feudal nobility during the French Revolution and was ruthlessly pillaged. Today's visitors are amazed to see the care that has been devoted to creating a pleasing interior decor.

Overleaf: A bird's-eye view of the Château of Chenonceaux. A visit to this château is one of the high points of any journey through the Loire Valley.

157

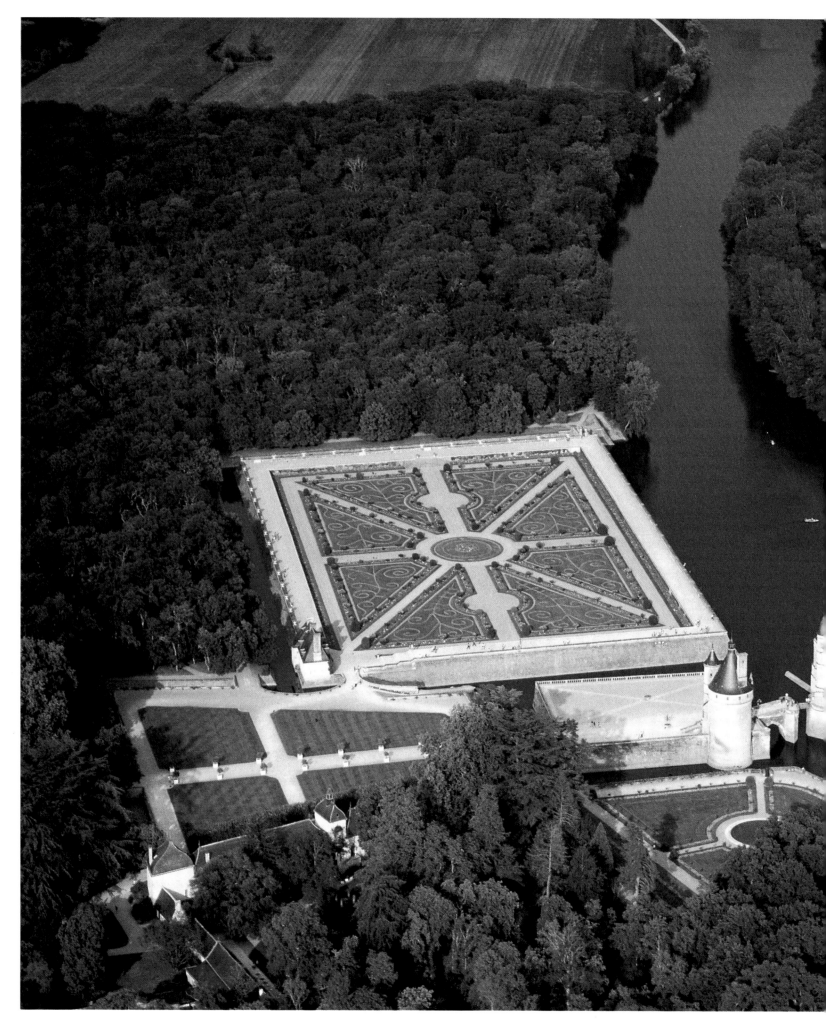

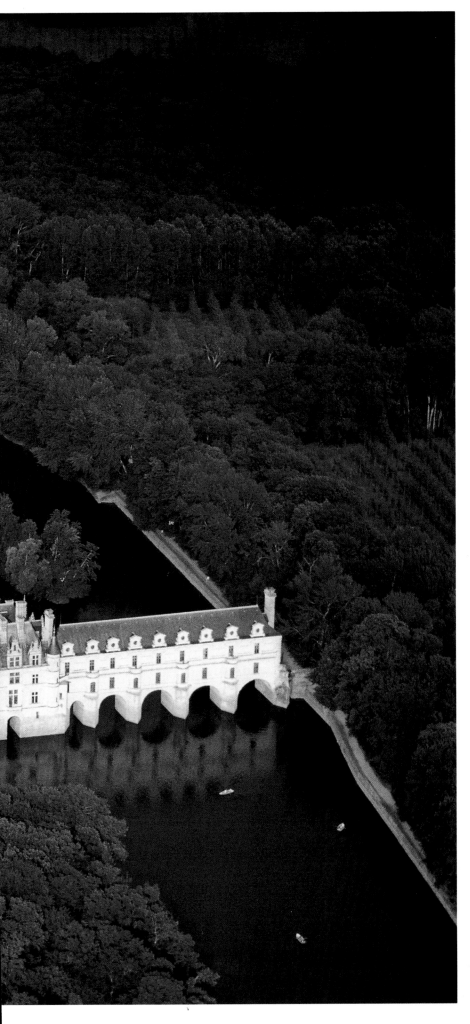

Renaissance, *Leonardo da Vinci*, summoned by Francis I to Amboise in 1516, is buried here. Leonardo moved to the *Manoir Clos Lucé*, a comfortable fifteenth-century manor house near the château, which is also open to visitors. In the cellar is a display of models, constructed using Leonardo's own sketches. They show astonished visitors that nearly five hundred years ago Leonardo invented workable bicycles, tanks, swing bridges and even flying machines. There is another sight to see outside Amboise, beside the Bléré road. The *Pagoda of Chanteloup* is all that remains of a château built by the *Duke of Choiseul*, who was banished from the court of Louis XV. The tapered, seven-storey oriental-style building testifies to the popularity of the art of Asia in eighteenth-century France.

Tours We offer the same advice as for the Blésois. Try to find a suitable base in order to have a few days to savour Touraine's many delights. The wide selection of hotels and its central location makes Tours the perfect choice. There is plenty to see in the city itself. From the time of Saint Martin onwards, it became one of the kingdom's leading cities. Tours developed by leaps and bounds with the introduction of the silk industry in the sixteenth century. The horrors of the Wars of Religion – Tours was a bastion of Protestantism – led to its swift decline, which only ended with the arrival of the railway in the nineteenth century. With a population of little more than 150,000, modern Tours is a bustling industrial and business centre. Situated at the crossroads of major north-south and east-west commercial routes, the city plays a major role in the life of western France. Many charming old houses are preserved in the historic old town, as well as the *Cathedral of Saint-Gatien*, one of France's finest examples of late Gothic architecture. The façade is a blend of Gothic and Renaissance styles. Sadly, only the foundations remain of *Saint Martin's Basilica*, one of the city's most important buildings.

We suggest three excursions around Tours. The first provides a contrast to the ground so far covered, leading to some Romanesque monuments north of the city. The best route is via Château-Renault, since, shortly after Tours, the road takes you past *Grange-le-Meslay,* a thirteenth-century tithe barn, and a venue used for performances during the *Fêtes musicales en Touraine*, the music festival founded by *Sviatoslav Richter* in 1964.

Lavardin The first stop is Lavardin, where the ruins of a fortress and its keep tower above the village. In the choir of the *Romanesque Church of Saint-Genest*, there are twelfth-century frescoes. Paintings from the same period adorn the pillars, although some have deteriorated badly.

Montoire-sur-le-Loir Meanwhile, the *wall paintings in the Church of Saint-Gilles* at Montoire-sur-le-Loir are beautifully preserved. In the trefoil choir, all three apses are decorated in many colours with late Romanesque representations of Christ. The east

apsis shows the Last Judgement, while its southern counterpart shows Him handing the keys of the kingdom to Saint Peter. The north apse represents Pentecost, with the Holy Spirit portrayed as rays emanating from the figure of Christ beaming down on the heads of the Apostles. The transverse arches are also painted; the western arch shows a figure of Christ and the struggle between the vices and the virtues, as well as elaborate ornamentation and a further half-length portrait of Christ. The painting in the east apse is rather older than the others and was executed 'al fresco', in other words painted on wet plaster. The two others, meanwhile, date from the late twelfth or early thirteenth century and were painted 'al secco', that is to say on dry plaster. This technique allowed the artists greater freedom in their use of colour but had the disadvantage that the paintings tended to fade.

Saint-Jacques-des-Guerets The nearby church of Saint-Jacques-des-Guerets offers yet more *Romanesque murals.* Large-scale paintings of the Resurrection of the Dead, the Last Judgement, the Last Supper and the New Jerusalem adorn the walls of the choir. As these were also executed 'al secco', they are badly faded.

Vendôme This excursion to northern Touraine can easily be combined with a detour via Vendôme and the Château of Poncé-sur-le-Loir. As well as a huge ruined fortress and a charming old quarter, Vendôme possesses a large abbey church, a rare example

of a Gothic church built by a religious order. *Poncé-sur-le-Loir*'s greatest treasure is a magnificent Renaissance staircase. Each caisson of the vaulted ceiling above contains a relief with a different decorative motif.

Villandry The second excursion from Tours takes us back to our main theme. One unmissable château is Villandry. It consists of two buildings dating from different periods: a medieval donjon and a Renaissance building in three sections. The main courtyard faces northwards to the Cher, only a short distance from where the river joins the Loire. Here it is obvious that the question of defence was no longer a consideration for château architecture in the early sixteenth century. The Renaissance part was commissioned by *Jean Le Breton*, who had overseen the building of Chambord and enjoyed the special trust of Francis I. The real attraction of Villandry is not the château itself but the *gardens*, arranged on three levels beside the château. They are the result of a reconstruction carried out in the Thirties by the then owner, *Doctor Carvallo*. The gardens at Villandry are unique in the whole of France, and are an authentic representation of a Renaissance park. On the lowest level is the kitchen garden with fruit trees and vegetable plots, arranged in clear geometric shapes. On the next level is the ornamental garden whose wonderful flowerbeds are surrounded by carefully trimmed box hedges. Each of the four large flowerbeds is laid out with symbols of the different kinds of love. Heart-shaped letters stand

160

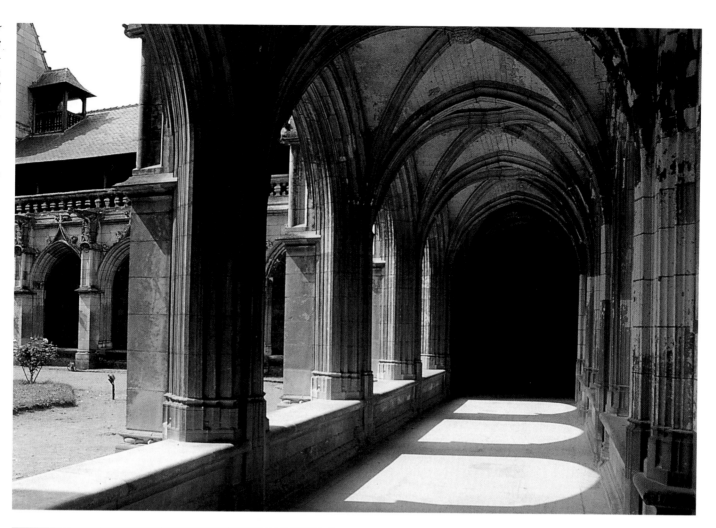

Tours. The cloister adjoining the Cathedral of Saint-Gatien was built in the fifteenth and sixteenth centuries for the Dominicans. Its name, la Psalette, refers to the psalms once rehearsed here by the cathedral choristers.

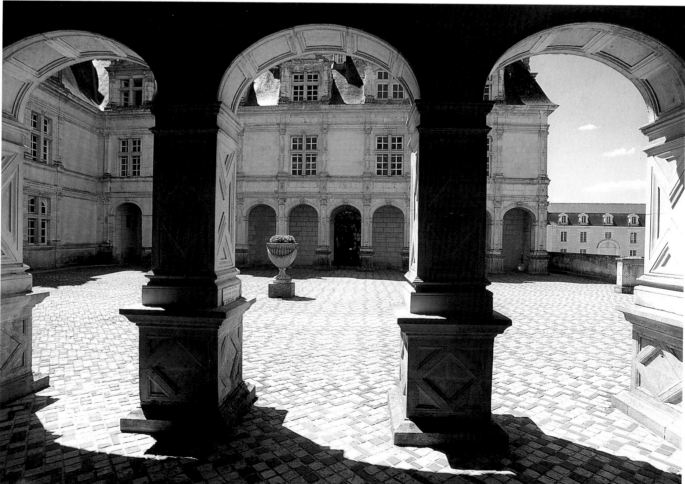

Villandry. Most visitors to Villandry concentrate on the magnificent gardens. This view of the impressive inner courtyard suggests that the château itself also deserves close inspection.

for light-hearted flirtation, hearts and flowers for tender love. Swords symbolize tragic love, while a labyrinth of broken hearts represents overwhelming passion. On the highest level are the water gardens, whose ponds are designed to supply water to the ornamental and vegetable gardens. Together the gardens exemplify the basic principle of Renaissance garden design: to achieve a combination of beautiful shapes with symbolic meaning and practical usefulness.

Langeais The Château of Langeais has occupied a key strategic position since time immemorial. Standing close to the border between Anjou and Touraine, it was often a bone of contention between the two dukedoms. In the late Middle Ages, Langeais provided Louis XI with a bulwark against Brittany. He had the old fortress pulled down and replaced by the present building, which makes no secret of its militaristic intention. Only with the historic marriage of Charles VIII to Anne of Brittany in 1491 did Langeais relinquish its former role as a frontier post, and it was no coincidence that the wedding celebrations took place at Langeais. Despite repeated changes of ownership, the buildings have not been substantially altered since the eighteenth century, and the interior has remained largely untouched. The château boasts a dizzying array of *tapestries*. The great *banqueting hall*, with its vast

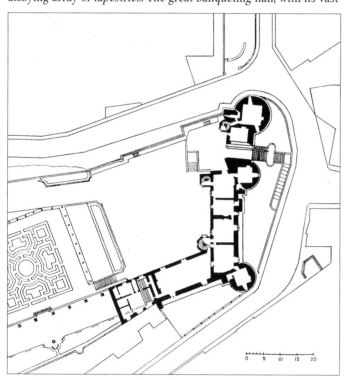

Langeais. Ground plan of the apartments. Three round towers protect both sections of the building. Most of the moat has now been filled in.

beams made from the trunks of chestnut trees, is particularly impressive. Chestnut was also the preferred wood used in the living and bedrooms, since it has the virtue of attracting spiders, which in turn can be relied upon to make short work of undesirable pests.

Ussé Close to the border with Anjou, the Château of Ussé is the quintessential late medieval castle. The felicitous harmony between the fifteenth-century ramparts and the charmingly arranged residential buildings, dating from the sixteenth century, creates a romantic scene that epitomizes the fairy-tale castle, especially in its setting amid dense woodland reaching right up to the château walls.

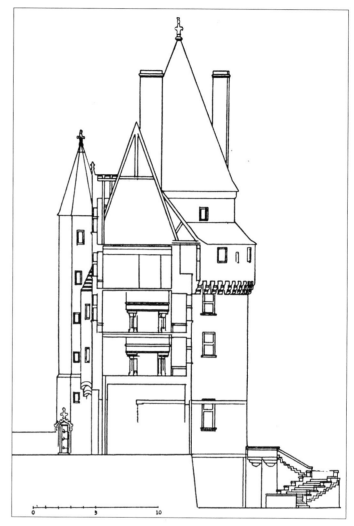

Langeais. Cross section of the apartments.

Azay-le-Rideau The joyful, exuberant face of the Renaissance beams at visitors to the Château of Azay-le-Rideau, once called Azay-le-Brulé (burnt-down Azay). The name recalls an episode from the Hundred Years War. Azay was taken over by a Burgundian garrison, who hurled abuse at the Dauphin, the future Charles VII, as he passed by. Enraged members of the Dauphin's entourage launched a surprise attack on Azay, and massacred the Burgundians. From the ruins sprang the enchanting château in the middle of the River Indre, built by *Gilles Berthelod*, treasurer to Francis I, between 1518 and 1529. The unity of the exterior of the building, composed of two wings with slender round towers at each corner, is modelled on medieval lines. In this case, however, the fortified tower has been transformed into an adornment, while the large windows and the abundant decorations clearly take their cue from Blois, which is itself a vibrant synthesis of traditional French

Continued on page 181

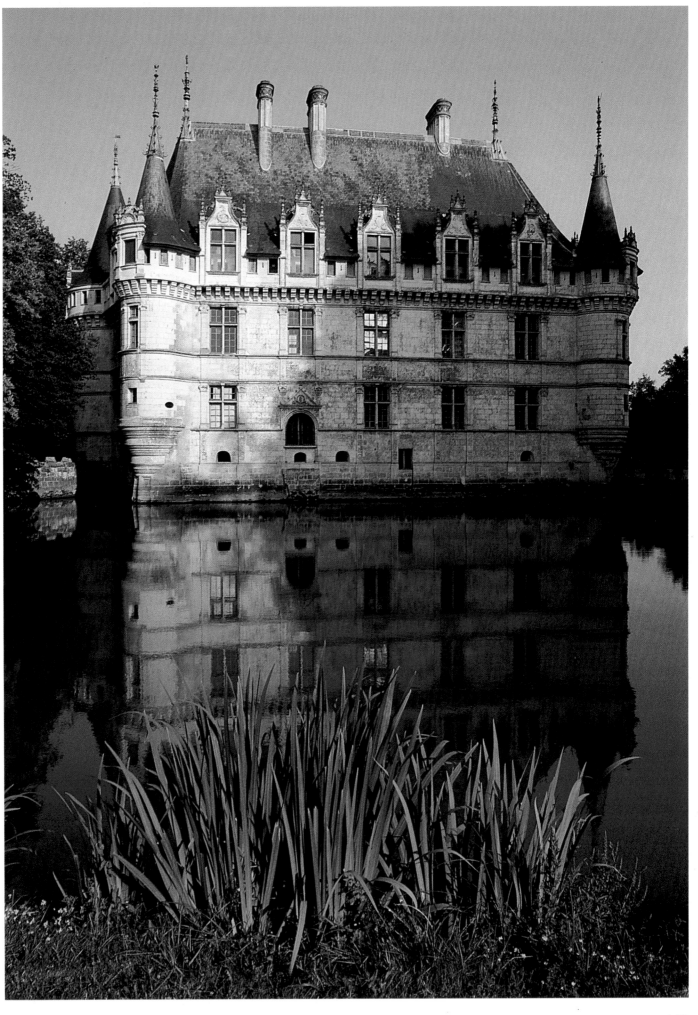

Azay-le-Rideau. In the Middle Ages, the moat was there to defend the château. Renaissance architects exploited the location of the building on a small island for aesthetic ends. The reflection of the château on the still surface of the water only adds to its charm.

Overleaf: The Château of Ussé originally consisted of four wings and an inner courtyard. In the seventeenth century, under Louis de Valentinay, the north wing was demolished to give an uninterrupted view across the Indre valley, and was replaced by a sloping terraced garden.

163

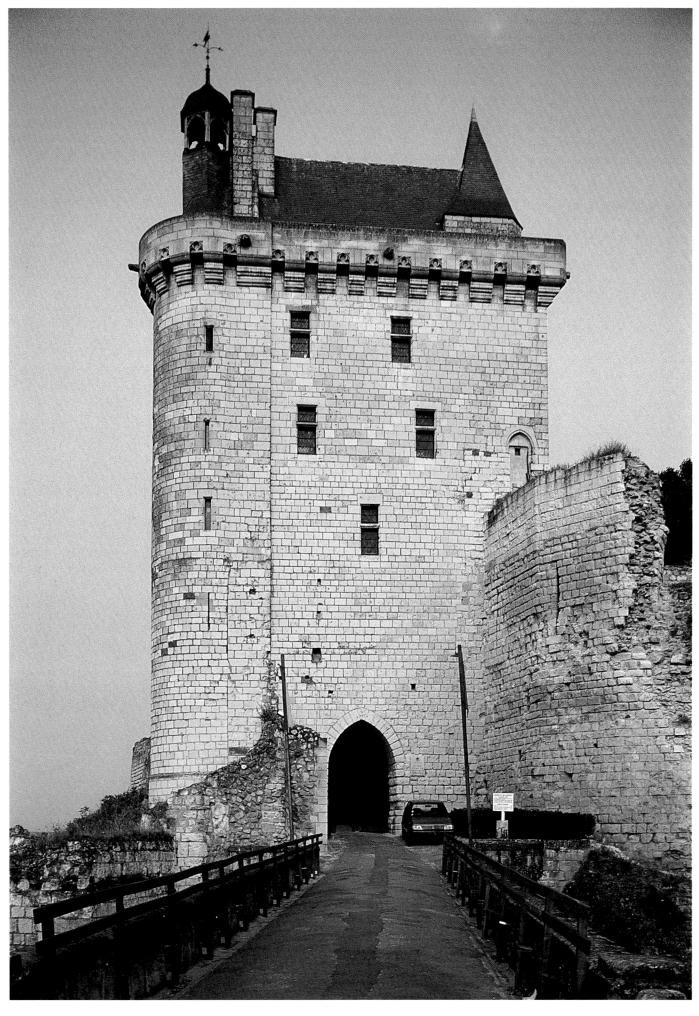

The massive 'Tour de l'Horloge' protects the entrance to the 'Château du Milieu', centrepiece of the vast château complex of Chinon. This is the only undamaged part of the largely ruined building which, in the Middle Ages, was one of the kingdom's best-protected strongholds.

Chinon. Above the rooftops of the town, the great ruins of the château provide an impressive architectural backdrop.

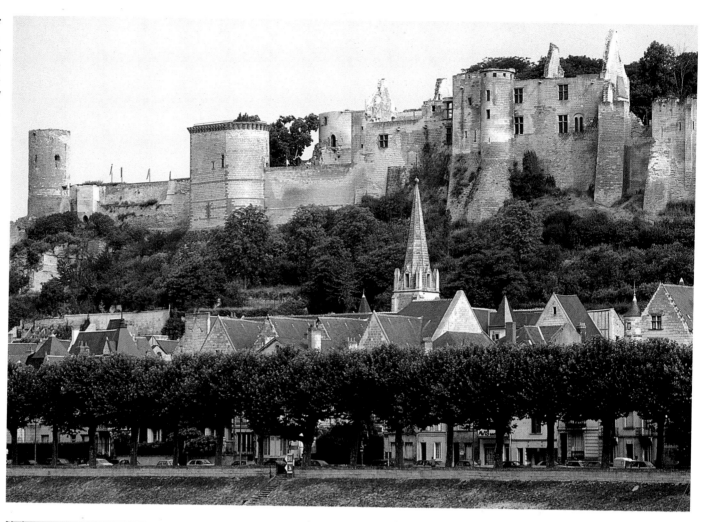

Although Ussé dates from the Middle Ages, its exuberant appearance makes it clear that, in the decades following the Hundred Years War, the defensive function of châteaux played a secondary role.

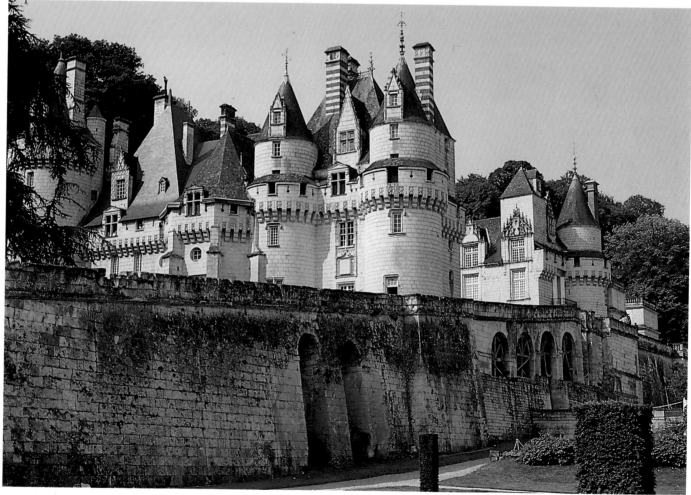

167

A family photograph of the present owners of Brissac, who still keep up a charming tradition. In the old days, feudal lords always tried to follow trends set by the king; today, some of them like to emulate the President of the Republic. Brissac's owners have two labradors, just like Monsieur Mitterrand.

Only in the middle of the last century, when the Château of Chinon was in danger of imminent collapse, was there any attempt to shore up the walls. From the walls, there is a fine view across the valley of the Vienne.

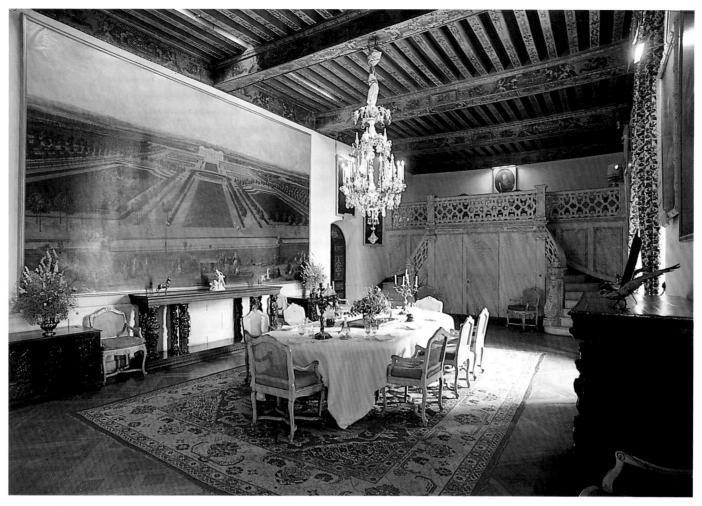

The dining room at Brissac has an exquisite minstrels' gallery (rear right of the photograph) where musicians sat serenading guests while they ate. The eighteenth-century, gilded, coffered ceiling is one of the château's treasures.

Brissac is one of the few châteaux still occupied today, so the rooms are homely with no museum-like atmosphere.

Charmingly decorated and furnished in wine red, Brissac's delightful little theatre offers the chance of experiencing chamber music concerts in the atmosphere of a château.

The so-called Judith Room at Brissac, where Louis XIII and his mother, Maria de Medici, are said to have been reconciled.

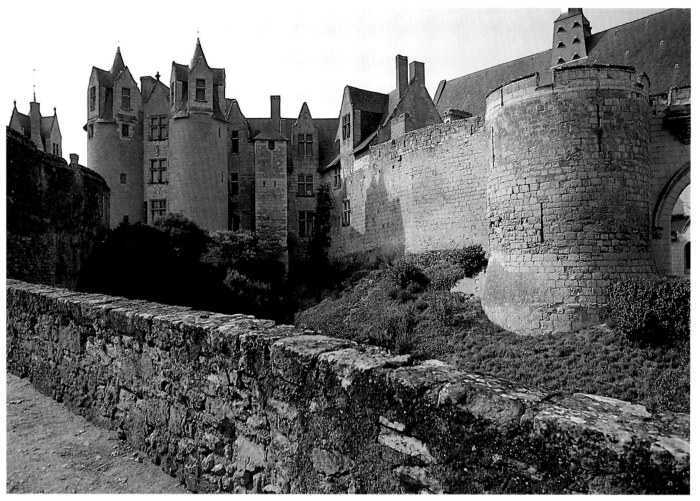

The Château of
Montreuil-Bellay,
standing high above
the Thouet valley, is
protected by a great
curtain wall. The
château complex
comprises several
buildings. On the left
of the photograph is
the old château, on
the right the entrance
to the fortress.

Baron Xavier de
Thuy, Montreuil-
Bellay's present
owner, poses for the
camera outside his
ancestral home. Four
separate entrances
lead to the rooms
where the four canons
attached to the
chateau's chapel once
lived.

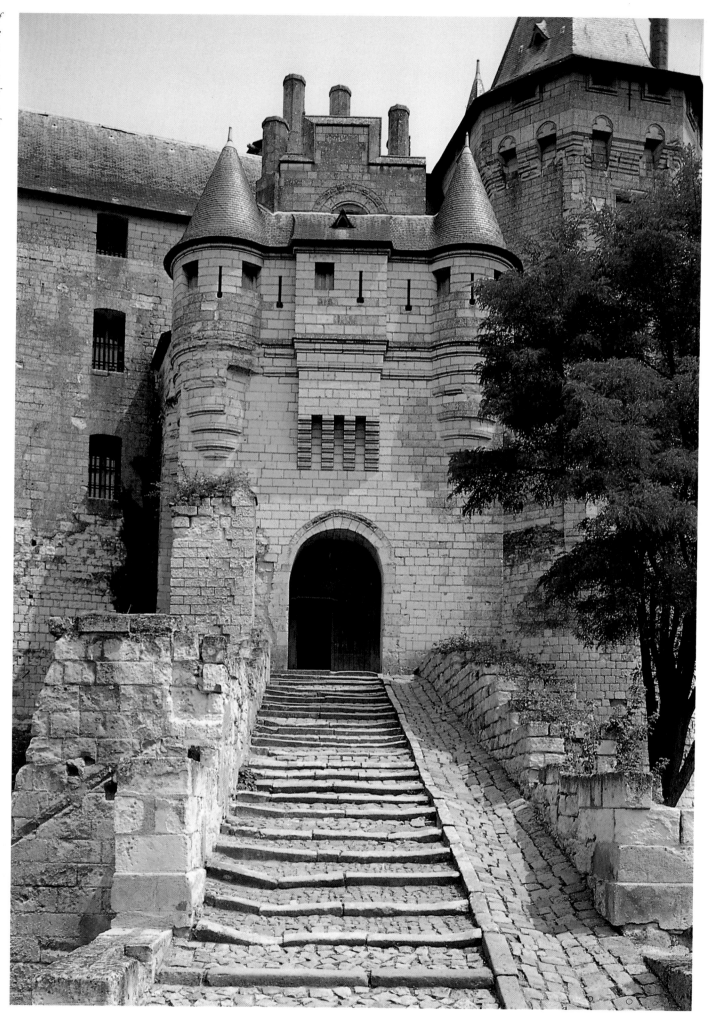

An uneven flight of steps leads up to the Château of Saumur. It now houses two museums, one with a collection of decorative arts, the other a museum of horses and saddlery.

Overleaf: The façade of the Château of Serrant is enlivened by the contrasts produced by the use of different building materials. The château, built in three sections, is surrounded by a vast park.

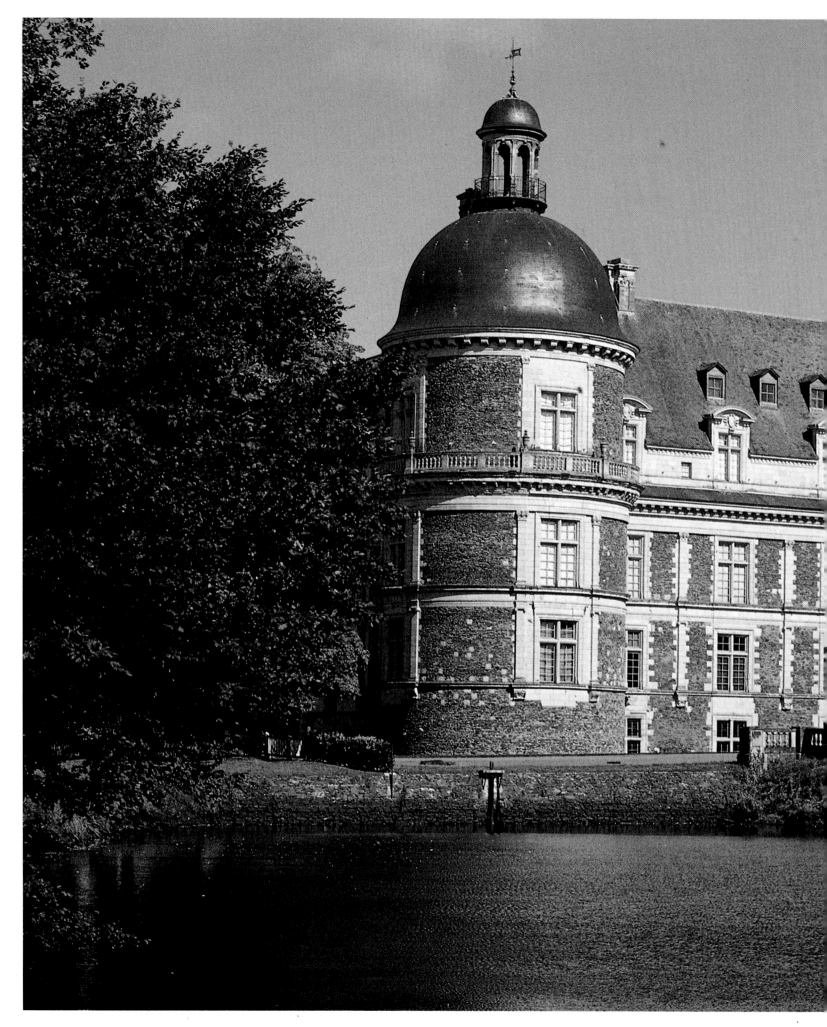

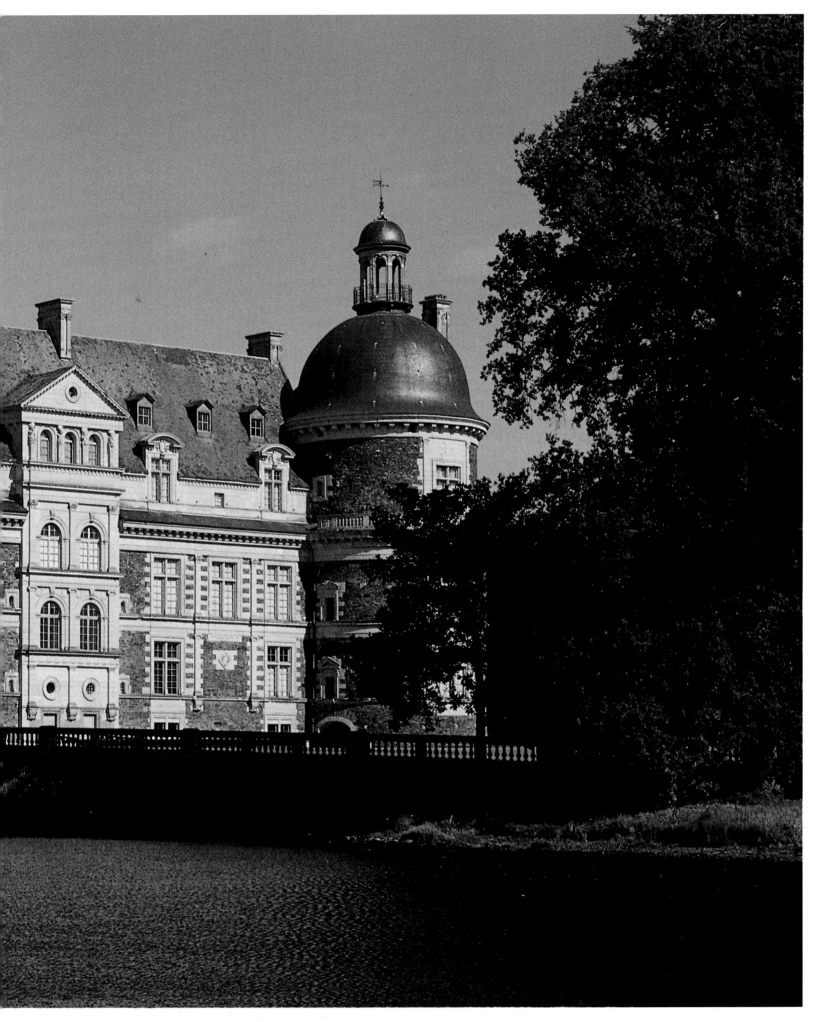

Le Rivau is one of the more modest châteaux. Although only a few kilometres south-east of Chinon, few visitors stray this way.

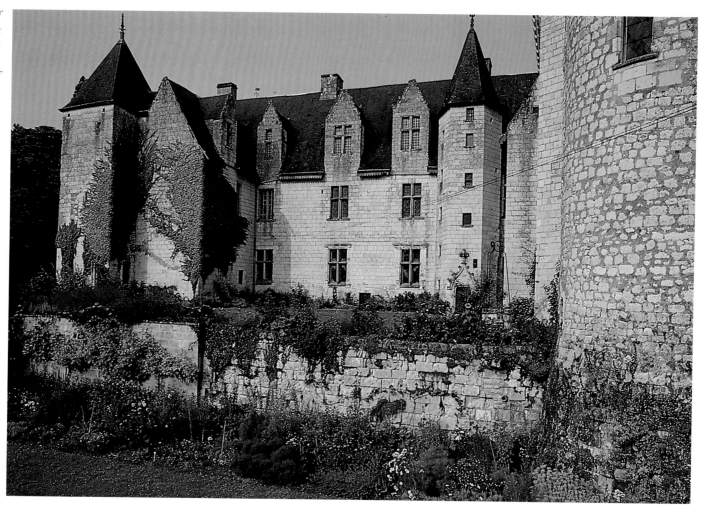

A drawbridge leads into the courtyard of Le Rivau, where the Renaissance-style apartments are open to visitors.

Overleaf: Some châteaux stage Son et Lumière *performances, with lighting effects, music and fireworks, on different themes each year. Here a dazzlingly illuminated Azay-le-Rideau is reflected in the waters of the Indre.*

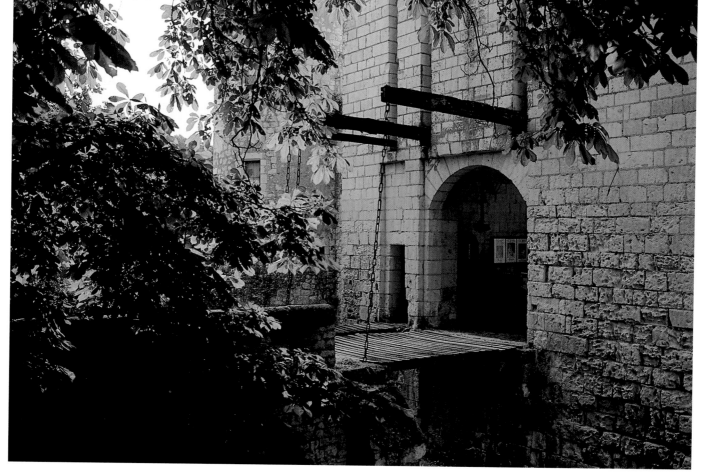

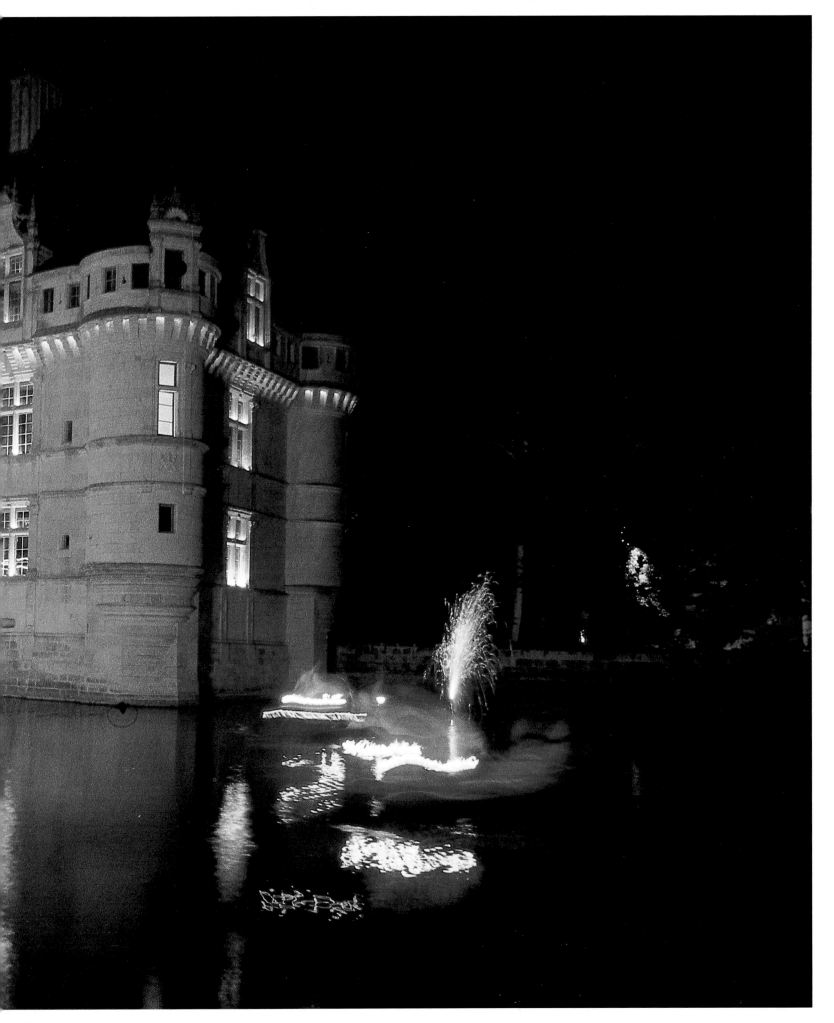

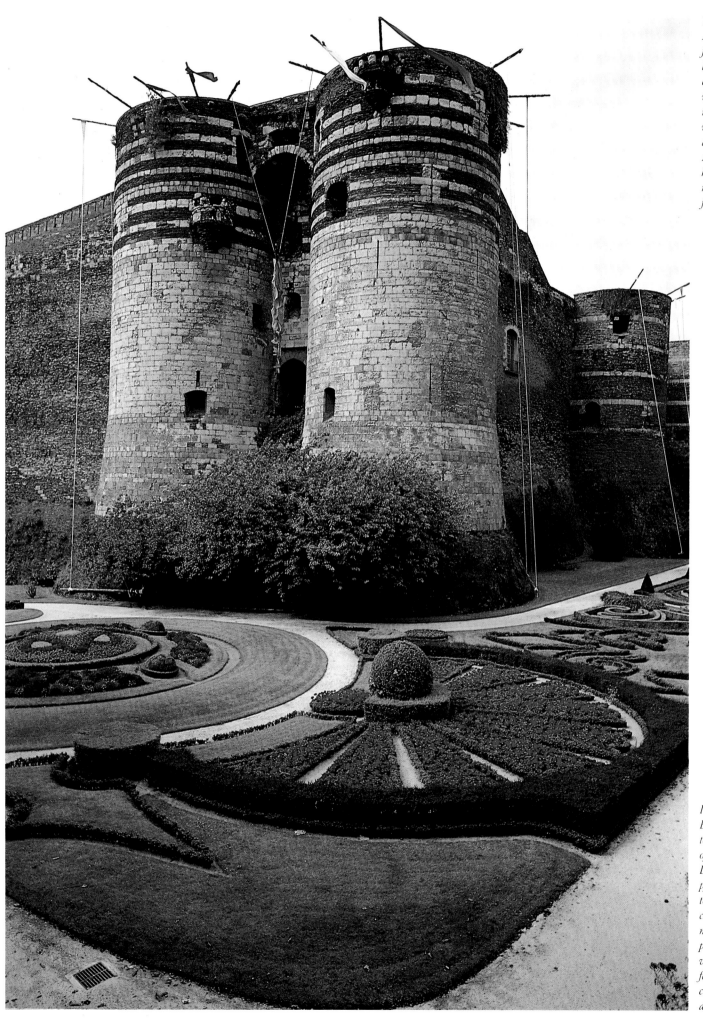

The Château of
Angers is a
fortification encircled
by round towers and
curtain walls. On its
western side it is
made even less
vulnerable by the steep
drop to the River
Maine. Large
herbaceous borders
now occupy the
former moat.

Pages 182/3:
Between the two tall
towers of the Church
of Saint-Ours in
Loches are two low
pyramid-shaped
towers. Inside the
church, above the
nave, they form high
pointed octagonal
vaults – an unusual
feature of twelfth-
century religious
architecture.

180

forms and Italian innovations. Even the water in the moat no longer serves any defensive purpose. Instead, it is used to produce a reflection to enhance the château's visual appeal. Although Azay cannot compete with Chambord, Blois or Amboise in terms of size, the immaculate little building radiates such charm that it attracts almost as many visitors.

Azay-le-Rideau. Ground plan of the building's two wings.

Near the château, in the village of Azay and rather undeservedly overlooked by many visitors, is the Romanesque church of *Saint-Symphorien.* The façade includes very flat bas-relief panels, depicting figures of saints, an archaic example of Romanesque sculpture in the Loire Valley, dating from around the middle of the eleventh century.

Saché Far less spectacular, but nevertheless worth a detour, is the little Château of Saché, not far from Azay. Built in the sixteenth century and restored in the eighteenth, it was for twenty years the country home of Honoré de Balzac. The interior has remained virtually untouched since the great novelist's death and is now a museum.

A further detour leads to the village of *Villaines-les-Rochers,* where basket-weavers can be seen practising their craft in numerous workshops.

Loches The third of our excursions from Tours takes us to southern Touraine where the accent is once again on medieval religious architecture. First stop is Loches, the archetypal walled city. In the twelfth century, the town was the eastern outpost of the Plantagenets' Angevin empire, but was returned to France by right of succession in the thirteenth century and from then on was the site of a state prison. In an elongated oval, the curtain walls, protected by numerous towers, encircle the rock soaring above the Indre.

At the southern corner, the fortress' most vulnerable point, the Counts of Anjou constructed a fortified tower in the eleventh century, the best-preserved example of early medieval feudal architecture in the whole Loire region. It is matched at the northern end of the city by the château, a blend of late medieval and Renaissance features. In the fifteenth century, the château was the home of *Agnès Sorel,* mistress of Charles VII. Her tomb, which was previously in the nearby church of Saint-Ours, was transferred to the château in 1970. Visitors taking a guided tour of the building are shown the room where, according to tradition, Joan of Arc persuaded the apprehensive Dauphin to travel to Reims for his coronation.

Near the château is the Romanesque *Church of Saint-Ours.* Inside, under two rather curious, pyramid-shaped roofs, are two dome-shaped vaults, an ingenious example of the twelfth-century

Azay-le-Rideau. Cross section of the staircase.

domed architectural style of Aquitaine. An enclosed porch leads to a magnificent portal decorated with a whole series of carved figures, the most complex of its kind in the Loire Valley. The archi-

181

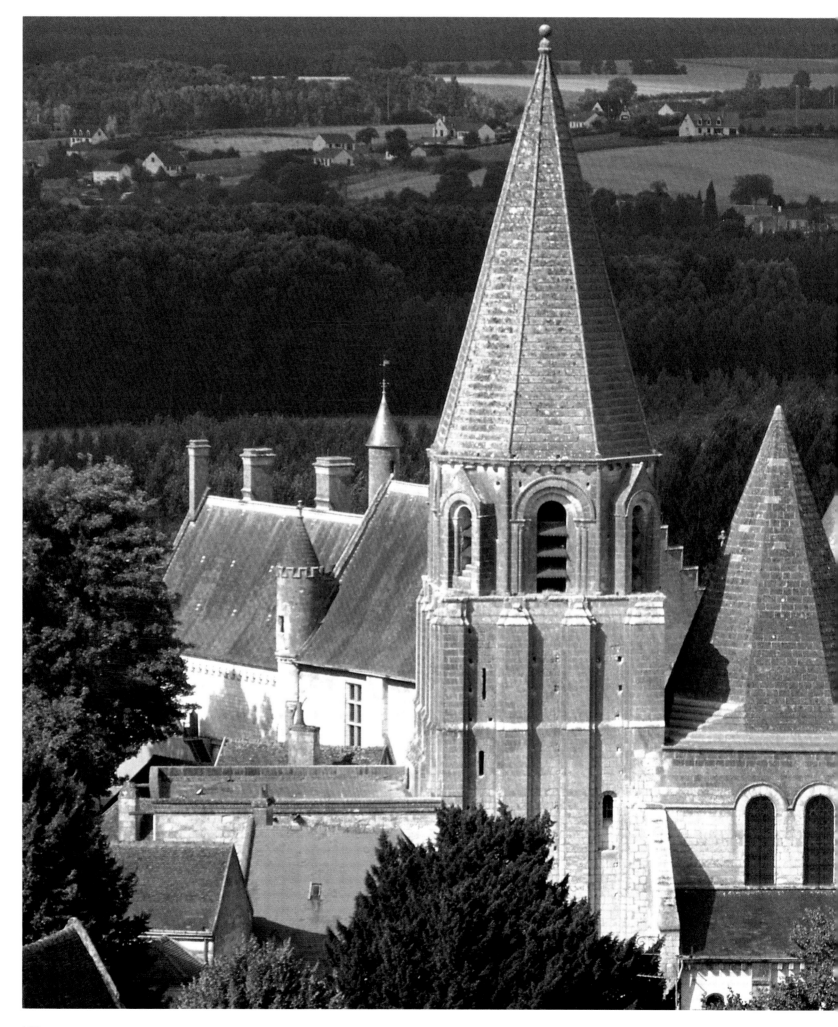

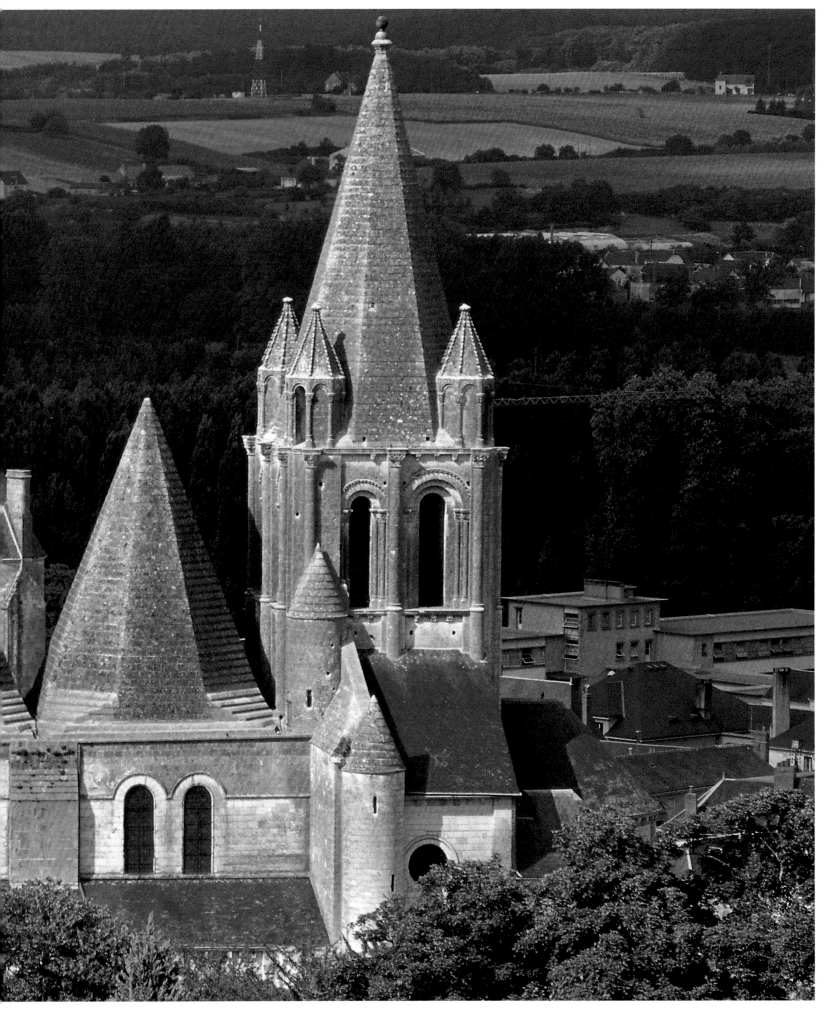

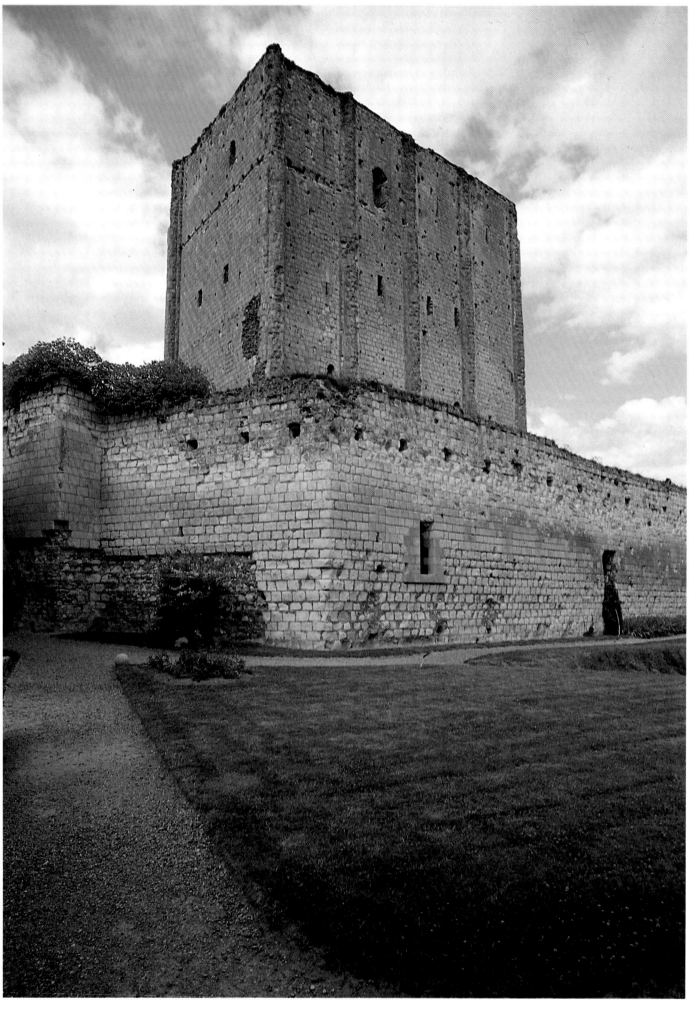

Approached from the north, the ramparts and the donjon – symbol of Loches – appear invincible, which is precisely the impression the massive keep was intended to give. In the event of enemy attack it also provided a place of safety and shelter for the occupants.

volts above the entrance are modelled on the Romanesque style typical of neighbouring Poitou. The large figures on the wall above and beside them are assumed to be of somewhat later date, since they show early Gothic influences.

Le Liget Just to the east of Loches, is the *chapel of Saint-Jean-de-Liget*, once part of a former Carthusian monastery founded by Henry II of England to atone for the murder of Thomas à Becket, Archbishop of Canterbury. This rotunda is decorated on the inside by a well-preserved series of Romanesque murals.

Turning westwards from Loches, towards the valley of the Vienne, more Romanesque monuments wait to be discovered.

L'Ile-Bouchard On the way to Chinon it is easy to fit L'Ile-Bouchard and Tavant into your itinerary. At Ile-Bouchard, the *choir* is the only surviving section of the former *priory church*. Exposed as they are to the clear light of day, the rich details of the elabo-

Augustus, King of France, each left their mark on the face of the fortress. Accordingly, there are three distinct sections of the château complex: the *Fort Saint-Georges*, the *Château of Milieu* and the *Château of Coudray*. In 1308, members of the Order of Knights Templar were incarcerated in the keep of Château of Coudray, until King Philip the Fair brought them to trial in Paris on a flimsy set of accusations. In reality, the crown was attempting to undermine the influence of the powerful order and to use its legendary wealth to replenish the ailing state coffers.

Inscriptions scratched by unfortunate inmates can be seen on the stones of the former prison. The first meeting between Joan of Arc and the Dauphin took place in the apartments in the now ruined château du Milieu. Because of the initial scepticism about the sacred mission of the Maid of Orléans, she was taken from Chinon to Poitiers, where she was subjected to two weeks of interrogation by a commission. Only then was she recognized, and sent to Orléans with a small army. In the seventeenth century, Riche-

It is clear from the ground plan of the Château of Chinon that the complex consisted of several buildings constructed at different times.

rately carved *capitals* can be closely examined. The emphasis on the human figure rather than on ornamentation, somewhat unusual in Romanesque sculpture, is a characteristic of the work of the twelfth-century sculptors in the Auvergne, to which the Ile-Bouchard capitals are closely related.

Tavant More *Romanesque murals* can be admired in Tavant's little church. Connected scenes surrounding the birth of Christ – the Annunciation, Visitation, Nativity, the Slaughter of the Innocents and the Flight into Egypt – are represented, together with Christ in Glory, set in a mandorla. The vaults of the small *crypt* feature more scenes from the Old and New Testaments, as well as mythological and allegorical paintings.

Chinon At Chinon, we finally arrive at the threshold of Anjou. This frontier post was bitterly contested for centuries and was therefore developed into a citadel, as strongly fortified as Loches. Henry II Plantagenet, his son Richard the Lionheart and Philip II

lieu ordered the château to be razed to the ground because of the Protestant sympathies of its occupants. This is why the once vast building is now no more than a ruin.

The town also has a large number of historic houses. On the edge of town stand the ruins of the *Church of Sainte-Radegonde*, partly hewn from the rock face. A sensational fresco was discovered here in 1964. It shows Eleanor of Aquitaine with her youngest son John Lackland, his wife Isabelle of Angoulême and two royal kinsmen, one of them with a falcon. Painted around 1200, it is an unusual example of secular painting during the transition from the Romanesque to the Gothic.

JOURNEY'S END: ANJOU

The history of Anjou is closely bound up with the Plantagenet dynasty, whose representatives await visitors right at the start of their journey at Fontevraud Abbey. In the abbey church, Eleanor of

Aquitaine, her second husband Henry II of England, and their eldest son Richard the Lionheart, rest in their magnificent tombs.

Fontevraud The abbey was founded by *Robert d' Arbrissel*. In 1091 he formed a *monastic community*, with a monastery for men and a convent for women. The appointment of a single abbess to control both establishments aroused considerable controversy at the time. Two more communities were founded to provide shelter for those on the margins of society: lepers, convicts, prostitutes and other outcasts. Eleanor of Aquitaine, who had wholeheartedly supported Fontevraud in its work, herself retired there in old age. Fontevraud became the mother house of a congregation which, in its heyday, ruled eighteen monasteries throughout France. Later, however, the altruistic intentions of the order's founder were consigned to oblivion. In the eighteenth century, Fontevraud, whose twenty-six abbesses had all been of noble blood, fourteen of them princesses, was acknowledged to be the wealthiest monastery in the land. Its charitable aims were completely obscured by a way of life resembling that of a royal court, which explains why, during the Revolution, the population vented their anger against the monastery with such unbridled ferocity. Many of the nuns were condemned to the guillotine and large sections of the building fell victim to the pick-axe. What survived was converted into a prison, and was used as such until 1963, when extensive restoration began. The abbey with its rich history was later opened to the public.

The twelfth-century abbey church is the epitome of an *Aquitaine-style domed church*. The nave is divided by pilasters into four bays with a single aisle. Above it rise four massive domes whose monumental dimensions give the relatively low nave a feeling of space. The wide transept containing the Plantagenet tombs leads to the choir which is surrounded by an ambulatory and radial chapels. Another reminder of the Romanesque period is the *former monastery kitchen*, the most curious example known to us from the Middle Ages. Four communities living together under one roof needed a large kitchen in order to feed their many members. The building is octagonal. A large rectangular space in the centre is surrounded by eight apse-like sections, each equipped with its own fireplace. A whole forest of smoke outlets can be seen on the outside of the building. All the other buildings in the Fontevraud complex date from later periods, particularly the eighteenth and nineteenth centuries.

Candes-Saint-Martin Only a few minutes away from Fontevraud, Candes-Saint-Martin, standing at the confluence of the Vienne and the Loire, is home to another piece of medieval religious architecture. The *church* was built on the spot where, according to tradition, Saint Martin died. The existing building typifies perfectly the Angevin style with its spacious, billowing, eight-ribbed vaults.

Saumur The next port of call on the journey westwards is another magnificent château: Saumur. Towering above the Loire, it can be seen for miles around. Despite some alterations carried out during the Renaissance – such as enlarging the windows – the château is still predominantly a well-fortified, square, medieval stronghold. Saumur was so highly regarded in the fifteenth century, that it featured in the background of the illumination depicting the month of September in the *Très Riches Heures du Duc de Berry*.

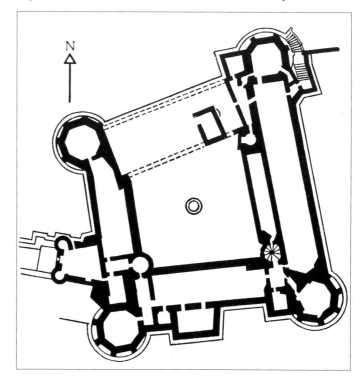

Saumur. As also occurred at Chaumont, one of the four sections of the original château was torn down in the seventeenth century to make way for a terrace giving an uninterrupted view of the surrounding countryside.

However, Saumur's golden age came in the late sixteenth century, when Protestants enjoyed the protection of Henry IV. The governor, the *Duke of Duplessis-Mornay*, known half-scornfully, half-fearfully as the 'Huguenot Pope', founded a Protestant university here that soon acquired an international reputation. Saumur was thus particularly hard hit in 1685, when Louis XIV revoked the Edict of Nantes issued by his grandfather. Two-thirds of the population joined the mass exodus of Huguenots from all over France. The town took hundreds of years to recover from the blow.

The château is home to a fine *museum of decorative arts*, whose excellent exhibits include a priceless *porcelain collection*. No one should leave Saumur without visiting the *Romanesque church of Notre-Dame-de-Nantilly* and the prestigious *National Riding School*.

Montreuil-Bellay South of Saumur, the château of Montreuil-Bellay is worth a detour. The four buildings forming the château complex originate from different periods. The oldest was built in

186

Continued on page 195

Many worshippers come to Tours Cathedral to pray in this brightly decorated side chapel with its altar dedicated to Our Lady.

Overleaf: A stylish setting for a quick coffee – there are many such places in Tours.

187

A typically French way of relaxing – a game of boules beside the suspension bridge at Langeais.

There's no escaping the châteaux: even this ice cream cart is decorated with a picture of one of them, in this case Azay-le-Rideau.

Tours. Half-timbered houses are still a common sight in towns along the Loire Valley. Stone was an expensive building material which only the wealthy – which usually meant the church and the aristocracy – could afford.

In Amboise: in this case 'Le Château' is a good place to stop for a drink. You can always cycle from one château to another, which is certainly better for the environment. Allow at least seven days from Orléans to Angers.

Overleaf: The pleasures of the Château of Serrant: 20,000 books to browse through, or a game of billiards.

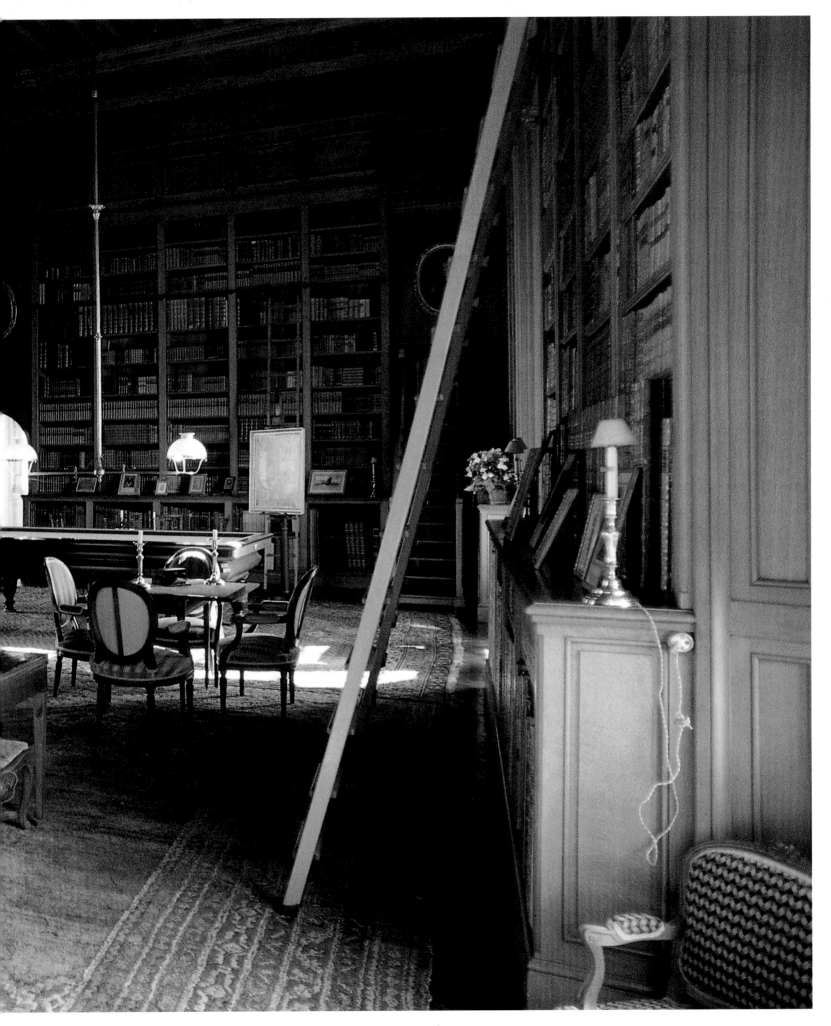

The sun's rays add a warm glow to the elegant study and library at Serrant.

the thirteenth century, and the more recent date from the fifteenth and sixteenth centuries. The complex is divided into the *châtelet*, the *Petit château,* and the *Nouveau château.* There is also the *kitchen*, set apart from the main building, clearly modelled on the kitchen at Fontevraud.

Cunault Continuing from Saumur towards Angers, there is a choice of two routes. One leads along the left (south) bank of the Loire to Cunault. The small town's *Romanesque church*, with its nave and two side aisles, was clearly influenced by the architectural style of Poitou. Angevin vaulting was added at a later date.

Cunault's greatest claim to fame is a *series of more than two hundred capitals*, one of the most extensive of its kind in the entire history of medieval art.

Brissac Another essential stop along the way is the Château of Brissac, just before Angers and one of the few châteaux in the Loire Valley built in the seventeenth-century *style Louis-Treize.* Nevertheless, it incorporates part of its medieval predecessor, most obviously in the massive round tower. More attractive than Brissac's rather inharmonious outward appearance is its interior, where some of the rooms are exquisitely furnished. Brissac was the scene of yet another historic meeting, an encounter that was to transform the spirit of the age. It was here that Louis XIII was reconciled with his mother Maria de Medici, second wife of Henry IV, whom he had kept locked away at Blois for many years. In order to come to Brissac, she had made a daring escape from Blois.

Boumois The alternative route along the right bank of the Loire leads past yet more châteaux. The first on the road from Saumur to Angers is Boumois, whose situation off the main tourist trail means it attracts few visitors, which makes it especially appealing. Its bold round towers date from the fifteenth century, a time when the master builder's most important brief was to protect the château in the event of enemy attack. The sections linking them were remodelled in the sixteenth century, so that even Boumois could enjoy the exuberance of the Renaissance, which can also be seen from the furniture preserved inside the château.

Montgeoffroy The next stop is the Château of Montgeoffroy. Dating from the eighteenth century, this was one of the last châteaux to be built in the Loire Valley. The classical restraint of the three-storey building seems to symbolize the dwindling self-confidence of the declining feudal aristocracy. Even in this late example, the slightly protruding corners and the discreet emphasis of the central projection confirm that château architecture is firmly rooted in medieval fortress design. Since the château was left in peace by the Revolution and remained in the possession of one family, the interior is completely unspoiled. Every table, every armchair, every wall hanging has stayed in the very same place for

which it was intended, giving visitors a true insight into the grand and, at the same time, rather austere way of life on an aristocratic country estate on the eve of the French Revolution.

Plessis-Bourré Before heading for Angers, turn northwards into the Sarthe valley, where the Château of Plessis-Bourré provides a perfect illustration of a well-fortified medieval feudal residence. Unlike most of its contemporaries, this fifteenth-century building has undergone practically no change (externally, at least). A wide moat surrounds the four-section building arranged in a strict rectangle, with a massive round tower at each corner. A bridge forty-three metres long crosses the moat. At the time the château was built, what now appears as a charming detail in a romantic scene was an essential safety measure to protect the lives of the occupants. On arriving at the inner courtyard the picture changes. Here, the modifications made in the Renaissance soften the building's rugged medieval features.

Angers Of all the cities of the Loire, Angers is without doubt the most attractive, not only because of the array of interesting monuments, but also thanks to the picturesque atmosphere of the historic old town. Looming over the city is the *château*, whose west-facing ramparts plunge steeply down to the banks of the Maine, which flows into the Loire a few kilometres further south. The irregularly shaped château complex is protected by a curtain wall with seventeen fortified towers. It was built in the thirteenth century, after Louis IX (Saint Louis) handed Anjou over to his younger brother Charles. The buildings within the walls were not constructed until the fifteenth century, when the star of the Anjou dynasty whose power had spread through Provence as far as Naples and Sicily, was already on the decline. The final additions to the château were carried out in the days of *René the Good*, the highly cultivated titular king of Sardinia, who stood idly by as the imperious Louis XI seized the throne of Anjou. René withdrew to Provence, another of his dominions, where he died in 1480. With him, the Anjou dynasty came to an end and Provence finally became part of France.

The château's greatest treasure is the *Apocalypse Tapestry*. Originally 168 metres long, the 70 scenes from the Apocalypse that survive after being torn apart during the Revolution still occupy an impressive length of 107 metres. Commissioned in 1380 by Louis of Anjou, it was executed in a Paris workshop and is now regarded as the finest medieval tapestry in Europe. It is worth the journey to Angers just to see this great work of art!

The spiritual centre of the city of Angers is the *Cathedral of Saint-Maurice.* Built in the twelfth century (the choir section was added in the late Middle Ages), it is a blend of Romanesque and Gothic styles and is among the most original masterpieces of French medieval architecture. The Angevin vaults above the nave are the oldest examples of this local form of vaulting. The culmination of

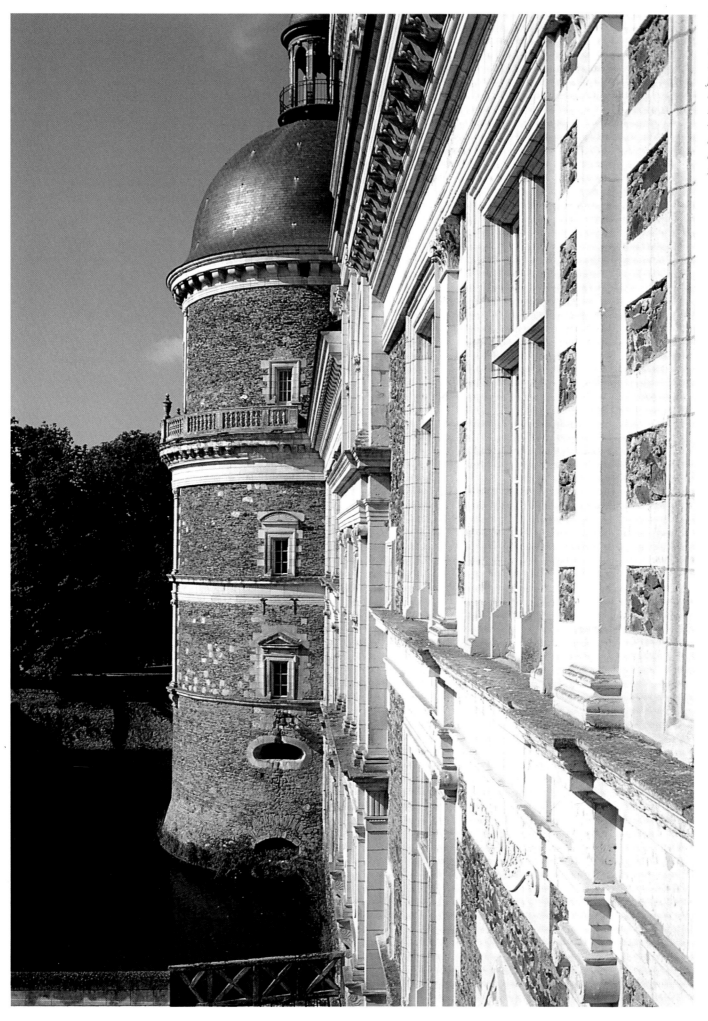

The Château of Serrant. Massive round towers flank the sweeping rear façade, one of the château's variously shaped sections, whose unique effect is created by the use of contrasting types of stone.

196

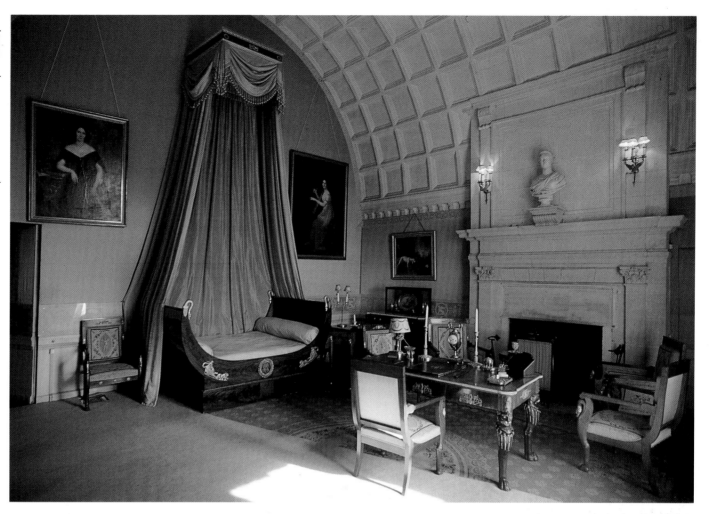

Above and below: Interior views of Serrant. Both Louis XIV and Napoleon visited the owners of the château, whose interior design is strongly influenced by the styles prevailing in the times of these illustrious guests. The homely atmosphere of the rooms is also due to the fact that Serrant is privately owned and still occupied.

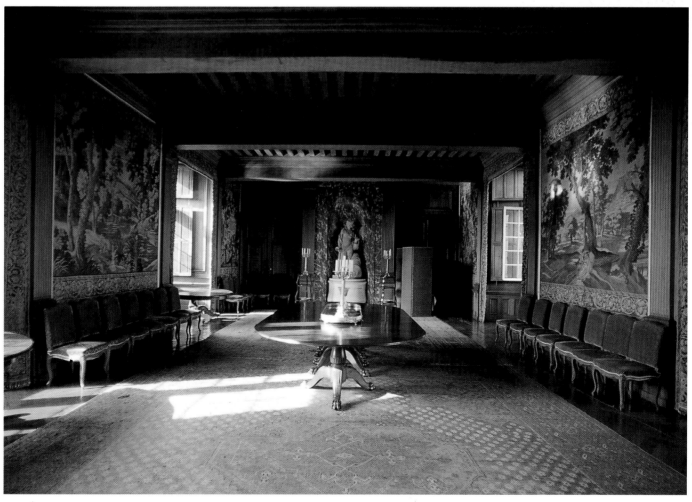

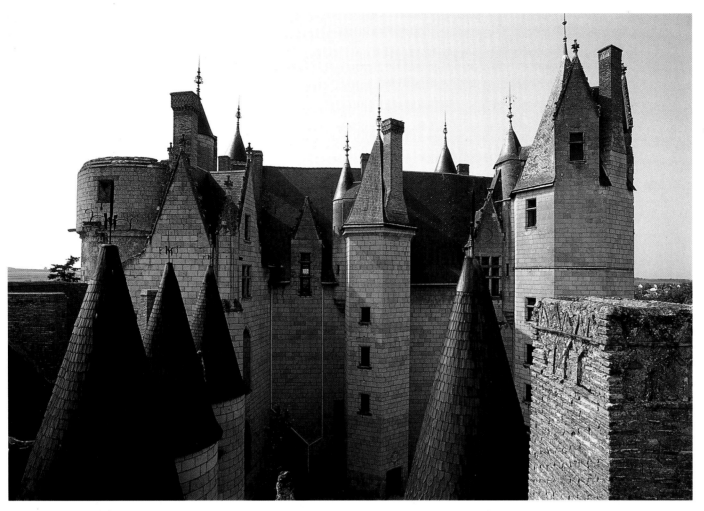

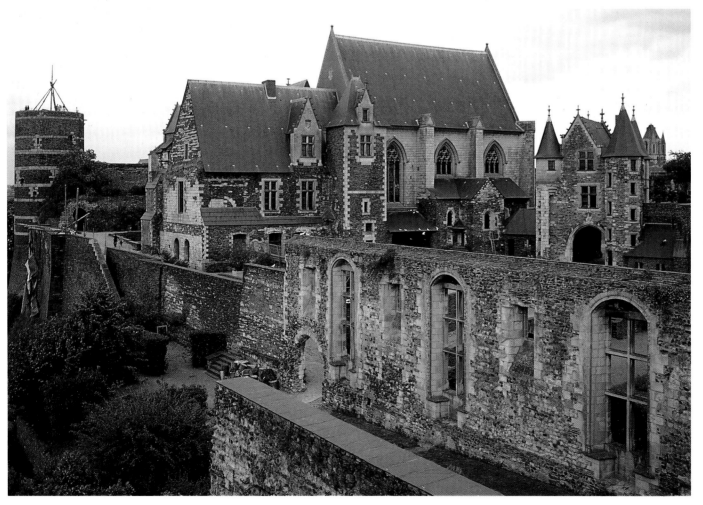

The so-called Petit
Château at
Montreuil-Bellay also
dates from the
fifteenth century. It
was here that the
clergy attached to the
château had their
living quarters.
Adjoining the Petit
Château on the left is
the kitchen, assumed
to be a more modest
version of the abbey
kitchen at
Fontevraud.

Built only in the
eighteenth century for
Field-Marshal de
Contades,
Montgeoffroy is both
the most recent and
the last of the
châteaux of the Loire
Valley.

199

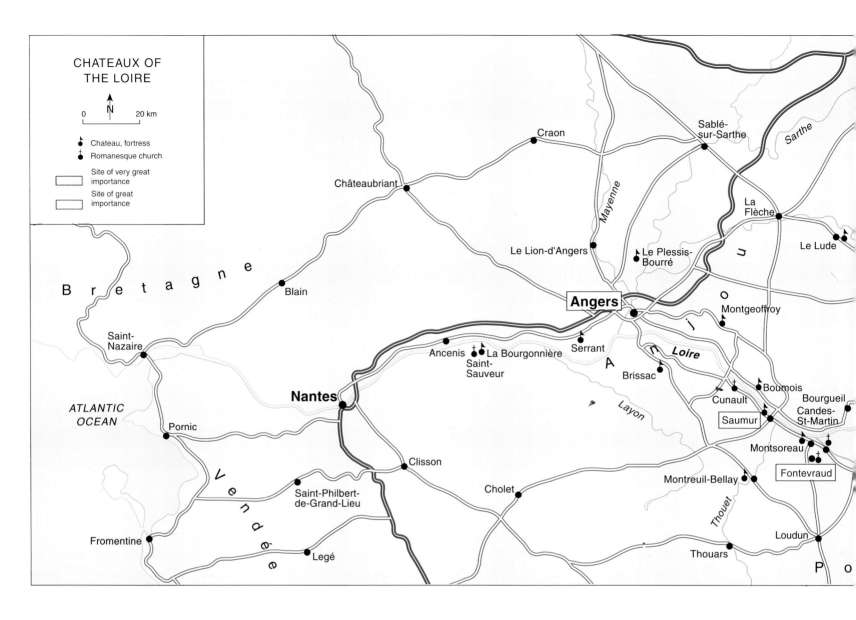

the Angevin style can also be seen in the city. The elegant vaulting, created at the turn of the thirteenth century in the *choir of the Church of Saint-Serge*, has been compared to billowing sails. The former *Hospital of Saint-Jean* is also of Romanesque origin. Other Romanesque and Gothic churches testify to the dominant position of Angers in the twelfth and thirteenth centuries, although in some cases only fragments remain. They include *Saint-Aubin*, with the vestiges of a cloister; *Saint-Martin*, one of the oldest churches in the Loire Valley, dating back to the eleventh century; the ruined *Toussaint abbey*, as well as *Notre-Dame-du-Ronceray* on the opposite bank of the Maine.

For many visitors to the Loire Valley, Angers marks the journey's end. We should like to add a coda to the great château symphony, extending the itinerary to Nantes.

Serrant A final, triumphal climax of château architecture awaits the visitor to Serrant, ten kilometres west of Angers. Although built in stages between the sixteenth and eighteenth centuries, the château creates an amazingly harmonious whole. The courtyard was adapted from a medieval castle moat. The château itself consists of three wings of considerable dimensions and can be described as a felicitous blend of Azay-le-Rideau and Versailles.

La Bourgonnière Halfway between Angers and Nantes, on the left bank of the Loire, is La Bourgonnière, a château only constructed in the days of Napoleon I, in the early nineteenth century. The main attraction here is not the classical château itself, but the *Chapel of Saint-Sauveur* in the grounds, once part of a settlement founded by members of the *Order of Saint Antony of Egypt*. The opulent decorations in the early sixteenth-century chapel successfully combine late Gothic French forms with the splendour of the dawning Italian Renaissance.

Nantes This city is not only the grand finale to our tour of the Loire, it is also the introduction to a new theme: Brittany. There are both historical and geographical reasons to end our imaginary

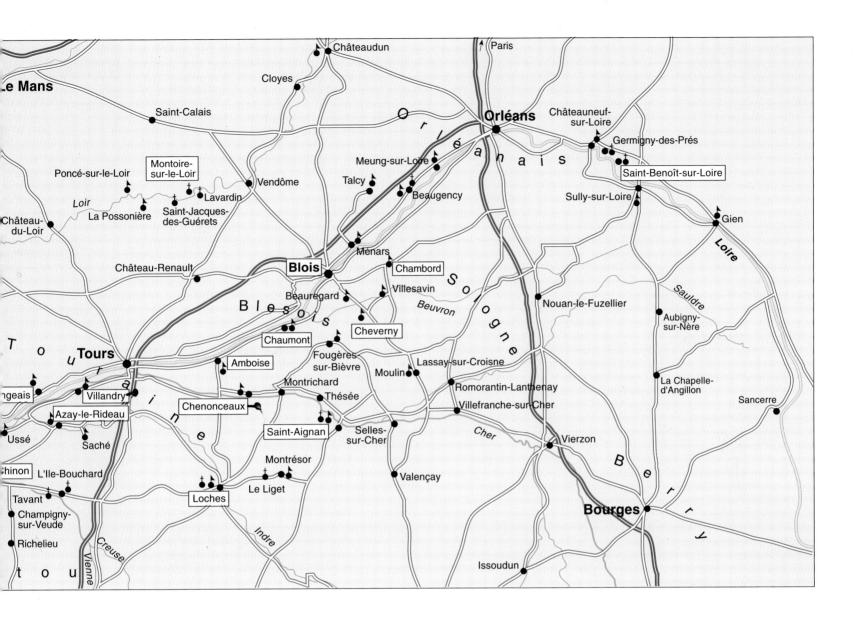

journey at Nantes. It was here, in 1598 at the ancient *Ducal castle*, a late medieval fortress, that Henry IV issued the Edict of Nantes, guaranteeing Protestants the freedom to practise their beliefs. The edict signalled the start of one of the more peaceful chapters in France's turbulent history. At the same time, it brought down the final curtain on the Loire Valley, whose major role as the adopted country of the French kings was now played out. Memories of the great days of the Loire are still deeply rooted in the consciousness of every francophile, and the valley of this mighty river will always stand as a symbol of *la douce France*.

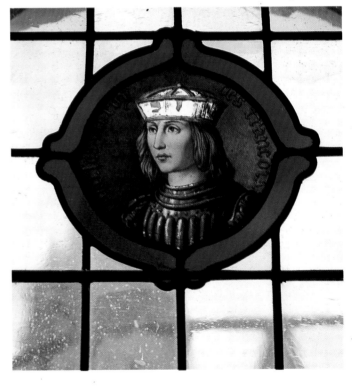

A stained-glass window in Loches representing Charles VII (1403–1461). It was in this chateau the French King met Joan of Arc, after which, with her help in 1429, the liberation of Orleans took place.

APPENDIX

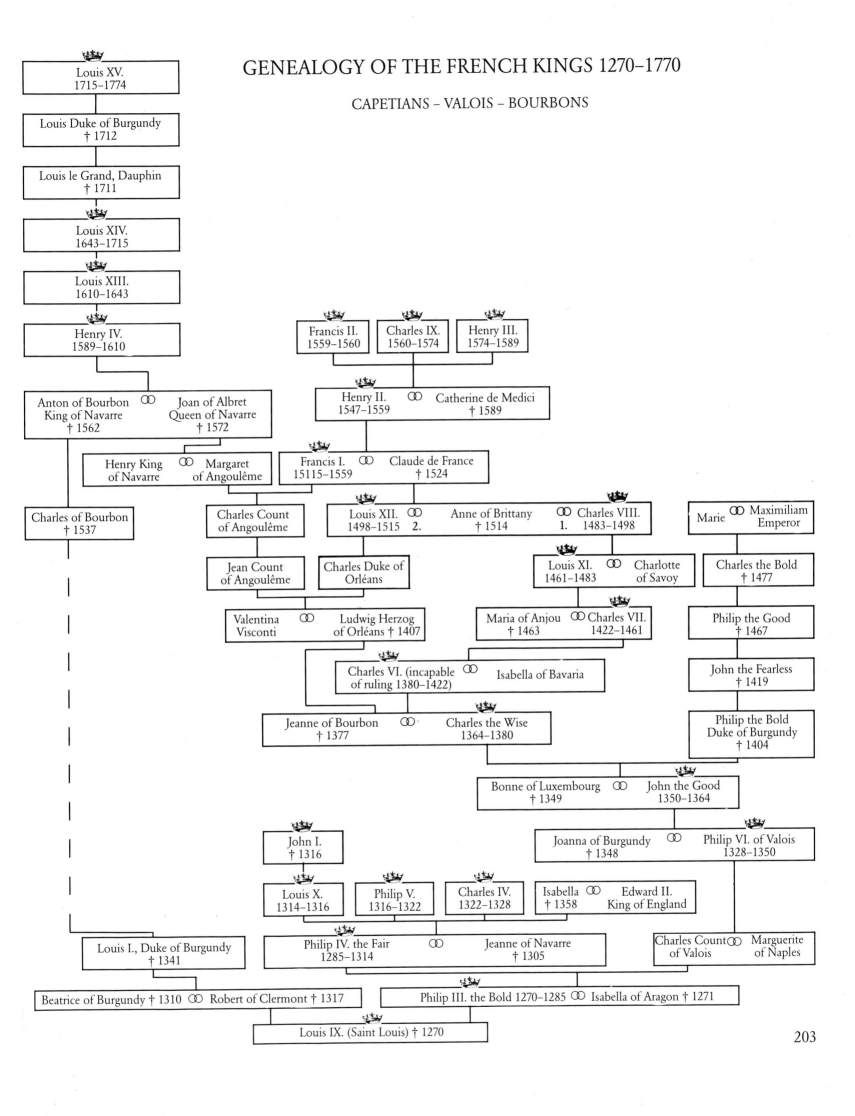

GENEALOGY OF THE FRENCH KINGS 1270–1770

CAPETIANS – VALOIS – BOURBONS

Louis XV.
1715–1774

Louis Duke of Burgundy
† 1712

Louis le Grand, Dauphin
† 1711

Louis XIV.
1643–1715

Louis XIII.
1610–1643

Henry IV.
1589–1610

Francis II.
1559–1560

Charles IX.
1560–1574

Henry III.
1574–1589

Anton of Bourbon
King of Navarre
† 1562

Joan of Albret
Queen of Navarre
† 1572

Henry II.
1547–1559

Catherine de Medici
† 1589

Henry King
of Navarre

Margaret
of Angoulême

Francis I.
15115–1559

Claude de France
† 1524

Charles of Bourbon
† 1537

Charles Count
of Angoulême

Louis XII.
1498–1515 2.

Anne of Brittany
† 1514

Charles VIII.
1. 1483–1498

Marie

Maximiliam
Emperor

Jean Count
of Angoulême

Charles Duke of
Orléans

Louis XI.
1461–1483

Charlotte
of Savoy

Charles the Bold
† 1477

Valentina
Visconti

Ludwig Herzog
of Orléans † 1407

Maria of Anjou
† 1463

Charles VII.
1422–1461

Philip the Good
† 1467

Charles VI. (incapable
of ruling 1380–1422)

Isabella of Bavaria

John the Fearless
† 1419

Jeanne of Bourbon
† 1377

Charles the Wise
1364–1380

Philip the Bold
Duke of Burgundy
† 1404

Bonne of Luxembourg
† 1349

John the Good
1350–1364

John I.
† 1316

Joanna of Burgundy
† 1348

Philip VI. of Valois
1328–1350

Louis X.
1314–1316

Philip V.
1316–1322

Charles IV.
1322–1328

Isabella
† 1358

Edward II.
King of England

Louis I., Duke of Burgundy
† 1341

Philip IV. the Fair
1285–1314

Jeanne of Navarre
† 1305

Charles Count
of Valois

Marguerite
of Naples

Beatrice of Burgundy † 1310 Robert of Clermont † 1317

Philip III. the Bold 1270–1285 Isabella of Aragon † 1271

Louis IX. (Saint Louis) † 1270

INDEX

Numbers in italics indicate illustrations

INDEX OF NAMES

INDEX OF PLACES
AND SUBJECTS

TEXT CREDITS

Laurent d'Arvieux: Mémoire. Paris 1735, in: Bernard Champigneulle: *Loire-Schlösser*. Munich: Prestel Verlag 1966.

Balzac, Honoré de: *Le Lys dans la vallée*. Manesse: Manesse Verlag, Zurich 1977.

Balzac, Honoré de: *Les contes drolatiques*. Munich: Winkler-Verlag 1958.

Brantôme, Seigneur de: *La vie des dames galantes* Munich: Wilhelm Heyne Verlag 1962.

Flaubert, Gustave: *Journaux. Par les champs et par les grèves*. Potsdam: Gustav Kiepenheuer Verlag 1929.

Gozlan, Léon: *Balzac en pantoufles* © Artemis & Winkler Verlag, Munich.

James, Henry: *A Little Tour in France*: List Verlag 1986

Koeppen, Wolfgang: *Reisen nach Frankreich* © Suhrkamp Verlag, Frankfurt am Main 1979.

Laube, Heinrich: 'Französische Lustschlösser' in *Laube's gesammelte Schriften*. Vienna: Wilhelm Braunmüller 1876. Pückler-Muskau, Prince Hermann von: *Semilassos vorletzter Weltgang*. Place of publication unknown 1835.

Rabelais, François: *Gargantua et Pantagruel*. Munich: Biederstein Verlag 1974.

Romains, Jules: 'Ein königliches Tal' in Merian: *Tal der Loire*. Year 10, vol. 2 Hamburg: Hoffmann & Campe Verlag 1957.

Rousseau, Jean-Jacques: *Confessions*. Transcribed from the Geneva manuscript by Alfred Semerau. Berlin: Propyläen-Verlag 1920.

PICTURE CREDITS